NORTH NOTTS COLLEGE
This book is

1000

24 APT 2010

HANDBOOK

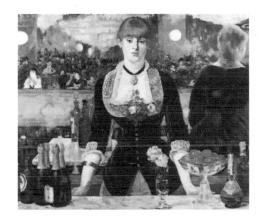

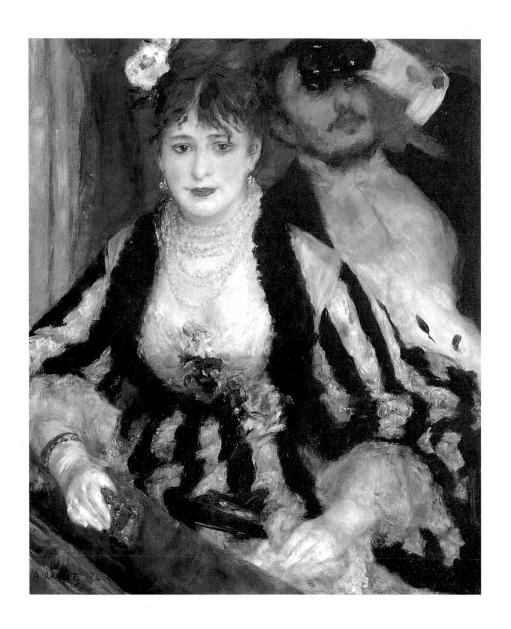

THE

Impressionists

HANDBOOK

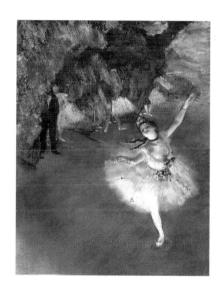

ABBEYDALE PRESS

This edition published in 1999 by Abbeydale Press An imprint of Bookmart Limited Desford Road, Enderby Leicester LE9 5AD England

© Bookmart Limited 1999 All rights reserved. No part of this publication may be reproduced, stored in a retrieval system, or transmitted in any way, or by any means, electronic, mechanical, photocopying, recording, or otherwise, without the prior written permission of the copyright holder.

> Originally published in 1991 by Bookmart Limited as The Impressionists

> > ISBN 1-86147-046-0

Printed and bound in Slovakia

757.054

Many thanks for help and advice to
12219 The Bridgeman Art Library
17-19 Garway Road, London W2 4PH

LIBRARY / LRC Tel.0171-727-4065/Fax 0171-792-8509

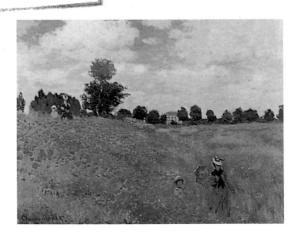

CONTENTS

SECTION ONE

A HISTORY OF IMPRESSIONISM	
FRANCE AND IMPRESSIONISM	8
THE BIRTH OF IMPRESSIONISM	18
THE AGE OF IMPRESSIONISM	94
SECTION TWO	
THE LIFE AND WORKS	
CAMILLE PISSARRO	124
EDOUARD MANET	148
EDGAR DEGAS	172
CLAUDE MONET	196
PIERRE-AUGUSTE RENOIR	220
ALFRED SISLEY	244
INDEX	255
ACKNOWLEDGEMENTS	256

SECTION ONE

A HISTORY OF IMPRESSIONISM

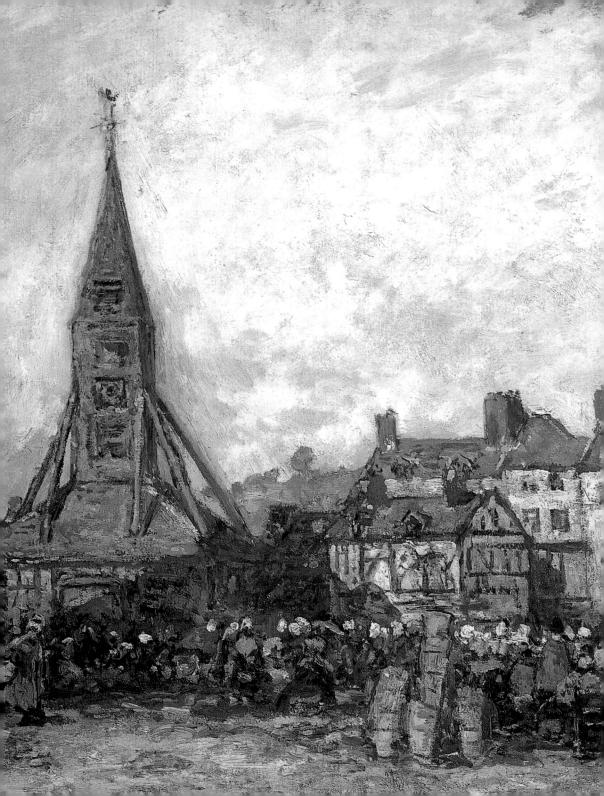

FRANCE AND IMPRESSIONISM

HE IMPRESSIONISTS DID NOT choose their name - it was foisted upon them in 1874 by a critic hostile to their work. However the name soon stuck and was used to describe a group of artists who never intended to be a unified radical movement, who never set out to shock or be revolutionaries. What they had in common was that they were all in Paris in the early 1860s and quickly got to know each other - some in art schools which they abandoned early on, some in the cafés where they would meet and realized that they shared a desire to paint the landscape, cityscape, and modern life in new ways. The first Impressionist exhibition took place because none of these artists had achieved any regular success at the official Salon, the major venue for the Paris art market, whose juries were notoriously inconsistent and reactionary.

The first exhibition by this group did little to challenge the all-powerful Salon, but it crystallized critical opinion and pushed the so-called Impressionists into the limelight. They were pilloried by hostile critics and supported by writers such as Baudelaire and Zola who saw in their work an important advancement of art into the modern era.

Opposite
JONGKIND
The Sainte
Catherine's
Market
at Honfleur.
Oil on canvas
1865.
42 x 66cm

APRIL 1874: SHOCK OF THE NEW

The Impressionist eye is, in short, the most advanced eye in human evolution . . .

IULES LAFORGUE, 1883

For one month from 15th April 1874 a new exhibition was to be seen at 35 boulevard des Capucines in Paris. Felix Nadar, a well-known photographer, had lent his studio free of charge to a group of artists who had come together as the Société anonyme des artistes peintres, sculpteurs, graveurs, etc. (a joint stock company of artists, painters, etc.). The show was open from ten to six during the day and eight to ten at night for an admission price of one franc. Among the twenty-nine artists showing their work were Paul Cézanne, Edgar Degas, Armand Guillaumin, Claude Monet, Berthe Morisot, Camille Pissarro, Pierre-Auguste Renoir, and Alfred Sisley.

The show was rapidly becoming a disaster. The members of the Société anonyme who had banded together to stage the show had of course aimed to generate sales as well as a greater awareness of their work with the public. Around 3,500 people visited the exhibition before it closed on 15th May but very few pictures were bought - the work of Degas and Morisot remained unsold, whilst Renoir had to knock down the price of his painting La Loge from 500 to 425 francs before he could sell it. Generally the public came for the novelty value, to see a cause célèbre in the making. Only the critics were triumphant. Writing in the satirical journal Charivari on 25th April 1874, Louis Lerov, a minor critic and playwright, composed an acerbic satirical review of the exhibition in the form of a tour around it in the company of an imaginary landscape painter called Joseph Vincent. Having relentlessly debunked most of the other artists on show, Lerov devoted part of the climax of his satire to a picture by Claude Monet:

"What does that canvas depict? Look at the catalogue."

"Impression, Sunrise."

"Impression – I was sure of it. I was just telling myself that, since I was impressed, there had to be some impression in it . . . and what freedom, what ease of workmanship! Wall-paper in its embryonic state is more finished than this seascape."

Monet had chosen the title of this picture in some haste for the exhibition catalogue, not wanting to call it a simple "seascape", and in doing so he had unwittingly provided Leroy with the hook-line for his piece, *Exhibition of the Impressionists*. Leroy had coined a name which would be certain to outlive his own.

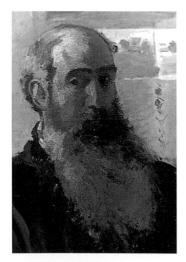

CAMILLE PISSARROSelf-portrait
1873

What were these so-called Impressionists doing that was so unacceptable? Leroy had put his finger on the obvious qualities of one aspect of their work, what henceforth would be called the "Impressionist" use of paint – a method that was as shocking as it was new to its public.

Leroy, of course, could read the painting and see the effect that Monet's brushwork intended to convey, but a tradition of officially sanctioned, respected and respectable Salon painting inevitably meant that the public were looking at Monet's Boulevard des Capucines and Impression, Sunrise, or Degas' ballcrinas, with a conservative, unprepared eve. To many, all that really could be seen from a couple of feet were blotches, strokes and scrapes of compacted pigment, which viewed from a "safe" distance would then coalesce meaningful into shapes. The "Impressionist technique" (in reality each artist was developing his own), allied with a new approach to colour and a range of subject matter. made the Société anonyme's first exhibition the laughing-stock of Paris. Yet it represented to the world at large a revolution in art that had been gathering since the early 1860s, when Edouard Manet caused a scandal with his Luncheon on the Grass (Déjeuner sur l'herbe).

In the early 1860s Frederic Bazille, Monet, Renoir, and Sisley had met in Paris to study at the atelier of the Swiss painter Charles Gleyre, whilst Pissarro had come to know Monet and Paul Cézanne. The high period of Impressionism was brief, but its influence, however, has lasted to this day.

The idea of an independent show outside the auspices of the Salon - the annual exhibition of the Académie des Beaux-Arts held in the Louvre's Salon d'Apollon and later in the enormous Palais d'Industrie - was increasingly discussed. Until then, the Académie des Beaux-Arts determined exclusively the showing of art. Without the sanction of the Salon an artist's work was practically unseen by the bourgeoisie which constituted his (and increasingly her) public. For good or ill, Lerov's insistence on the word "impression" tied together for posterity a group of artists whose aims were frequently at loggerheads, vet who had sct out together, rejecting the Salon which had so often rejected them.

What the unimaginative public and critics like Leroy found gross and unpolished, slapdash and meaningless in the work of the Impressionists shown at Nadar's studio was exactly what later generations came to value most in it. Writing in 1883 to introduce a small show by Pissarro, Degas, and Renoir in Berlin, the poet Jules Laforgue (who died three vears later at the age of twentyseven) considered the work of the Impressionists in a remarkable essay. What he had to say then evokes the qualities that were

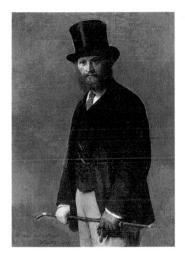

EDOUARD MANETBy Fantin-Latour
1867

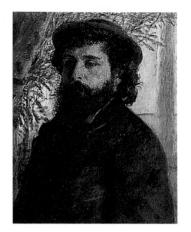

CLAUDE MONET By Renoir 1875

to make Impressionism a lasting and vital phenomenon. He pays particular attention to the Impressionists' capturing of the conditions of light, colour, and form as they are transmitted unmediated to the artist's eye at a particular moment in time:

In a landscape bathed with light, in which entities are modelled as if in coloured *grisaille* [i.e. monochrome painting in greyish colour], the academic painter sees nothing but white light spreading everywhere, whilst the Impressionist sees it bathing everything, not in dead whiteness, but in a thousand conflicting vibrations, in rich prismatic decompositions of colour. Where

the academic sees only lines at the edge of things . . . the Impressionist sees real living lines, without geometrical form, built from thousands of irregular touches which, at a distance, give the thing life. Where the academic sees only things set down in regular, separate positions . . . the Impressionist sees perspective established by thousands of imperceptible tones and touches, by the variety of atmospheric states, with each plane not immobile, but shifting. . . The Impressionist sees and renders nature as she is, which is to say solely by means of coloured vibrations. Neither drawing, nor light, nor modelling... these infantile classifications all resolve in reality into coloured vibrations, and must be obtained on the canvas solely by coloured vibrations.

ART IN THE SECOND EMPIRE

Stop, monsieur le Président, here is France's shame IEAN-LÉON GÉRÔME TO PRÉSIDENT LOUBET. 1900

Pissarro, Manet, Degas, Sisley, Monet, Bazille, and Morisot were all born between 1830 and 1841 into a France whose recent history had been as dramatic and changeable as the era the painters were to live through. France had not had a history of durable regimes; by the end of 1830 the King, Charles X, had abdicated after the July revolution in Paris, to be replaced by the Duke of Orleans, Louis Philippe, who assumed the lieutenant-generalship of France, Louis Philippe devoted himself to the bourgeoisie and the juste milieu, but ironically ruled amidst periodic riot and revolt until 1848 when Paris once again erupted in revolution, causing the abdication of Louis Philippe and the birth of the Second Republic. Two of the new republic's first acts were the Proclamation of Universal Suffrage and the Abolition of Slavery. In December 1848 Louis Napoleon, nephew of Napoleon was elected President of the Republic. Three years later, after the coup d'étât of 1851, Louis Napoleon became Emperor Napoleon III.

Napoleon III marked the start of his rule with a crack-down on political dissent and a suppression of the press while at the same time regulating the price of bread and encouraging growth in industry and commerce. France had languished behind the rest of Europe as the Industrial Revolution gained momentum, but Napoleon III's reign saw the development of banking institutions, railways and factories, as well as a patronage of the arts.

It is not surprising to learn that the Emperor's personal taste in painting favoured the academic style with its erudite classical and biblical subjects. although Romantics like Delacroix had little trouble making very successful careers for themselves under the Second Empire. However, a group of Realists who were more concerned with "common subjects", which had emerged under the vociferous leadership of Gustave Courbet, was anathema to Napoleon III's imperial sensibilities.

The new art, shortly to be named Impressionism, which succeeded Courbet, took as its subject matter not only nature, but also the prosperous middle class which had begun to make itself felt in the Second Empire. Edouard Manet's Music in the Tuileries Gardens (Musique dans le Jardin des Tuileries) of 1862 is regarded as one of the first great paintings of modern urban life, and what it shows is a bustling middle-class crowd

of professionals and artists at their leisure. It is representative of a nation, transformed in part by the policies of Napoleon III into an economically competitive state ready to enjoy its new found success and confidence.

To advance his nation further. Napoleon III had embarked on a series of successful wars against Austria, Russia, and China. In 1855 and 1867 the highly spectacular Expositions Universelles in Paris, rivalling the British Great Exhibition of 1851, announced to the nation and the world that France had arrived. Alas, the vagaries of French history caught up with Napoleon III. In 1870, just as he was attempting a measure of political liberalisation, he seriously misjudged the nation's readiness for conflict and engaged in war against Prussia on a point of diplomatic etiquette.

Hopelessly out-organized, and out-gunned, the French armics disintegrated, with the loss of the important eastern province of Alsace-Lorraine. The Prussians invaded Paris in September 1870, and the Second Empire fell soon after.

After the Prussians had paraded through Paris and the new, republican government had attempted to disarm the National Guard, the city erupted into revolution resulting in the Commune of 1871. Victor Hugo called it *l'année terrible*, a brief violent revolution which rose against the government and ended in massacre. In only one week, 20,000 Parisians were

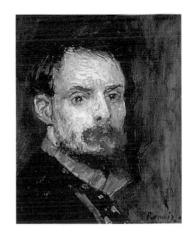

PIERRE-AUGUSTE RENOIR Self-portrait c.1875

killed as civil war erupted in the streets of what had recently been the dazzling capital of Europe. Scarcely two years before Monet's Boulevard des Capucines went on show in 1873, the boulevards of Paris had been stripped of trees cut down for firewood; the animals in the zoos, including the elephants as well as the city's racehorses, had been slaughtered for food in the beseiged and starving city. Yet these momentous events touched the work of the Impressionists very little. There is no trace of upheaval in any of the Impressionists' paintings; most fled to avoid the war and only Manet and Degas remained in Paris. The former, who had been anti-imperialist since the age of sixteen, was the only one amongst the group to record the bloody events of the Commune. However, the relationship of Manet and Degas with the other Impressionists is a special case in itself.

The Franco-Prussian war and the brief and bloody rise and fall of the Paris Commune formed the conclusion to the Second Empire. During the childhood and adolescence of the Impressionists many changes had swept over France, such as the massive construction of railways throughout the country to rival the systems of both Britain and the German states. Between 1851 and 1859 the French railways had trebled in length, facilitating the further expansion of industry and communications. Importantly for the Impressionists and their precursors who painted in the open air, the growth of the railways made the countryside available to the city-dweller in a way that was to have great consequences. During the Second Empire and well into the Third Republic, the cities, and Paris in particular, were undergoing fundamental change whilst in rural France the way of life was altered very little - only the occasional industrial chimney is to be seen poking up in the background of the Impressionists' landscapes.

In 1853 Napoleon III had appointed Baron Georges-Eugene Haussmann, Prefect of the Seine, to set about the reconstruction of Paris. This he began with grandiloquent gusto, aiming to transform a city of narrow streets and congested, practically medieval areas into a modern European Haussmann capital. built eighty-five miles of new roads that included the rue de Rivoli and the boulevard Saint-Michel. Along these new roads, modern buildings auickly sprang up, their height and style controlled by the authorities. For more than a decade Paris was a wonderland of new buildings, roads, squares, and other construction projects.

The Impressionists found the transformed city an ideal place for a new kind of art. The mile-long perspectives offered by the new boulevards, the St Lazare station in the centre and the iron railway bridges on the

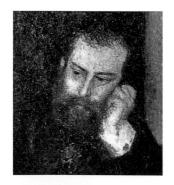

ALFRED SISLEY By Renoir 1874

outskirts became the subjects, for example, of Monet's urban paintings.

What "Haussmannization" meant, above all, was the gentrification of Paris, making its centre the exclusive habitat of the bourgeoisie. However, behind these new streets the slums that had been cleared reappeared, only more cramped and squalid. Meanwhile hundreds of thousands of workers had been moved out to new industrial suburbs and slum areas, like Belleville and Menilmontant, where they subsisted much as they had done before, but this time dispossessed of their ancient city.

When the rubble of 1870–71, caused by heavy Prussian bombardment and violent civil war, was cleared away, Paris quickly became *la ville lumière* it had been during the Second Empire. By 1874 it was hard to imagine that dogs and rats had once been on the menu. Although memories of the civil war remained, the economic growth of the Second Empire resumed under a republican guise. Paris reclaimed its place as the centre of European art.

The Impressionists lived in an age of struggle between modernity and a traditional order. We see in their paintings a radical, and, for their time, shocking break with traditional notions of art, the culmination, but not the end, of a series of new ways of seeing. The Abstract movement of the twentieth century stemmed from experiments with existing art just as the Impressionists' innovations grew out of the paintings of Courbet, Corot, Delacroix, Constable, and the old masters who had gone before in the world of art.

The Impressionists' sense of wonderment at their world has, ironically, become for us a comforting reflection of times passed. Although it would be convenient to think that before Monet, Renoir, Sisley, and Pissarro light could never have been seen and set down in a series of broken, prismatic colours, that shadows were never blue or red, vet in fact these approaches were already becoming possible in the early nineteenth century. It is certainly true, nevertheless, that a short time after these artists had come together, blue shadows and green skies were, and have remained, commonplace in the vocabulary of art.

The Impressionists were named in jest; collectively they never published a manifesto their name is a catch-all for a fragile movement of men and women briefly united in their belief that the time had come for a new art to be seen and appreciated. They came from different social backgrounds, from the patricians Manet and Degas to the working-class Renoir, and in the end their friendships broke up and they scattered across France. All of them, however, were in Paris during a critical period in French history; they knew and

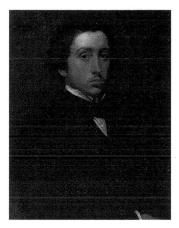

EDGAR DEGAS Self -portrait c.1855

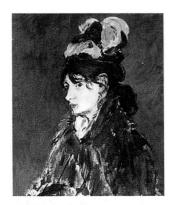

BERTHE MORISOT By Manet c.1869

worked with each other and often lived in each other's pockets. Some - Monet, Sisley, and Pissarro, for example - were overwhelmingly attracted by the landscape and were driven to depict it. Others - Degas, Manet, and Renoir - were more concerned with the human figure and the life of the city and its suburbs. In their time they were all accused of being revolutionary; their supporters held them up as the iconographers of a new, modern age; their critics claimed they were subverting a set of artistic ideals and methods which had obtained for centuries.

In some ways the Impressionists were revolutionaries in their use of colour, for example, or choice of subject and methods of exhibition, and in their assertion of the right to recreate the world as they saw it. The history of the Impressionists is full of contradictions. Edouard Manet (who together with Degas we should be wary of calling an Impressionist in any case), a generous and devoted supporter of the younger artists such as Monet, Renoir, and Sisley, never exhibited in the series of Impressionist exhibitions which shook the Parisian art world. However, he had caused a sensation a decade before with Luncheon on the Grass (Déjeuner sur l'herbe), and though he was considered to be their leader, he sought distinction through the Salon - a reluctant revolutionary. Degas, of the same generation as Manet, exhibited in all eight of the Impressionists' shows from 1874 to 1886. Monet, Renoir, and Sisley all dropped out of the group's exhibitions in the late 1870s, whilst the most politically revolutionary of them all, Pissarro, would not abandon Degas (politically an arch conservative and anti-semite) or the Impressionist exhibitions even when the others begged him to. Despite all of these contradictions there existed for a short period in late nineteenth-century France a movement, a loose and informal "academy" whose members learnt from one another and changed the course of art.

When Claude Monet died in 1926, Impressionism was firmly enshrined in the past - new forces had been at work since the 1880s. In the lifetime of Monet and most of the Impressionists, France had seen two revolutions, the rise and fall of the Second Empire and the establishment of the Third Republic. By the last years of the nineteenth century the style had evolved into Neo- and Post-Impressionism. But the shock waves of Impressionism continued to reverberate. In 1900, the academician Gérôme, was guiding Président Loubet of France around the Exposition Universelle when he stopped him at the entrance to the Impressionist Room with these words: "Arrêtez, monsieur le Président, c'est ici le déshonneur de la France!"

MONET
The Artist's Garden at Argenteuil
Oil on canvas
1872. 61 x 74cm

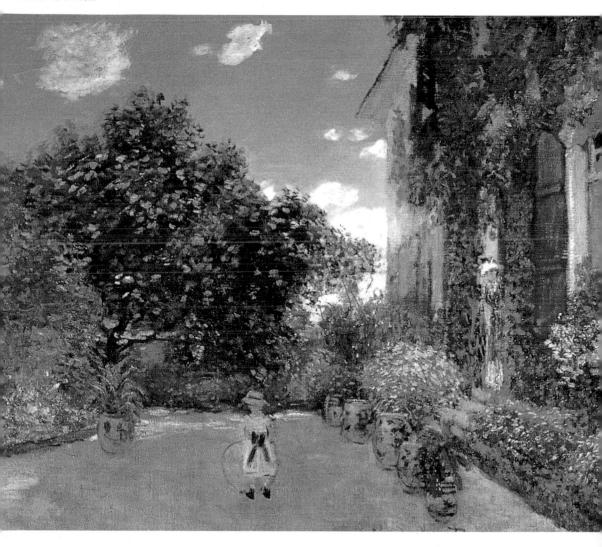

THE BIRTH OF IMPRESSIONISM

EVERAL INFLUENCES IN THE earlier part of the nineteenth century are crucial to the development of Impressionism. In the first three decades of the century the inspiration of Dutch and English landscapists began to have an important effect on French landscape painting and art in general. Eugène Delacroix - who was to influence many of the Impressionists, especially Renoir had brought a new brilliance of colour and virtuosity of brushwork to his paintings and was an admirer of Constable, as were the Barbizon School of open air painters attempting a new naturalism in and around Fontainebleau Forest. The latter were the precursors of Monet and Pissarro, who were also influenced by the landscapists Boudin and Jongkind on the Normandy coast. By mid-century the Realists had come to prominence headed by Gustave Courbet.

In 1863, Edouard Manet caused a scandal with his *Luncheon on the Grass* which portrayed its classical subject in a modern idiom to shocking effect and he became the reluctant leader of the younger generation of Monet, Renoir, Sisley, and Bazille who had come together the year before at the atelier of Charles Gleyre and formed the nucleus of the Impressionists.

Opposite
COROT
Landscape at
Mornex, Savoy
Oil on canvas
Undated.
40 x 61.5cm
(detail)

1820–1863 FROM THE ENGLISH LANDSCAPE TO THE SALON DES REFUSÉS

... I did not really see a less negative colour, but I felt as if it were an effort towards a less negative colour, the pulsation of a hesitant ray struggling to discharge its light.

MARCEL PROUST, SWANN'S WAY

The Impressionists par excellence, Monet, Pissarro, Sisley, and Renoir, met in Paris in the early 1860s and were bound together in their admiration for the work of an older generation of landscape painters who had left their studios to paint in the open air in the countryside near Paris. Tracing the immediate origins of Impressionism, a phenomenon which began in the French countryside, takes us back to the English landscape and the excitement felt by early nineteenth-century French Romantic painters, such as Eugène Delacroix and Théodore Géricault, on encountering the experiments and achievements in oil and watercolour of the English landscape painters John Constable, J.M.W. Turner, and Richard Bonington.

In 1820 the French writer Charles Nodier, was in London at the Royal Academy summer exhibition. In Nodier's journal, entitled *From Dieppe to the Mountains of Scotland*, he offered the following opinion of the summer exhibition:

In painting, landscapes and sea views are the pieces in which the English have the fewest rivals in Europe . . . the palm of the exhibition belongs to a large landscape by Constable . . . Near, it is only broad daubings of ill-laid colour which offend the touch as well as the sight, they are so coarse and uneven. At the distance of a few steps it is picturesque country, rustic dwellings, a low river where little waves foam over the pebbles, a cart crossing a pond. It is water, air and sky . . .

When Eugène Delacroix saw The Hay Wain at the Paris Salon of 1824 he was so impressed by the natural transparency and brilliance of colour Constable's sky, trees, earth, and water that he immediately set about reworking his own Massacre at Chois (Massacre à Scio), adding glaze and thick patches of pure pigment in an attempt to emulate the effect of Constable's work. Delacroix's radical use of colour and his technique of flochetage, using large flakes (floches) of colour to heighten his forms, was later to be developed further by the Impressionists.

Théodore Géricault had seen The Hay Wain in London, two years before Delacroix's encounter and had expressed his astonishment to Delacroix and others on his return to Paris. With the practical interest of Delacroix and Géricault in the an important step had been taken along the road which was eventually to lead to Monet and Pissarro.

During the 1820s and 1830s the sketches of Constable, Turner, and Bonington were of particular interest to Delacroix and his contemporaries. In order to capture "with a pure apprehension of natural effect," the incessantly changing qualities of light and colour, Delacroix observed that in the natural world "light and shadow never stand still." Consequently,

the French Romantic painters developed the habit of making quick, but by no means cursory, sketches of a particular scene in oil and watercolour. These sketches, although they were not considered to be "finished" by the authorities and Salons of the time, are of importance in the development both of the artist's way of seeing the world and the technique of depicting it. They display to a remarkable degree the totality of the artist's vision and observation, and are nowadays often more highly

CONSTABLE

A Cottage among Trees with a Sand Bank
Oil on paper on canvas c.1830
An example of Constable's direct approach to landscape. The sketchy nature of works such as this was

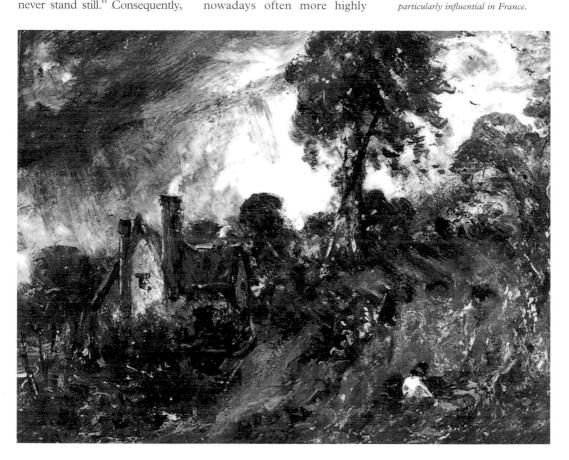

prized than the "finished" work they frequently preceded. In fact, Delacroix and many others of his generation agreed that the vitality of outdoor sketches suffered from being transferred and reworked into studio compositions.

Until Constable and his fellow English landscapists had made their dazzling impact on the French art establishment in the 1820s, French landscape painting had enjoyed an honourable, if dull history. It is often, though quite wrongly assumed that the Académie in Paris at this time had no interest in the promotion of landscape painting. A major quadrennial competition in historical landscape painting, the Prix de Paysage Historique, had been instigated at the Ecole des Beaux-Arts in 1817 after many years of agitation by landscapists for the genre to be recognized within the school's establishment. Although the competition for the Prix de Paysage Historique was abolished in 1863 - a date central to the history of Impressionism as it marked the first Salon des Refusés - the teaching of landscape painting at the Ecole was at a significant level of development by the time Constable showed The Hay Wain at the 1824 Salon in Paris.

It is important to note that the Prix de Paysage Historique was precisely that – a competition for historical landscape, not landscape after nature or paysage champêtre. To compete, students had to choose a classical or biblical theme "of the noble and historical type" for their subject, and figures to be set in the landscape were not to exceed a prescribed height and disturb the proportions of a picture which was, after all, to be devoted to landscape. Despite this, the teaching of landscape after nature at the Ecole was surprisingly advanced, echoing some of the dicta of Constable and vaguely foreshadowing the loose theories of the Impressionists. I. B. Deperthes, who published his Théorie de paysage (Landscape Theory) in 1818, advised students of landscape painting that their aim in depicting nature was to paint it "in the light that falls on it at the exact moment when the painter sets out to capture the scene." According to the landscapist Pierre-Henri Valenciennes (who was partly responsible for the Prix de Paysage Historique), under whom Deperthes had studied, a study (étude) for a landscape painting made "from Nature should be done within two hours at the outside, and if

CONSTABLE

The Hay Wain
Oil on canvas
1821. 130 x 185.5cm
The quintessential English landscape.
This and other works by the English landscapists were a source of great inspiration to the Barbizon School and the Impressionists.

THE BIRTH OF IMPRESSIONISM

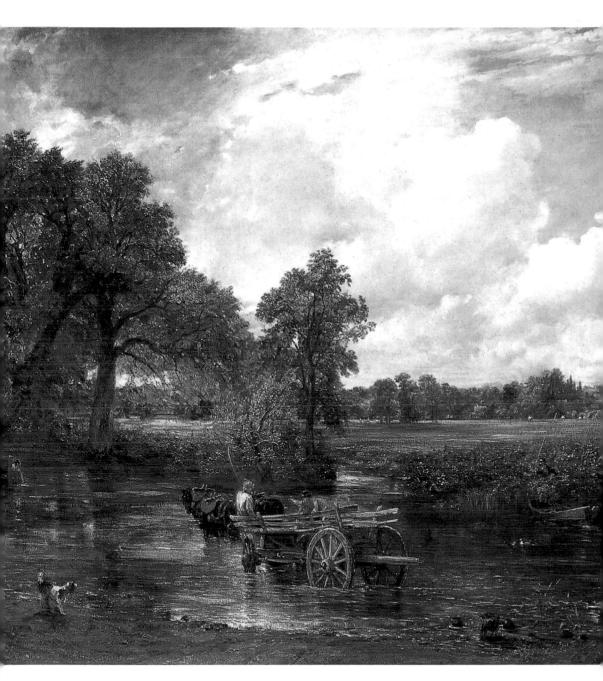

vour effect is a sunrise or a sunset, you should not take more than half an hour." Neither of these two instructions would have been out of place in a hypothetical manual of the art of Impressionism. Yet landscape painters such as Constable, Bonington, Valenciennes, and Deperthes were confined by tradition to their studios for the completion of their works of art. Painting outdoors did not lead to acceptably "finished" pieces of art. Indeed, Constable, as he was working in his London studio on The Hay Wain, was forced to dispatch an underling to the depths of East Anglia to make drawings of the eponymous cart. After the apprentice returned with the drawing Constable then completed the composition of the picture. This was the most practical approach.

The move into the country and the development of the idea that a sketch made outdoors, en plein-air, was a legitimate end in itself came with a group of painters known as the Barbizon School. Barbizon is a village in the Fontainebleau Forest to the southeast of Paris. The Fontainebleau Forest and the nearby plain of Chailly had been locations for painters since the mid-eighteenth century, and

COURBET

Entrance to the Straits of Gibraltar Oil on canvas 1848. 18 x 26cm Small hastily executed sketches were not made for public consumption, but the aesthetic of the sketch was gaining ground amongst French landscapists.

had been suggested by Valenciennes as useful substitutes for the Roman Campagna, a landscape held in great esteem for its classical associations. Between 1830 and 1850 a group of landscape painters, which included Constant Troyon, Théodore Rousseau, Virgile Diaz de la Peña, François Daubigny, François Millet, and Jean-Baptiste Corot, made use of the area around Barbizon and often settled there for long periods. Daubigny was a devoted pleinair painter who built a studio boat in order to paint in situ on the river Oise (an example later followed by Monet). In 1891 Frédéric Henriet, in The Campaigns of a Landscape Painter (Les Campagnes d'un paysagiste), describes the great struggle Daubigny had with the elements:

Daubigny attached his canvas to some posts solidly planted in the ground. And there it stayed... until it was completely finished. The painter had specifically chosen a turbulent sky filled with large clouds chased by the angry wind. He was constantly on the alert for the right moment and ran to take up his work as soon as the weather corresponded to his painting.

DAUBIGNY

Spring
Oil on canvas
1857. 96 x 193cm
A perfect example of the
Barbizon landscape, Daubigny's
painting was exhibited at the
Salon of 1857.

THE BIRTH OF IMPRESSIONISM

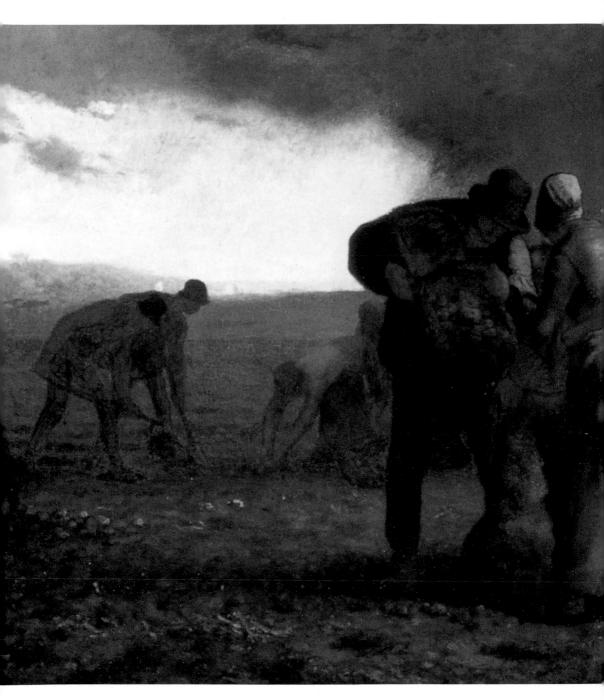

The Barbizon School was as indebted to the English landscapists as Delacroix although in historical terms the art being created around Barbizon quickly came to represent a strong reaction against the Romanticism of Delacroix Géricault, who were not particularly interested in landscape or blein-airisme as a genre or method of painting. Just as the Romantics had rebelled against the ingrained Neo-Classicism of the Académie, as exemplified by David and Ingres and taught in th Ecole des Beaux-Arts, so the painting of nature for its own sake amounted to a rejection of both the erudite Noo-Classical and the flambovant Romantic subject matter The Barbizon painters, as well as admiring th English landscapists of their own era, were much taken with the eminent seventeenth century Dutch School of landscape painting particularly the works of Ruysdael and Hobbema. In this the Barbizon School was supported by the Director of the Académie, Théophile Thoré, who had commissioned Rousseau and made an extensive study of Dutch art. On the

MILLET

The Potato Harvest
Oil on canvas
1858. 54 x 65cm
The dignity of the peasant labour was
Millet's great theme, which influenced
both Pissarro, and later van Gogh.

other hand the Comte de Nieuwerkerke, the Director-General of National Museums after 1849, spoke for many when he described the Barbizon School in the following incandescent and patronizing terms: "This is the painting of democrats, of those who don't change their linen and who want to put themselves above men of the world. This art displeases and disquiets me."

Thankfully the Comte de Nieuwerkerke and the French authorities were increasingly disquietened to find their stranglehold on matters of taste weakening. The clear line of development from the Dutch to the English artists, and thence the French landscape painters and their attempt to capture "the exact moment", was leading to the art of Monet and his fellow Impressionists.

Capturing the landscape meant being in it, with all the attendant difficulties of being away from the studio. In 1841 John Goffe Rand, an American portraitist living in London, had invented the first collapsible paint tube, an idea quickly taken up by the colour mer chants Winsor and Newton. As Pierre Auguste Renoir is reported by his son, Jean, to have said, "Without paints in tubes there would have been no Cézanne, no Monet, no Sisley or Pissarro, nothing of what the journalists were later to call Impressionism."

The three pictures on these pages have been enlarged to show the brushwork of three of the great Impressionists – Manet, Renoir and Monet. The similarity in the looseness and immediacy of the strokes contrasted greatly with the refined concentrated brushstrokes of the classical schools and more conventional artists of the time.

Before the arrival of these new tubes, made of inert tin so as not to react with the various chemicals in the pigment, the ground pigment was supplied by the colour merchant, mixed with oil by the painter and kept in a small pouch of pig's bladder. To use the paint, the artist had to make a small hole in the wall of the bladder and squeeze it out. For centuries these bladders had been the only way of dispensing a ready mixed combination of pigment and oil, but paint could not be kept for long in them before the oil began to

oxidize. Once opened, the life of the paint - made up of expensive pigments - was considerably shortened. The tin tube was a revolutionary device by comparison, both for the colour merchant, who had a new product with which to service an increasing clientele of amateur or "Sunday" painters littering banks of the Seine on summer days, and serious artists, who could now venture outdoors confident that the paint was in a stable condition and swiftly to hand. The tube paint had the consistency of fresh butter, which made it ideal for application to the canvas in thick impasto brushstrokes, or even with palette knife - both methods used by Impressionists and after them to particularly remarkable effect by Vincent van Gogh. Paint could still of course be further tempered with linseed, walnut, or poppy oil, or diluted with turpentine.

To fill the new tubes a whole new range of bright, stable colours began to appear on the market. The advancement of chemistry in the early part of the century had heralded new colours such as cobalt blue, artificial ultramarine (previously made of lapis lazuli, very expensive and available only in small quantities), chromium vellow with its shades of orange, red and green, emerald green, zinc white and a stable lead white. By the 1850s the artist had at his or her disposal a palette more brilliant, stable convenient than ever before.

MANET
An Italian Woman
Oil on canvas
Private collection

In 1839 the French chemist Eugène Chevreul, director of dyeing at the Gobelins tapestry workshop, who had begun an investigation into why some dved colours seemed less brilliant than others, published his study On the Law of Simultaneous Colour Contrast and the Arrangement of Coloured Objects (better known as The Principles of Harmony and Contrast of Colours), which explained the phenomenon that when two colours are placed touching one another the differences between them are perceived to be at their greatest. From this he codified a theory of colours which says that certain pairs of colours,

such as green and red, or violet and yellow, complement each other. This gives rise to the phenomenon of "negative or complementary after-image" where the complementary colour of a red, i.e. green, can be seen as an aura around the colour when staring at the red for a moment and then looking away towards another direction. Delacroix had used shadow in his work, and the Impressionists were to exploit their own perception and Chevreul's theory further with the bright new colours available to them, whilst the Neo-Impressionists were to take this phenomenon to its logical extreme.

RENOIR
The White Hat
Oil on canvas
1890. 55.5 x 46cm

MONET The Red Road Oil on canvas 1884, 65 x 81cm

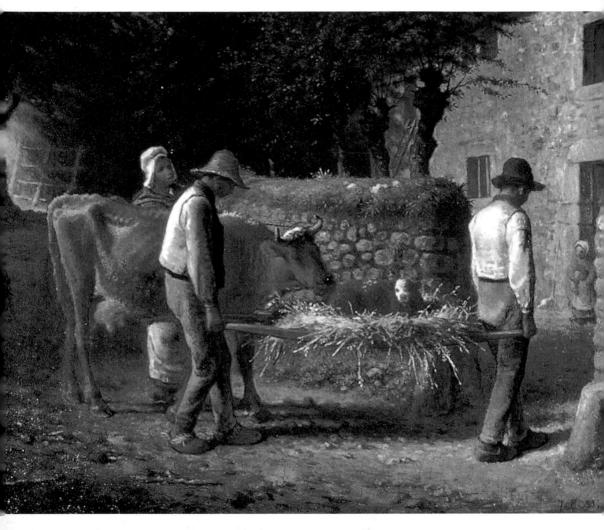

MILLET

Bringing Home the New-born Calf Oil on Canvas 1857–61. 81 x 99cm This painting was ridiculed by some contemporary critics, who considered Millet's subjects to be vulgar and unworthy of fine art. Meanwhile, the Realism developed by François Millet and Gustave Courbet, which was a complete rejection of Neo-Classical and Romantic styles, began, in the late 1850s and early 1860s, to have a strong influence on young painters like Monet. Millet's great achievement was to paint

the peasantry as he found and remembered it, being himself the son of a Normandy peasant farmer. Although paintings such as *The Gleaners (Les Glaneurs)* and *Angèlus* show the peasantry at backbreaking work and pious rest, and do not appear today to be particularly realistic, their very subject matter

was a cause for controversy at the time among those traditionalists who thought agricultural labour a subject unfit for "proper" representation, and those at the other extreme who believed Millet's work to be the embodiment of socialist values. Despite the claims of the right and the left, Millet remained resolutely apolitical.

Not so Gustave Courbet, the son of a wealthy wine grower from Ornans near Switzerland. Courbet's art, like his politics, was uncompromising. His choice of subjects eschewed everything that had previously been thought suitable for fine art. They were, as Bernard Denvir observes, "unheroic, unhistorical, and entirely unconcerned either with religious symbolism or patriotic propaganda." Courbet was a friend and comrade of the printer Pierre Joseph Proudhon, and his staunch socialism ensured him a spectacular career in politics, eventually landing him in jail for taking part in the destruction of the Vendôme Column, a huge victory memorial in the heart of Paris. But in spite of his radicalism in painting and politics he exhibited two works, The Stone Breakers (Les Casseurs de pierre) and The Burial at Ornans, at the Salon of 1850.

COURBET

A Spanish Woman
Oil on canvas
1855. 81 x 65cm
Courbet usually painted what he saw and did not try to prettify his sitters.

"I hold", Courbet wrote in 1861, "that painting is essentially a concrete art and does not consist of anything but the representation of real and concrete things". Five years later, at the Exposition Universelle in Paris, Courbet erected his own Pavillon du Réalisme where he rivalled the official Salon by showing forty pictures including the massive The Artist's Studio (L'Atelier du peintre), which depicts in "an Allegory of Realism" the artist and the influences at work on him

In the decade after 1850 French painting underwent an unparalleled fragmentation of styles, partly tolerated but never promoted by the authorities. experiments of the Barbizon School and the Realists were encouraging the young painters who had been born in the 1830s and 1840s along a path which was artistically a logical progression but which was to appear to the public and the arbiters of the Salon shockingly revolutionary. By the time the Impressionists began to show in the mid-1870s, the Barbizon artists were readily accepted by the Salon and were beginning to fetch high prices.

COURBET

The Burial at Ornans Oil on canvas 1849–50. 315 x 668cm

This massive, dark, unconventional composition showing the lower echelons of society provoked ourraged criticism. His rejection of historical and religious subjects made Courbet the champion of the new generation of "painters of modern life".

THE BIRTH OF IMPRESSIONISM

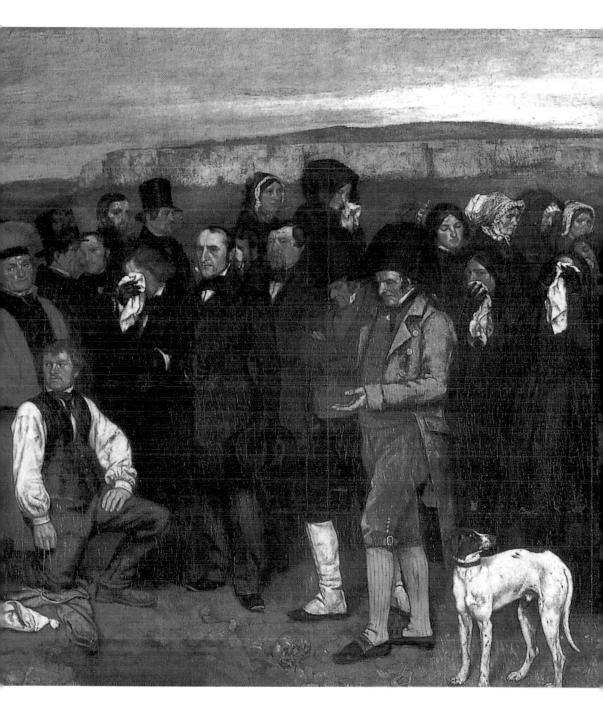

PISSARRO, MANET, AND DEGAS

Camille Pissarro, Edouard Manet, and Edgar Degas, born in 1830, 1832, and 1834 respectively, were in their twenties when the 1855 Exposition Universelle was proving to be the delight of Paris. The work of Delacroix, who was now fiftyseven and achieving great popular acclaim, was the main attraction, having been eloquently lauded by the poet and art critic Charles Baudelaire (who was later to befriend Manet). Work by Daubigny, Corot, and Millet was also to be seen hidden amongst the thousands of paintings on show, but it would have been difficult to miss Courbet's spectacular sideshow.

Pissarro, the third son of Franco-Jewish parents, had arrived in Paris from St Thomas, a Danish colony in the Virgin Islands where his father was a merchant. Camille had been to school in France, but after returning to St Thomas to work in his father's store, he had gone to Venezuela in 1853 to work with the Danish artist Fritz Melbye. Eventually his parents decided to send him to Paris to study art. He arrived in 1855, as the Exposition was in progress, to attend the Ecole des Beaux-Arts. He soon left the Ecole for the Académie Suisse, a studio in the quai des Orfèvres, run by an ex-model, which charged small fees, offered no teaching, but had models and equipment for

young artists to study life drawing and painting as they wished. At the Exposition Universelle, Pissarro was particularly impressed by the six Corots on show - the young Pissarro had become a landscapist under the influence of his friend Melbye and later went to visit Corot in search of guidance. A couple of years later he was found by Claude Monet to be "peacefully working away in Corot's style"; ten years after the Exposition Universelle, Pissarro was officially exhibiting at the Salon as Corot's pupil. At that time it would be hard to imagine that he would become, with the exception of Claude Monet, perhaps the most influential of the landscape Impressionists.

In contrast to Camille Pissarro, Edouard Manet, twentythree at the time of the Exposition, was the son of a Parisian magistrate, a member of the haute bourgeoisie and blessed, as was his slightly younger contemporary Edgar Degas, with the security of independent means. He had enrolled in the school of Thomas Couture in 1850, where he studied painting for six years. Couture had been a pupil of Paul Delaroche, whose The Execution of Lady Jane Grey exemplified the conservative but popular qualities of the Davidian academic style. The painting had delighted the Salon of 1834 where visitors are reported to have wept. They were no doubt moved by the sight of the young English

COROT

The Forest of Fontainebleau Oil on canvas c.1855. 39 x 54.5cm The archetypal Barbizon landscape.

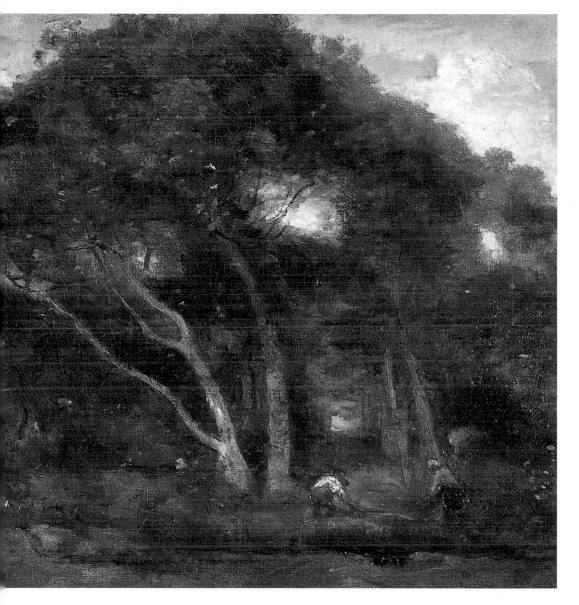

noblewoman with her head on the block, a fate close to the hearts of all French citizens not so long after the horrific mass executions that followed the 1789 Revolution.

Couture had caused controversy and ensured himself his own place in the popular imagination of the French public and critics with his huge painting The Romans of the Decadence (Les Romains de la décadence), a sprawling depiction of a Roman orgy which shocked and titillated Parisian society when it was shown at the Salon of 1847. In the same year, doubtless to make the most of his new-found notoriety, Couture had opened his own private art school in Paris, advertising it as offering "teaching based above all on the great art of ancient Greece, the Renaissance masters and the admirable Flemish school." Couture, in order to clarify his view further, declared himself against the "spurious classical school which reproduces the works of the past in a banal and imperfect fashion," and "hostile to that abominable school, known [as] Romantic."

COUTURE

The Romans of the Decadence Oil on canvas 1847. 466 x 775cm Couture, the teacher of Manet, scored an immense success with this work at the Salon of 1874.

THE BIRTH OF IMPRESSIONISM

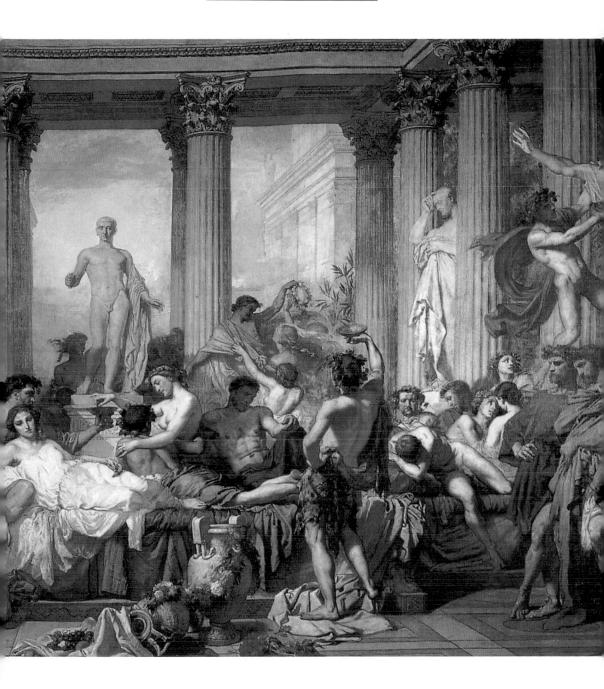

All this was true to the spirit of Louis Philippe's juste milieu, and linked Couture to his contemporaries such as Charles Glevre and Alexander Cabanel, who were in fact content to use those elements of Classicism. Romanticism and even Realism which would make up an acceptable picture. As an allegory of contemporary hedonism veiled in the skimpy tunic of Classicism, The Romans of the Decadence stands in ironic contrast to the juste milieu professed by all and which was to continue after the fall of Louis Philippe and well into the Third Republic. The burgeoning French middle classes of the 1850s would have been outraged if Couture had depicted the contemporary French male bourgeoisie at one of its favourite leisure activities, the brothel. Yet, this is exactly what Couture's pupil Edouard Manet set out to do eight years later at the Salon des Refusés of 1863 with his Luncheon on the Grass (Déjeuner sur l'herbe). That painting scandalized Paris and pushed Manet reluctantly into the forefront of what became known as the Impressionist movement.

MANET

Copy after Delacroix's Dante
Oil on canvas
1855. 33 x 41cm
Manet went to see the deeply respected
Delacroix with his friend Antonin Proust,
and asked permission to copy his work.

DEGAS
Self-portrait
Oil on canvas
1854–55. 81 x 64.5cm
One of many self-portraits the artist painted in his youth.

During his time as a young "apprentice" at Couture's atelier Manet was less concerned with shocking Paris than studying his master's teaching and pondering how literally to reverse the academic technique to his own ends. He also spent many hours in the Louvre studying and copying the techniques of the old masters. The Spanish artists Velazquez, Murillo, and Ribera particularly interested him; an influence which can be seen in his later paintings. Manet was in effect a pivotal force in the long tradition of European art. His wish was to evolve from the old masters, not reject what he had learnt from them. He was also significantly in awe of Delacroix, so much so that in 1855 he wrote to him asking permission to copy his Barque of Dante (La Barque de Dante).

Edgar Degas was the youngest of his generation of artists to study in Paris in the mid-1850s. He spent only one semester at the Ecole des Beaux-Arts, however, before an extended tour of Italy where part of his family lived. Degas was the son of Franco-Italian parents who had made their fortune in banking. He registered with the painting and sculpture section of the Ecole des Beaux-Arts on 6th April 1855 after passing an entrance competition at which the painter Henri Fantin-Latour was also successful. (Fantin-Latour, however, was found wanting and left three months

later.) Degas' teacher during his brief studies at the Ecole was Louis Lamothe, who inspired him with his own deeply held respect for Ingres, whose pictures in any case Degas had been copying in the Louvre and at the homes of wealthy family friends for some time. In 1856 Degas was in Naples visiting his relatives, painting their portraits and touring the great museums of other Italian cities, absorbing all the Renaissance masters he could feast his eyes on. Although he was to be a prime mover in the Société anonyme just under a decade later, the relationship of Degas' work to the other Impressionists was to be marked both by his experiences in Italy and by his abiding interest in the human form as opposed to the landscape.

THE NURSERY OF IMPRESSIONISM

1862 France annexed Cambodia, Victor Hugo published Les Misérables, Edouard Manet painted Music in the Tuileries Gardens and four unknown young artists met in the Paris atelier of Charles Glevre, a Swiss artist who had been an instructor at the Ecole des Beaux-Arts, Claude Monet, the eldest son of a grain merchant in the north-western port of Le Hâvre, Frédéric Bazille, whose family were affluent wine producers in the southern Hérault, Auguste Renoir, previously a porcelain-painter, and Alfred Sisley, at twenty-three, the oldest in the group by two years and the son of an English businessman. They had little in common except art. Gleyre's atelier had a reputation for being cheap and Gleyre himself was known to be fairly tolerant and kind to his *élèves* (pupils). Although he was neither famous nor a member of the Académie, one painting by him, of 1843, had enjoyed great success at the Salon. The painting won him a medal and respect from the critics of the day.

The teachers of the Impressionists were men raised in an academic ethos of painting stretching back to principles laid down in the seventeenth century. To prepare for entry into the Ecole, aspiring artists in the mid-nineteenth century entrusted themselves (and their purses) to men such as Charles Gleyre and Thomas Couture who ran private independent ateliers where they could receive formal instruction (a system which persists to this day in France). Life at the atelier for a young rapin, or new boy, was often fraught with dangers. According to Albert Boime, the eminent historian of the Académie in the nineteenth century, the rapin would be first to arrive at the atelier in the morning and busied himself with menial tasks such as arranging the stools, sweeping the floor, washing the brushes, running errands and suffering occasional persecution by the older students.

INGRES
The Princess of Broglie
Oil on canvas
1853. 114.5 x 86cm
Degas was a consummate
draughtsman and Ingres'
perfection was an abiding
model for him.

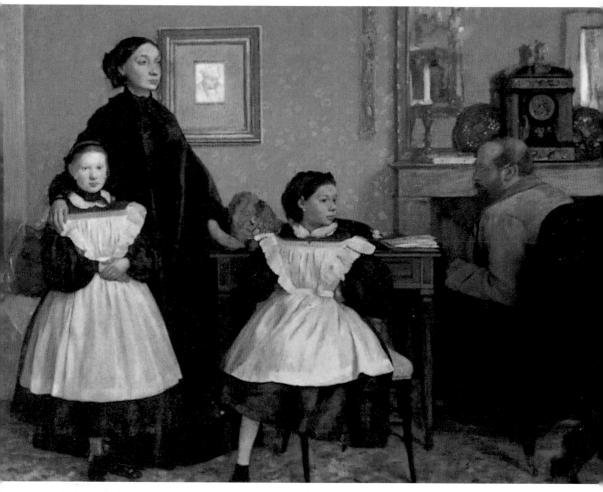

DEGAS

The Bellelli Family
Oil on canvas
1858–60. 200 x 250cm
Degas started a series of portraits
while visiting his relatives in Italy.

There were frequently initiation ceremonies, or *blagues*, for the hapless *rapins* to endure before they progressed in the social hierarchy of the atelier.

The course of studies at the ateliers relied on a long tradition of ensuring that the student could draw proficiently before he could be allowed to touch a paintbrush. Drawing exercises which started with copying

from engravings, then plaster casts of antique sculpture and finally live models were very rigorous and frequently mind-numbing. Only when the young student had mastered drawing technique to a high degree would he be allowed to paint copies of the teacher's work or old masters in the Louvre, as did Manet, Degas and a highly reluctant Monet.

An equally rigorous system of painting was taught in the ateliers and the Ecole with varying nuances of emphasis according to the predilection of the master. The practical work of painting onto the canvas was as strictly taught as drawing. The student was guided towards producing a painting of a nude or model's head known as an académie, which displayed the classical technique of applying the oil paint to the canvas in lavers of tones from dark to light. These académies were often undertaken in shades of grey or with a very limited palette to produce flesh-tones, for colour was considered a distraction, the sort of thing Delacroix was considered too free with by teachers, yet whose pupils revelled in it. The smoothness in texture and gradation of tone in the finished académie was of prime importance. Yet however stifling this kind of training might have been, it had served Degas and Manet well.

So in 1862, the young Monet and his friends found themselves sitting on their stools in Gleyre's atelier, perhaps sketching a plaster copy of an antique statue as countless young art students had done before them. For Monet, the atelier must have been stuffy indeed. He stayed there for only eighteen months until Gleyre was forced to close, and afterwards attended the Académie Suisse. Monet was the son of a small businessman who had

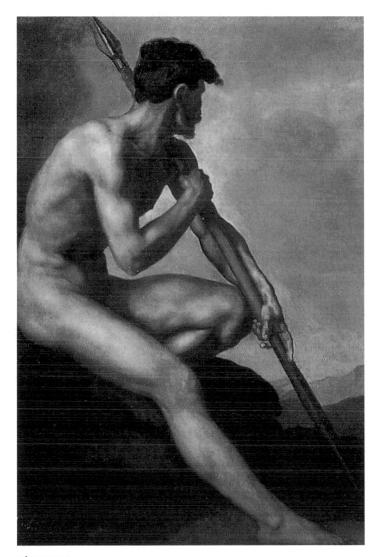

GÉRICAULTNude Warrior with a Spear
Oil on canvas
1810. 93.5 x 75.5cm
Although it was painted half a
century earlier, this type of academic
nude was still taught at the Ecole des
Beaux-Arts and the independent
ateliers such as those of Gleyre and
Couture.

MONET

Honfleur, rue de la Bavolle Oil on canvas 1864. 56 x 61cm The free rendering is reminiscent of Corot's studies.

moved his family from Paris to Le Hâvre on the Normandy coast. The sea and the countryside of his vouth were to become Claude Monet's natural habitat, not the Louvre or a Parisian atelier, and later years would find him braving the most appalling weather and terrain to capture a scene. He had returned to Paris on the sufferance of his father to study in the traditional way. Monet's artistic talents had already made an impact in Le Hâvre where he had been earning a reasonable living from selling caricatures. There he had met Eugène Boudin, a self-taught local landscapist, who persuaded him (initially reluctant, according to Monet) to take up painting in

the open air. Of the four rapins, Monet was the most experienced in painting and with the new Realist philosophies. By the time he had gone to study with Glevre he had already spent some time in Paris, done his military service in the French colony of Algeria and had been a habitue of the Brasserie des Martyrs at 75 rue des Martyrs, where Courbet, the art critic Jules Castagnary (who was to be a powerful spokesman for Impressionism), Baudelaire, and François Bonvin (a conventional painter with advanced views) would meet and talk. Edouard Manet's work was much discussed there although he himself was an infrequent visitor.

Auguste Renoir's family were provincial tailors from Limoges who had moved to Paris shortly after he was born. He was apprenticed to a porcelain-painter (who went out of business in 1858) and then, for a living, Renoir painted fans, copying scenes from artists such as Fragonard, Watteau, and Boucher as well as painting blinds and other odd jobs before enrolling in Gleyre's

atelier in 1861. Having been trained as an artistic craftsman, his whole philosophy in art was geared to the acquisition of technique. Like Manet and Degas, Renoir had studied the old masters in the Louvre, something Monet was reluctant to do. As the art historian John House has observed, by deciding to become a painter Renoir was moving from a trade to a profession, from the skilled

BOUDIN

Low Tide near Honfleur Oil on wood 1854–57. 26.7 x 36.5cm This small-scale work is reminiscent of earlier British studies.

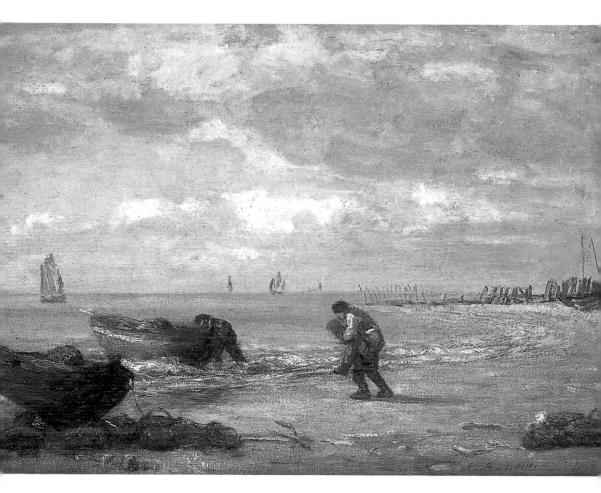

working class into the middle class, yet from the very beginning he seems consistently to have thought of himself as a workman in paint, an "ouvrier de la peinture". Unlike Renoir, who in the mid-1850s had been painting to live, Alfred Sisley and Frédéric Bazille had been living to paint. Sisley had narrowly avoided a business career in London and Bazille had given up a career in medicine when they met Monet and Renoir at Gleyre's atelier.

Often spoken of as "the nursery of Impressionism," Gleyre's atelier became the meetingplace for four of the most important figures in the movement. There is little evidence that the four young painters immediately sympathized with each other in the cosmopolitan atmosphere of Glevre's school, but they soon realized they had several interests in common one of which was landscape painting and often went on plein-air expeditions into the countryside around Paris. In 1921, five years before his death, Claude Monet recalled the early days:

At Gleyre's atelier I found Renoir, Sisley, and Bazille. As we were drawing from a model . . . Gleyre criticized my work. "It's not bad," he said, "but the breast is too heavy, the shoulder too powerful, the foot too large." "I can only draw what I see," I replied timidly . . . "Praxiteles borrowed the best elements from a hundred imperfect models to create a masterpiece," retorted Gleyre drily. "One must always think of classical antiquity."

It is tempting to think that the eighty-one year old Monet's memory had perhaps grown somewhat dim (if not bitter) on the subject of Gleyre, a teacher held in the highest respect by Renoir and many other élèves.

In addition to Monet, Renoir, Bazille, and Sisley, two more young artists who were to be involved in the Impressionist movement, Paul Cézanne and Armand Guillaumin, born in 1839 and 1841 respectively, had also gravitated to Paris by 1862. Twentieth-century art historians revere the former as the creative talent who was eventually to go beyond Impressionism, while posterity has largely forgotten the latter precisely because he became one of the most faithful exponents of the new genre.

Cézanne had come to Paris in 1861 on the urging of the novelist Emile Zola, a childhood friend from Aix-en-Provence where Cézanne's father was a banker. Cézanne had been studying law but had abandoned this to become a painter, working at the Académie Suisse. It was here that he met Armand Guillaumin, who was painting during the time off from his job for the Paris-Orleans railway, and Camille Pissarro, who introduced them both to Monet and his friends from Glevre's atelier.

Opposite

RENOIR

Trees in the Forest of Fontainbleau Oil on canvas c.1860.

It would be difficult to guess that this robust and literal view is by Renoir, but his interest in the effects of light, even at this early stage, is quite evident.

DEPICTING MODERN LIFE

1862 was certainly a year of coincidental meetings which would have great consequences for art. That year, whilst he was copying Velazquez's Infanta Margarita onto a copper plate at the Louvre, Edgar Degas was interrupted in his work by Edouard Manet, signalling the beginning of an extraordinary relationship between the two men. They had much in common; both were of patrician Parisian families, and neither had been greatly influenced by the plein-air movement. Degas and Manet were also consciously resisting Courbet's call for a "social realist" art. Despite the fact that circumstances link them very closely with the "true" Impressionists such as Monet and Pissarro, their own artistic concerns in painting la vie Parisienne were largely to hold them together and apart from the others.

Manet and Degas were great admirers of one another's work (albeit on occasion very grudgingly), but they differed greatly in matters of politics and philosophy. Manet was staunchly republican in his politics and a considerable intellectual who craved and enjoyed the society of writers and critics involved with the new art such as Champfleury, Duranty, Baudelaire and later Mallarmé. Degas, on the other hand, was an archconservative and was frequently to be seen as a peevish antiintellectual.

At the Salon of 1861 Manet exhibited his Spanish Singer (Le Chanteur Espagnol) to considerable acclaim. Reminiscent of Velazquez and Gova in style and of popular interest in its Spanish subject, the painting displays the beginnings of the broad brushwork and rich colouration which were to be a feature of Manet's later work. Moreover the Spanish Singer disdained the fine finish of the Académic style and showed a sense of Realism which challenged Courbet at his own game attracting a cabal of critics, writers, and painters to Manet's door where he welcomed their attentions and the beginnings of fame. Much later Matisse called Manet "the first great modern artist because his free and spontaneous brushwork liberated the artist's instincts."

It is tempting to imagine a republican leaning, critical, artistic avant-garde armed with the desire for the untrammelled, the vigorous, the "real" in art, simply lying in wait for someone like Manet to come along and bear the standard of a new art. In many respects this was the case. Baudelaire, who in fact was twenty years Manet's senior, was respected as a rigorous art critic, he was a friend of Delacroix, an admirer of Courbet and lately a close friend of Manet. In 1862 Baudelaire was working on his The Painter of Modern Life (Le Peintre de la vie moderne) a critique which, as the title suggests, discusses which direction art should take in the modern

Opposite

MANET

The Spanish Singer
Oil on canvas
1860. 147.5 x 114.5cm
This painting and The Artist's
Parents were accepted at the
Salon in 1861 and received an
honourable mention, a welcome
distinction after the rejection of
The Absinthe Drinker in 1859.

world of the big city. The subiect of The Painter of Modern Life is not Edouard Manet, however, who was as yet relatively unknown, but Constantin Guys, an illustrator and watercolourist who had covered the Crimean War for the Illustrated London News and whose pictures of Parisian life brought much admiration from artists and critics alike. Baudelaire's critique concerned itself with his own time and demanded an art which could deliver it up in all its present reality, not in anachronistic Neo-Classical allegories:

The past is interesting not only because of the beauty which the artists of the past whose present it was - have extracted from it, but because of its historical value. The same applies to the present. The pleasure which we derive from the presentation of the present derives from the beauty which it may possess, as well as from its essential quality as the present. Modernity is the transitory, the fugitive, the contingent, which make up one half of art, the other being the immutable. This transitory fugitive element, which is constantly changing, must not be despised or neglected. If you do so you tumble into the emptiness of an abstract and undefinable beauty

Manet was shortly to prove himself to be the painter of this modern life. He was already evolving compositions with subjects such as *The Old Musician (Le Vieux musicien)*, *The Spanish Dancers (Le Ballet Espagnol)* and *Lola de Valence* which, although they were not

the *actualités* of Guys, represented real people. Baudelaire considered Manet to "combine a vigorous taste for reality, modern reality – already a good sign – with an imagination which is both abundant and lively . . ."

In 1859 the Salon had rejected Manet's *The Absinthe Drinker*, a picture which was seen to be portraying life on the streets, and with it the reality of modern Paris, but had accepted the more innocuous *Spanish Singer* two years later.

In 1862 he finished *Music in the Tuileries Gardens*, perhaps the first great painting of "modern life"; its subject matter was on one level completely up to date; the Parisian elite had recently totally abandoned the Palais-Royale Gardens for the Tuileries, which was larger and closer to their residences.

Whether consciously or not, Manet was answering Baudelaire's call; and whilst he was working on the subject of modern life, Degas, Monet, Sisley, Renoir, Bazille, Pissarro, Guillaumin, Cézanne, and Berthe Morisot (who later married Manet's brother, Eugène, and was a very close friend of Manet himself) were also becoming painters of the modern world. Changing the way the world would view itself forever. Reluctantly Manet was becoming, if not the leader of this new wave of artists, then the whipping boy for the art sins they were poised to commit.

Opposite MANET

Gypsy Woman Smoking a
Cigarette
Oil on canvas
c.1862. 91 x 73cm
This is probably what the Carmen
in Prosper Merrimé's original story
would have looked like. However,
Bizet's opera was not performed
before 1875.

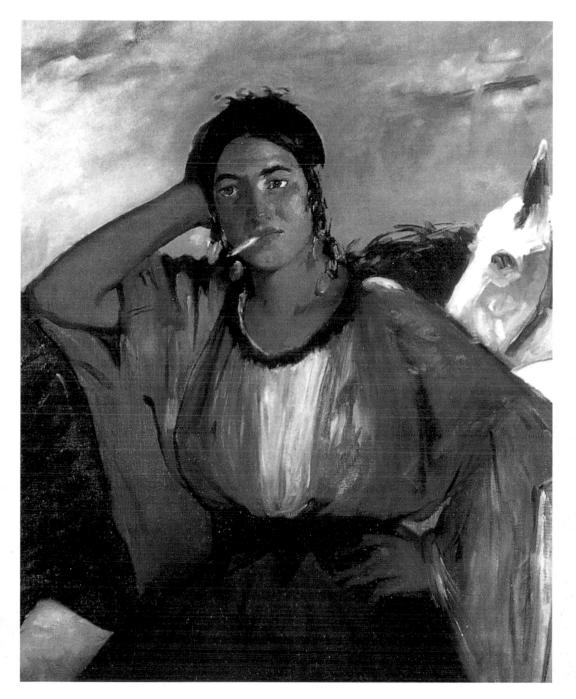

Music in the Tuileries Gardens

is a painting central to the development of Impressionism in that it seems to embody almost by design the transitory, the fugitive, the constantly changing. It has little in practical terms to do with the increasing desire of Monet, Pissarro, Renoir, and Sisley to find a way of capturing, in Jules Laforgue's elegant words, "nature as she is, which is to say solely by means of coloured vibrations," but it opens up a whole new realm of the possible. It is the view of a fashionable *flâneur*, a stroller in the park taking in the scene, a montage of frozen moments of Parisians at their leisure. We are

in the age of photography after all and Manet studied photographs for some of the heads. The painting conveys movement and colour with virtuosic brushstrokes, vet the lighting is flat, the background has been scraped and smeared with the palette knife to give the impression, and not much more, of foliage; the figures at the extreme edges are real people. Baudelaire himself is there as well as the poet Théophile Gautier, Fantin-Latour, the Inspector of Museums Baron Taylor, the sculptor and poet Zacharie Astruc, Eugène Manet and Offenbach. These people are easily discernable but the

MANET

Races at Longchamp
Oil on canvas
1864. 44 x 85cm
Manet and Degas were frequent visitors
to Longchamp which was rapidly
becoming an important social attraction
for the wealthy bourgeois of Paris.

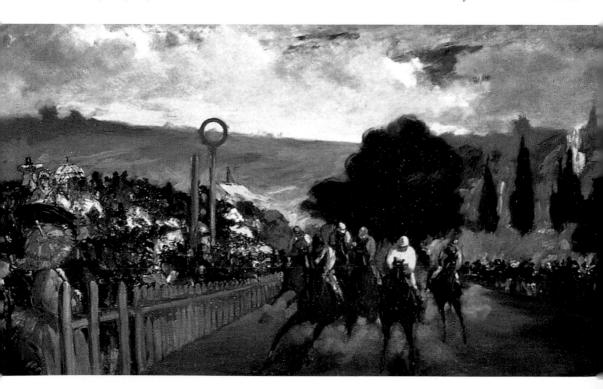

woman seated in the centre of the picture exists in a confusion of yellow and violet next to an enigmatic, two dimensional tree.

Two paintings by Edgar Degas from this period, The Young Spartans and Gentlemen's Race: Before the Start, both painted between 1860 and 1862 (and reworked in the 1880s) continued to answer the broad demands of Baudelaire, and of Edmond and Jules de Goncourt who sought "a line which would precisely render life, embrace from close at hand the individual, the particular, a living human, inward line . . ."

The Young Spartans (Les Jeunes Spartiates) despite its classical theme, avoids the stock classical motifs, there are no temples or plane tree groves, the sky is not an attic blue; most importantly the figures are not characterized as Greek, but are modelled on contemporary Parisian boys and girls. The achievement can be seen as that of a thoroughly modern history painting The Gentlemen's Race together with two others, At the Races (Aux Courses) and At the Races: The Start (Aux Courses: Le Depart) reflect the Parisian passion for the new race course which had opened Longchamp in the Bois de Boulogne in 1857. The new track was a direct result of the rebuilding of Paris and presented a new venue for the beau monde to entertain itself; indeed some of Manet's and Degas' patrons were members of the Jockey Club which organized the races.

The new Paris being summoned into existence by Napoleon III and Haussmann was admirably suited to the realization of Baudelaire's project. The increasing wealth and number of people who made up the middle classes, the proliferation of entertainments, the sheer novelty of the new streets and squares with their airy prospects, were the new reality which a painter of modern life had to subsume in his or her work. In retrospect, we can see that the work of Manet and Degas outdoors in the city, and that of the Gleyre students led by Monet, who were escaping Paris to paint in the nearby countryside, would eventually coincide. In his eloquent essay of 1883, Jules Laforgue formulates a definition of plein-air painting which declares that "the open air concept governs the entire work of Impressionist painters, and means the painting of beings and things in their appropriate atmosphere . . ." This is what, in a sense, Manet and Degas were already about as early as 1862, strolling through Paris and its environs, sketch-book in hand. In fact Degas' range of vision was much wider than that of Manet. His notebook revealed subjects which were to include previously unpainted everyday scenes such as mourners and the local undertakers.

At this early stage in the story of Impressionism, in a vear when Monet, Renoir, Sisley, Cézanne, Guillaumin, Morisot, and Bazille were still in their early twenties and searching for something new, the influence on them of the plein-airistes and the Barbizon School was still to bear substantial fruit. Monet's links to an older generation of landscape painters increased when he met and became a lasting friend of Johan Jongkind, a Dutch artist whose work is linked to that of Corot, Courbet, and Monet's first real teacher, Boudin. Meanwhile Berthe Morisot, born the same vear as Renoir and Bazille, and daughter of the Secretary-General of the Crédit Financier, was working under the encouragement of Corot. He was teaching her landscape painting in Fontainebleau and Auvers where she was in frequent contact with Daubigny who had absolute devotion to plein-airisme.

Left PISSARRO

A Clearing in the Woods
Oil on canvas
c.1864. 26.5 x 21cm
Although this is only a small study, it is
clear the artist has not yet found his style.

Right MANET

Lola de Valence Oil on canvas

1862. 123 x 92cm
Manet produced a series of Spanish
pictures as the ballet company toured
Paris. He had never been to Spain at the
time and did not go there until 1865.

1863: The Salon des Refusés

... it is either a young man's idea of a joke, or it is a festering sore, unworthy of comment.

Louis Etienne, 1863

In 1863 the new railway line from Paris to Deauville was opened by the Duc de Morny, the internal combustion engine was invented, and in August, Eugène Delacroix, the source of so much colourful inspiration for the new artists, died. The 15th January was an ominous day for it marked the announcement by the Comte de Nieuwerkerke, the Director General of National Museums, that the Salon (which had been held in the vast Palais de l'Industrie since the Exposition Universelle of 1855) was to be reorganized. For established artists, who had won medals at previous Salons, entry was now automatic as they did not have to pass the jury, but they were limited to three works each. The new rules were to present a serious blow to relative newcomers like Manet and Pissarro, whose work the jury was to reject later in the year.

Meanwhile Manet's first major exhibition went ahead at Louis Martinet's gallery in boulevard des Italiens. It was here that *Music in the Tuileries Gardens* was first shown together with thirteen other paintings including *Lola de Valence* and *The Spanish Dancers*. The exhibition attracted the attention of Monet as well as Bazille who

declared in a letter to his parents that one session spent looking at the Manets was worth a month of heavy work.

In April it was becoming clear that the Salon was making heavy work of its new rules. Of the 5,000 works which had been submitted, 2,783 had been rejected by the jury, led by a traditionalist of the history painting school, Emile Signol, who had once been furious with Renoir for using colour in the flamboyant style of Delacroix. In fact Delacroix and Ingres were members of the jury, but were not involved in the selection of works. All three of Manet's submissions, which included Luncheon on the Grass were refused entry to the exhibition.

The importance of being shown at the Salon for artists could not be underestimated. There were certainly well over a hundred independent galleries like Martinet's, but the Salon was the only marketplace with an assured audience of thousands; le tout Paris would be certain to be there, and failure to show at it meant another year without significant exposure to the public, the commissioning authorities, the dealers, and the critics. Although Manet had been rejected before, in 1857 and

Opposite

BAZILLE

The Pink Dress
Oil on canvas
1864. 147 x 110cm
This rich and finely-finished piece –
also known as View of a Village –
shows how much the twenty-threeyear-old artist's technique and
vision were beginning to mature.

1859, he was well aware of the benefits of appearing at the Salon and continued to strive to be accepted there as did the younger artists such as Monet and Renoir. To make things worse, several regular exhibitors had also fallen at the new hurdles, artists with official commissions already behind them who would in the normal course of events be expected to show at the Salon. One artist had even submitted works done for the Empress Eugènie a more important patron, save the Emperor himself, could not be imagined - and had them rejected. The press seized upon the opportunity offered by the fiasco that the Salon was turning into, and the traditionalists as well as supporters of Manet and the vounger demanded that something should be done. In the end the Emperor paid a visit to the Salon to judge for himself and, with his wife's rejected commission no doubt firmly in his mind, he too declared that something must be done. However, the jury refused to reconvene and the exhibition had in any case already been hung. On 24th April just three weeks before the opening of the following Salon announcement appeared in the Moniteur Universel:

Numerous complaints have reached the Emperor on the subject of works of art which have been refused by the jury of the Exhibition. His Majesty, wishing to allow the public to judge the legitimacy of these complaints, has decided that the rejected works shall be exhibited in another part of the Palais de l'Industrie. This exhibition will be voluntary, and artists who do not wish to participate need only to inform the administration of the exhibition, which will hasten to return their works to them

In a sense Napoleon III had pulled off another coup; this time he had succeeded in showing himself as an enlightened liberal ruler concerned with art and ready to listen to public opinion. The press enjoyed a field day on this issue not least because there were few other causes for them to champion under the strict regime of censorship that had then been imposed by the Emperor.

The new exhibition came to be known as the Salon des Refusés, and, when it opened its doors directly adjacent to the Salon proper on 17th May, over 10,000 people came to marvel at it. Amongst the jumble of paintings which had been hung with no particular order or care (of course many pictures which deserved to be rejected were on show) were two which caused an especially violent reaction, James McNeill Whistler's White Girl which had previously been rejected by the Royal Academy in London, and Manet's Luncheon on the Grass. Whistler's painting was ridiculed by many whilst "Manet in the furthest hall," as the refusé Jean-Charles

Cazin observed, "went right through the wall with his Luncheon on the Grass." If Music in the Tuileries Gardens had caused a positive stir amongst his fellow artists and the Spanish paintings had delighted the public, Luncheon on the Grass was an instant succès de scandale.

Manet's technique aside, the general public was outraged at the depiction of a female nude together with two clothed young bourgeois, and Napoleon III pronounced it to be an offence against modesty. (The Emperor was not too modest however to purchase Alexandre Cabanel's studiously academic but erotic Birth of Venus (La Naissance de Vénus), which was on show in the official Salon next door to the refusés) Zola defended the picture by drawing attention to the fact that there were several paintings in the Louvre with clothed and nude figures. Zacharie Astruc also leapt to Manet's defence, going so far as to publish a newspaper Le Salon de 1863 which called Manet "one of the greatest artistic characters of the time," lauding his work for "brilliance, inspiration, power, flavour, surprise." Manet professed himself to be distressed by all this attention, complaining to his friend Baudelaire that abuse was raining down on him like hail.

Manet's painting had ultimately derived from a work of 1510-11 in the Louvre (by Titian, Giorgione, or both) known as La Fête champêtre; it also had a respectable precedent in an engraving by Marcantonio after Raphael Yet the flat vellowish lighting on the central nude depicts her without a trace of the customary budeur so obvious and conventionally appealing in Cabanel's pinkly suffused Venus, the star of the "official" Salon, One critic, Théophile Burger, a friend of Baudelaire's "[failed] to see what could have induced a distinguished and intelligent artist to adopt such an absurd composition." But he admitted that "there are qualities of colour and light in the landscape, and indeed some very tine passages of modelling in the torso," These fine passages were passed over in a pamphlet by Louis Etienne who pronounced what was on everyone's mind. when he was to describe the painting as:

A nonchalant *bréda* [a prostitute] . . . completely naked, impudently lounges between two dandies dressed up to the nines. They give the impression of two students on holiday who are behaving outrageously, to try and give the impression of real men . . . It is either a young man's idea of a joke, or it is a festering sore, unworthy of comment.

The prostitute in Manet's painting is referred to by Etienne as a bréda after the rue Bréda in the Batignolles district of Paris where the women worked. At the time of the Salon des Refusés Manet lived and worked nearby. It was in the Café Guerbois at 11 Grande rue des Batignolles that a group of like-minded artists and intellectuals, amongst them Manet, Monet, Pissarro, Bazille, Degas, Renoir, Zola, and Nadar would meet in the coming years to discuss their life and work. They became known as the Batignolles Group.

Zola's view, fortunately the one that has prevailed, was that:

What you have to look for in the picture is not just the picnic on the grass, but the whole landscape with its bold and subtle passages, its broadly painted, solid foreground, its light and delicate background and that firm flesh modelled in broad areas of light, those supple and strong pigments, and, particularly, that delicate splash of white among the green leaves in the background; in fact to look at the whole of this vast, airy composition, at this attention to nature, rendered with such accurate simplicity.

MANET

Luncheon on the Grass Oil on canvas

1863. 208 x 264.5cm
Neither the critics nor public could accept a classical scene in modern dress, and although there were several precedents for this subject in the Lowere, the shock of seeing a female nude in the company of two modern-day dandies was too much. The flat lighting and uncompromising realism in the depiction of the main figures brought much criticism of Manet's technique.

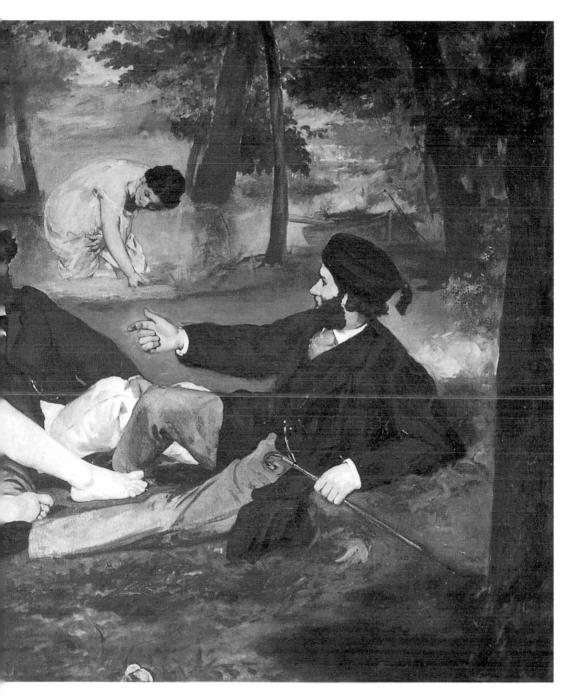

Luncheon on the Grass pushed modern life into the Salon and out into the world even though it was literally and figuratively one of the peintures refusées. Nowadays we find it extremely difficult to find anything scandalous in this picture, but at the time nudes were only acceptable in certain highly stylized and sanitized forms.

One more event was to cause uproar that year. In a decree the government introduced sweeping reforms of the Ecole des Beaux-Arts, removing it from the control of the Académie des Beaux-Arts, installing a system of ateliers to teach painting within the Ecole which had previously only taught drawing, and abolishing several important competitions, one of which was the Prix de Paysage Historique, Many of the Barbizon landscapists had taken part in the competition; Rousseau and Daubigny had both attempted it and, as art historian Albert Boime points out, Corot and Glevre had trained their students to compete for it whilst Monet and Sisley were both interested in it. The government had decreed the reforms partly under the pretext that they would foster more originality, but they were popular with neither the Académie nor the students. who feared they would no longer be able to choose which master they worked under in preparation for the Ecole, Sisley was one of those who signed a petition against the changes

proving, according to Albert Boime, that the group of students of Gleyre's atelier had not yet relinquished hope of official recognition through the Ecole's competition structure and the official Salon to which they still aspired, despite the success of the Salon des Refusés

1864-1866: "OLYMPIA WAKES"

In 1864 the Duc de Morny, who organized the building of a coastal resort at Deauville and connected it to Paris with a railway line so that affluent Parisians could take advantage of it, inaugurated the new race track there. Nothing was unusual about this commonplace development in an era of rapid industrial and economic expansion in France. It is simply another example of the new middle-class prosperity and (expensive) free time which many could now spend in a variety of pursuits. That year the first international victory at Longchamp by a French racehorse was celebrated. Speed was of the moment; the railway had already revolutionized trayel and was helping France on its way to becoming a major industrial power.

The Second Empire was attempting to extend its power base in other ways too; in Mexico, Napoleon III installed Maximilian of Austria as the puppet ruler, but like so much of the Emperor's foreign policy, this was to prove a disastrous chimera. Meanwhile Eugène

Opposite
MONET
Spring Flowers
Oil on canvac
1864. 117 x 89cm
This early piece proves that Monet
was able to produce commercially
accessible work.

Chevreul published his second work on colour, and Charles Gleyre was forced to close down his atelier due to failing health and lack of funds. In the summer Morisot, Renoir, and Pissarro had work accepted at the Salon which was now to be run annually. Manet, however, was rejected and out of the limelight for a year.

With the demise of Gleyre's atelier, Monet and his friends took off to the country to paint. In the early spring Monet had been working in and around Fontainebleau with Renoir and Sisley. That summer Monet returned to the Normandy coast at a farm near Honfleur, where Bazille, Boudin, and Jongkind later joined him. Bazille had returned to Paris when Monet wrote to him from Honfleur, entreating him to come back to the country and declaring that:

It really is appallingly difficult to do something which is complete in every way, and I think most people are content with mere approximations . . . I intend to battle on, scrape off, and start again . . . and when I look at nature I feel as if I'll be able to paint it all, note it all down . . . it's on the strength of observation and reflection that one finds a way. So we must dig and delve unceasingly.

FANTIN-LATOUR

Tannhäuser on the Venusberg
Oil on canvas
1864. 98 x 130cm
Fantin-Latour had discovered
Wagner the previous year. Tannhäuser
had failed in Paris, but Fantin-Latour
adored the music, an enthusiasm
shared by Bazille.

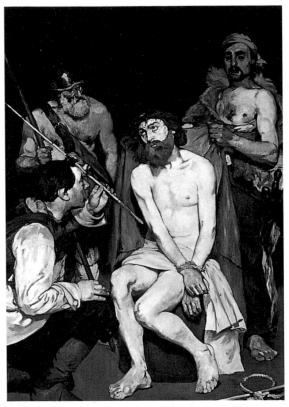

MANET

Christ Mocked by the Soldiers Oil on canvas 1865. 191.5 x 148.5cm. "You are the foremost in the decrepitude of your art", Baudeld

decrepitude of your art", Baudelaire wrote in vitriolic vein to an extremely unhappy Manet after the scandal of Olympia and Christ Mocked had broken at the Salon. Both paintings were taken down from their prominent position and rehung in the darkest corner of Room M.

The influence of Boudin and especially Jongkind is clearly evident in Monet's work from this early period. He even admitted to touches of Corot in some of the landscapes he was producing near Honfleur. But Rue de la Barolle and Farmyard Normandy (La Ferme Normande), both painted at this time, display the beginnings of his rapidly developing unique technique. At this point he was producing work at a phenomenal rate and he continued to do so for the rest of his life; his head was, as he wrote to Bazille in July 1864, "bursting with the desire to paint." This was just as well, for he lived on the edge of destitution and often had to call on friends like Bazille to help him out of financial difficulties. His diligence paid off in the next year's Salon where two works were accepted, along with Degas' first successful submission and what proved to be his last history painting, Scene of War in the Middle Ages (Scène de guerre au Moyen Age).

Monet showed two seascapes at the Salon of 1865, The Mouth of the Seine at Honfleur (L'Embouchure de la Seine à Honfleur) and Pointe de la Hève at Low Tide (Pointe de la Hève à marée basse). In both the influence of Jongkind and Boudin is evident, but the critic Gallet was moved to describe Monet as "a young realist who promises much. His two seascapes . . . display the work of a powerful hand uninterested in prettiness and greatly preoccupied with accuracy of effect." Another critic, Victor Fournel, offered a withering dismissal: "What is there to say, for instance, about this Mouth of the Seine at Honfleur? The waves are represented by lumps of earth, the sails of the boats by triangles of black wood: one might well think it had been scrawled by a child of twelve on the cover of his Sunday school book."

But both Monet and Degas, as well as Pissarro, who was again successful at the Salon, were about to be overshadowed by Edouard Manet and his *Olympia*.

Earlier in 1865 Manet had again exhibited at the Galerie Martinet to some acclaim. In May the Salon opened to a hysterical onslaught. The objects of the critics' scorn and the public's distaste were Manet's two submissions, Christ Mocked by the Soldiers (Jésus insulté par les soldats) and Olympia. Hanging together, they attracted crowds of curious viewers. The critic Victor de Jankovitz waxed sardonic: "Thanks to his brush work, Christ Mocked by M. Manet, is a picture beneath all criticism. It is Raphael as corrected by a third-rate Courbet." Christ Mocked by the Soldiers came away from its confrontation with the critics fairly unscathed in comparison with Olympia. Gentlewomen were said to have averted their eves from the shameful sight. Nevertheless they and their gentlemen-folk crushed into Room M to assure themselves of the veracity of the shocking reports.

Olympia's notoriety quickly transcended that of Luncheon on the Grass which, it should be remembered, had been shown outside the official Salon as a work which had been rejected as being unworthy of recognition. The Salon catalogue entry for the painting carried the following verse by the painter's friend Zacharie Astruc:

When, weary of dreaming, Olympia wakes, Springtime arrives in the arms of a black envoy; It is the slave, like unto a night of passion, Who comes to make the day bloom, a delight to behold; The august young girl in whom

the flame burns.

Everything about the painting – the disposition of its subject, her dishevelled sheets and her scant accoutrements, the black maid. the little black cat, the flowers, the technique, with some passages finely modelled and some blocked in with broad sweeps of the brush conspired to confuse and dismay its viewers. There was little doubt that this was another bréda, a prostitute, weary, not from dreaming, but from a night of work. Paris was awash with prostitutes; from the poorest streetwalker in the rue Bréda to the richest courtesans, lavishly entertaining in apartments along the grands boulevards. But painting them, other than in the enciphered form of a Venus or some demi-goddess. was unheard of until the first Salon des Refusés and now Olympia. Manet had liberated a new territory which others, Degas in particular, were later able to exploit with more or less impunity. Directly based on a pose much used by sixteenthcentury Italian painters, the English painter Peter Lely, and eighteenth-century French artists such as François Boucher, Olympia did not try to charm the public. Here was a real woman, unashamed, addressing the viewer without pretence or any attempt at seduction.

The Second Empire was all artifice. Away from the massive facades of the new Paris designed by Haussmann, half of the population, which Haussmann himself had described as "living in poverty bordering on destitution," was in the process of being relocated to featureless faubourgs (suburbs) or concentrated into areas like Belleville. It is significant that one critic openly described Olympia as une petite faubourienne, which is to say a common working-class girl, not as une cocotte, the euphemism most commonly used. The hypocrisy of the time may appear to be staggering, but it was a hypocrisy which tolerated its courtesanes as long as they hovered above the dirt and grime of reality. Manet broke the silence in this respect so thoroughly that, as T.J. Clark has penetratingly observed, it caused a crisis in the language of art criticism itself. Far from being lost for words, the arbiters of the nation's taste, from the meanest hack to the loftiest intellectual, were volubly falling over each other to avoid describing Olympia in traditional terms. Whilst they were busy likening Olympia's skin to India rubber, all but two of them could not or would not see the obvious reference to Titian's Venus of Urbino which Manet had once copied in oil at the Uffizi in Florence. The irony of calling a petite faubourienne "Olympia" was not however lost on them; any one of the several licensed brothels in

Paris would have offered up a number of women working under the classical noms de guerre of Olympia, Lucretia, Calliope or the most popular, Virginia. The chief problem for the critics and public alike was that Olympia had appeared dans le Salon-même, and this had stretched their tolerance beyond reason and their reason beyond tolerance. The outcry against the painting and its companion Christ Mocked was so great that they were eventually both removed to the furthest, darkest corner of the huge Palais de l'Industrie. Manet's fame (or infamy) was assured for the rest of his life. His position as the reluctant champion of the new artists of modern life was affirmed once and for all.

In the world at large life and death went on: across the Atlantic Ocean in the United States President Abraham Lincoln was assassinated, in Paris the First Communist International was held and in England a young mathematics don at Christchurch College Oxford, published a story called *Alice in Wonderland*, under the pseudonym of Lewis Carroll.

Encouraged by his own reception at the Salon, albeit mixed, and the example of Manet, Claude Monet had embarked in 1865 on his own monumental *Luncheon on the Grass*, obviously intended to make a much bigger splash in the Paris art world. Sadly the painting was abandoned in March 1866, when the deadline

for that year's Salon expired, and survives only in fragments and an oil sketch of what was once a vast picture almost fifteen feet high by twenty feet wide. Monet left the canvas in Bazille's studio for years as security against unpaid rent before he reclaimed it, by which time part of it had gone mouldy. Monet removed this portion and cut the remainder into two sections. The sketch for the painting indicates that Monet's conception was for a major plein-air work, using the relatively novel idea of figures sketched on the spot; these included Sisley, Bazille, and Monet's mistress, Camille

Doncieux. By all accounts Monet was obsessed with the massive project and spent the whole of the summer of 1865, as the Olympia scandal raged in Paris, devoted to it. He frequently begged Bazille by post to come down to the forest of Fontainebleau and sit for him. Throughout his work on the painting Monet was harrassed: firstly he was hampered by an injury to his leg in 1865 and then, having moved to Bazille's Paris studio in order to finish the picture for the 1866 Salon, he was forced to leave the studio and move across the river. Unable to complete the painting, Monet furiously produced

MANET

Olympia
Oil on canvas
1863. 130.5 x 190cm
This painting caused a storm
verging on outrage at the Salon of
1865 and established Manet's
reputation and fame, though not
perhaps in the way he had hoped.
It has been referred to as a turning
point in the history of modern art,
combining with Luncheon on the
Grass to entirely subvert the
traditional artistic view of the nude,
as it was previously encapsulated

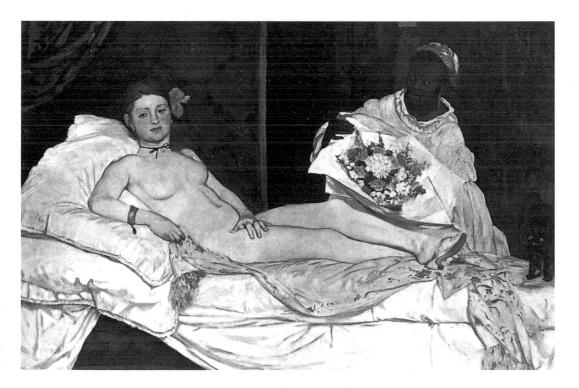

(in four days) a full-length portrait of Camille known as *The Woman in the Green Dress* (Femme en vert), which in turn proved a success at the Salon.

Luncheon on the Grass was a prodigious undertaking in every respect; and as Andrew Forge has suggested, "It was someas different from Courbet's earthy social analysis as it was from Manet's sophisticated reflections on the erotic in modern life. Monet was trying to present on an exhibition scale that particular area of painting that was specific to the direct study. He was trying to monumentalize the syntax of a sketch."

Undaunted by his failure to complete Luncheon on the Grass, in early 1866 Monet embarked on another large picture, nine feet by six feet in size, the Women in the Garden (Femmes dans un jardin). He had rented a house near Paris and dug a trench for the painting to be lowered into by pulleys so that he could work without moving his position relative to the subjects in front of him. The idea, ridiculed by Courbet, was to complete the whole picture en plein-air. The painting was finished but the Salon of 1867 rejected it, a bitter blow to Monet.

MONET

Luncheon on the Grass Oil on canvas 1865–66. 130 x 181cm A sketch of the unfinished work.

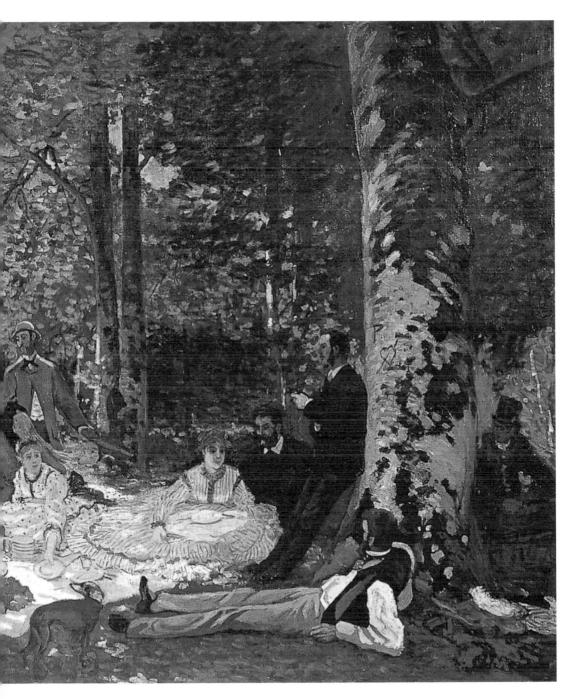

THE BATIGNOLLES GROUP

The year 1866 saw the invention of dynamite by Alfred Nobel. In France Napoleon III ordered the withdrawal of his forces from Mexico, a move that was to have disastrous consequences for the puppet Emperor Maximilian. In his own salvo of explosive prose, Zola published an article which was entitled "Mon Salon en L'Evènement" defending the work of Cézanne, Bazille, Monet, and Pissarro and supporting a letter which Cézanne had written to the Comte de Nieuwerkerke that demanded another Salon des Refusés. In it Cézanne had felt obliged to "content myself with pointing out to you again that I cannot accept the unlawful judgement of colleagues to whom I have not personally given the task of assessing me . . . I wish to make a direct appeal to the public and have my work exhibited without any restriction."

A complex network of relationships between Monet, Pissarro, Bazille, Cézanne, Guillaumin, Morisot, Renoir, Sisley, Manet, and Degas had already begun to form by this point. During the private view of the 1866 Salon Monet and Bazille had encountered Manet and his entourage leaving the exhibition. Monet's signature on his Woman in the Green Dress had been mistaken for Manet's. who had entered the Salon to a chorus of acclaim for his supposed work. Monet recounted the story in 1900 to Le Temps:

... imagine his consternation when he discovered that the picture about which he was being congratulated was actually by me! The saddest part of all was that on leaving the Salon he came across a group which included Bazille and me. "How goes it?" one of them asked. "Awful," replied Manet, "I am disgusted. I have been complimented on a painting which is not mine"

The next day Manet is supposed to have refused to be introduced to Monet because he was still bitter about Monet's purely unintentional slight on the young master. But as Monet recalled:

It was only in 1869 that I saw him again, and then we at once became firm friends. At our first meeting he invited me to join him every evening at a café in the Batignolles district where he and his friends gathered at the end of the day to talk. There I met Fantin-Latour, Cézanne, Degas . . . the art critic Duranty, Emile Zola and many others. For my part I used to take Sisley, Bazille, and Renoir there. Nothing could have been more interesting than the discussions we had, with their perpetual clash of opinions. They kept our wits sharpened, encouraged us to press ahead with our own experiments, and provided us with the enthusiasm to keep on painting for weeks on end until our ideas became clear and coherent . . . we emerged more finely tempered, our resolve firmer, our thoughts clearer and less confused.

1866 marks the beginnings of what came to be known as the Batignolles Group. Whilst

Monet, Bazille, Renoir, Sisley, and Pissarro were working in the country, the Batignolles area of Paris was becoming a focus of artistic attention. This area of Paris had expanded greatly, along with the large new boulevard des Batignolles. Between 1842 and 1866 the district population increased from 15,000 to 200,000. Its position away from the centre but close to the Gare St Lazare made it popular. The buildings were modern,

comfortably bourgeois and the area had become residential but still affordable. Parts of old Batignolles remained, populated by the poor and prostitutes, amongst whom Manet found his models. Manet had lived there for some time and had recently begun to haunt the Café Guerbois at 11 rue des Batignolles. During the next three years practically everyone of importance to Impressionism gathered there in the evenings.

PISSARRO

The Railway Bridge at Pontoise Oil on canvas c.1865.50 x 65cm Pissarro and his family moved to live in

Pontoise, a village on the river Oise (seen here) near Auvers, in 1867, about two years after this picture was painted. Anvone looking for the artistic

avant-garde in Paris would need

go no further than the Café

Guerbois, one of many cafés

in the extraordinary vivacity of

that had sprung up in the new Paris of wide pavements and rolling boulevards. Manet was certainly the first amongst his peers and held court with aplomb. A leading writer and critic of Impressionism Armand Silvestre described Manet as a revolutionary with the manners of a perfect gentleman: "he had

expression on his lips a very strong dose of the Parisian street urchin. He had a marvellous command of the annihilating and devastating phrase."Yet he still yearned for official recognition.

1867-1868: LA VILLE LUMIÈRE

The year 1867 brought with it crisis for the Second Empire. Since the proclamation of Napoleon III as Emperor in 1852 France had spent itself into a prosperity that was in

RENOIR

The Park of St Cloud Oil on canvas 1866, 50 x 61cm An early, surprisingly impressionistic painting by Renoir painted three years before the work with Monet at La Grenouillère

conservative and essence favoured the middle and upper classes. The new boulevards and buildings of Paris were symbolic of this prosperity, as were the resorts springing up on the Normandy coast. But they had all been constructed on credit and the equivalent of the modern junk bond. In 1866 the Crédit Mobilier, which had financed a great part of the new Empire, found itself with a monumental liquidity problem. Its shares fell the next year from 1,982 francs to just 140 francs. The Mexican fiasco ended with the death of Maximilian who was abandoned by the French and executed by rebels. Manet, who rightly saw this crisis as a failure of imperial politics, began a painting of the execution, making use of photographs, but also basing part of its composition on Gova's The Third of May which he had seen in Madrid in 1865. He was given to understand by the Salon that it would not be admitted on the grounds of its political sensitivity. A lithograph of the picture was officially banned by the censors.

Elsewhere in the world tensions ran high. In an attempt to help the Papal States French battalions were dispatched to Rome to defend them against the revolutionary Garibaldi. As usual relations with Prussia were tense. In January Napoleon III had announced constitutional changes with a move towards representative government for the Empire, but

it was to be of no avail. The American Civil War had disrupted cotton trade, and the vineyards were suffering from the phylloxera disease which had appeared in 1863 and taken hold, steadily reducing the crop. The outward success of the Second Empire had, as Alastair Horne claims, "blinded French eves to the realities beneath the surface. Syphilis was rampant and many of the great Frenchmen of the age were to die of it; Maupassant, Jules Goncourt, Dumas fils, Baudelaire [in 1867], and Manet. The dread disease was symptomatic of the Second Empire itself; on the surface, all gaiety and light: below, sombre purulence, decay, and ultimately death."

GOYA

The Third of May
Oil on canvas
1814. 266 x 345cm
Manet drew inspiration for his
painting The Execution of
the Emperor Maximilian
from Goya's earlier work
which he had seen in Madrid.

A visitor to Paris in the summer of 1867, and there were thousands, would have been hard pressed to believe all this doom, for the second Exposition Universelle had taken over a city which was already crammed with hundreds of theatres and cafés, all full of Parisians enjoying themselves. Visitors to the Prussian display of armaments marvelled at the Krupp artillery pieces. The implements of modern warfare certainly looked impressive and if the French had taken more stock of them they might have thought twice about engaging the Prussians in battle a couple of years later. A picture by Manet painted at the time, View of the Paris World's Fair (Vue de Paris pendant l'Exposition Universelle) shows the French and English lighthouses erected for the Fair and the photographer Nadar's balloon, known as "The Giant", hovering over the city. Renoir's Champs-Elysées during the Paris Fair of 1867 (Les Champs-Elysées pendant Exposition Universelle de 1867) depicts leisurely strollers; the women wear summer dresses, the sky is temptingly blue with fluffy clouds. In the background a tricouleur flies over the Palais de l'Industrie which had been built for the previous Exposition Universelle when Pissarro had marvelled at the Corots and when Courbet's Realist Pavilion had challenged the establishment.

The same was to occur in 1867. Again Courbet erected a

pavilion to rival the official Salon, and Manet, who had boycotted the Salon in disgust at having been rejected again, did the same. Pressure for another Salon des Refusés was strong: Monet, Renoir, Pissarro, Sisley, Jongkind, Manet, and Daubigny had all signed a petition to the authorities, but the refusés request was rejected. Unfortunately, Manet's pavilion did scant business. Times were getting harder for the avantgarde painters. The arbitrariness of the Salon juries who changed their views on what was acceptable from year to vear was a cause of intense frustration. In May Bazille wrote to his parents outlining a plan which had emerged among the group to:

... rent a big studio every year where we will be able to show as many of our paintings as we want. We will invite the painters we like to send paintings. Courbet, Corot, Diaz, Daubigny and many others with whom you may not be familiar have promised to send their work and strongly approve of the idea. With the latter, and Monet who is better than all of us, we are sure to succeed.

The plan came to nothing; the funds to mount the exhibition could not be found amongst the contributors, but this was essentially the first attempt to launch the *Société anonyme des artistes peintres, sculpteurs, graveurs, etc.* which was then seen by everyone to upstage the Salon of 1874.

In the meantime Claude Monet had gained permission from the Louvre to paint from one of its second floor balconies. One of the three pictures that resulted is the Garden of the Princess (Le Jardin de la princesse). This, and the views of the Quai du Louvre, and Saint-Germain l'Auxerrois mark what Forge has called "crucial experiments in which [Monet] seems to be pushing the principles of Realism to their furthest limits."

The Garden of the Princess indicates a new vision of the city using the technique Monet had been developing in his landscapes and the two large-scale figure paintings. The angle of the view shows the influence of the framing and distortive effects of photography which tend to "wrap" the field of vision at the edges and cut off the composition at arbitrary points producing a vertiginous sense of height, distance, and space.

MONET

Beach at Sainte-Adresse
Oil on canvas
c.1867. 75 x 101cm
Monet never tired of painting the coast
of Normandy in his youth and he
worked along this stretch of coastline
nearly all his life.

RENOIR Rose Field Oil on canvas Undated. 33 x 46.5cm Renoir's loose style was at the vanguard of Impressionism, but the artist later found that it was

too limiting.

Visitors to the Exposition Universelle were seduced and intrigued that year by the exhibition of Japanese prints and artefacts which soon launched an enduring fashion for all things Japanese. The studios of Whistler, Manet, Degas, and Monet were graced with Japanese china, fans, and prints, and these feature in several later paintings. Castagnary even called the Batignolles Group "the Japanese of painting". Monet said, that "[the Japanese] refinement of taste has always pleased me, and I approve of their aesthetic doctrine which evokes the presence of something by a shadow; and the whole by means of a fragment." Degas' work was increasingly reinforced by the Japanese print masters' sense of space and (to Western eyes) unusual perspectives and framings, as well as their subject matter which was often urban and refined. This new view was much in keeping with Degas' artistic interests.

Napoleon III's last years in power were marked by an increasing desire on his part to free up the country's moribund political and social system. Accordingly, in 1868 new laws allowed limited freedom of the press and the right to assembly for the first time since the First Republic. In a move symptomatic of the decline of the Second Empire, Baron Haussmann was forced to approach the ruling Legislative Body and request a loan to pay for the rebuilding of Paris which amounted to nearly a quarter of the whole French budget. Haussmann was almost finished, but so was Paris

Manct, Degas, Morisot, Pissarro, Monet, Sisley, and Bazille all made it into the Salon of 1868 after the dismal failure of the previous year and they had François Daubigny to thank because he had been invited to sit on the jury. Daubigny's inclusion was a sign that plein-airisme had finally been accepted by the Salon as a legitimate method of painting, although this did not make it any easier for the avant-garde. To artists like Manet, Bazille, and Degas, who were reasonably wealthy, not selling their work did not ultimately mean starvation. Monet on the other hand had none of the luxuries of a Manet or a Bazille; he was forced to sell or starve.

Paris in the early part of 1868 was depicted with increasing acuity and originality by artists. Degas, the most consistent of the "slice of life" painters, spent all of his time in the streets, cafés, theatres, and concert halls of the city; noting, sketching, and observing with a sharp eye the effervescent activity around him. Not a pleinairiste by any stretch of the

imagination, he composed his pictures very carefully post hoc in the studio. His Orchestra of the Paris Opera (L'Orchestre de l'Opéra de Paris) of 1868-69 is an excellent example of both his devotion to Ingres, his detailed technique and a thoroughly modern sense of composition: again the influence of photography is evident, with the figures cropped by the edges of the painting and the double-bassist turning his back to us looking at a conductor "out of shot". One of the second violinists is even captured gazing up at the incandescent tutus of the ballerinas, obviously bored with his part.

DEGAS

Orchestra of the Paris Opera Oil on canvas 1868–69. 56.5 x 46cm A fine example of the new theory of composition that the Impressionists were beginning to shape. The figures are caught as though in a photograph, cut off at seemingly random points and standing at odd angles to the artist. This is a radical departure from the highly stylized, carefully posed and fully framed tableaux of the classical schools.

MANET

The Balcony
Oil on canvas
1868–69. 170 x 124cm
Berthe Morisot, seated at the
front, had met Manet two months
before she posed for this painting.
Their friendship lasted till his
death in 1883.

Away from the bustle of the city, Bazille was succeeding to a great extent in meshing the forms of landscape and figure painting which had been started and abandoned by Monet. View of the Village (Paysage avec un village) and The Family Reunion (La Réunion de Famille) show the influence of Manet and Monet, but taking a firm grip on the elements of the pictures.

Whilst Monet, Renoir, Bazille, and Sisley had been working in and around Paris and on the coast, Camille Pissarro, (older than them by ten years and yet stylistically much more a part of their generation than Manet or Degas), had been living in Pontoise, a town to the northwest of Paris where in 1866 he had settled with his mistress, Julie Vellav. His frequent visits to Paris included the Café Guerbois where he expressed himself openly and eloquently in matters of art and politics: he was a radical republican, an anarchist in fact. Thanks to Daubigny two of Pissarro's views of the Hermitage at Pontoise (L'Ermitage à Pontoise) were shown at the Salons of 1868 and 1869. They were attacked as being vulgar, coarse, primitive daubings. The paint is certainly applied with vigour Pissarro's denial of detail and his concentration on structure using planes of colour prefigures the later work of Cézanne. But Zola considered that "the originality here is deeply human, not derived from a mere facility of hand or a falsification of nature: it stems from the temperament of the painter himself and comprises a feeling for truth resulting from an inner conviction."

1869: "ROTTEN SKETCHES"

The French elections of May 1869 produced a massive upsurge of support for the opposition parties – mostly varying shades of republicanism. Government control of the Legislative Body was sharply reduced and the Prime Minister was forced to resign. Haussmann's fortunes continued to wane as his opponents questioned the exorbitantly high cost of his rebuilding of Paris. Napoleon III's "Liberal Empire" was in its last days. A left-wing slogan frequently heard on the streets of the big cities was "Moderation is Death".

The convulsive politics of the Empire must have been on the agenda at the Café Guerbois, but of more prurient interest may well have been the erroneous gossip amorously linking Manet and Berthe Morisot who had been introduced to the clique via Fantin-Latour. At this stage gentlewomen were not in the habit of frequenting gentlemen's café societies, so Morisot's acquaintance with Manet would have been consolidated outside the auspices of the Café Guerbois, and thus she would have been denied what Monet had called the "constant clash of opinions" and the lapidary wit-sharpening of Thursday nights.

Nevertheless Manct and Morisot had become very close – Manet's main exhibit at the 1869 Salon shows a moody Berthe on *The Balcony (Le Balcon)*, for which she had posed a few months after they had met at the Louvre, where she was also a copyist. Manet's ponderous influence on Berthe

can be seen in a portrait of her sister, Edma, and her mother which Manet had retouched into what Berthe called "the prettiest little caricature". For her part Berthe, who had been brought up by Corot and Daubigny as a plein-airiste, encouraged Manet to take to the outdoors and lighten his otherwise sombre palette. At this time another woman painter, Eva Gonzales, the daughter of a novelist, appeared on Manet's horizon and much to Berthe Morisot's dismay he agreed to take Eva as his pupil the first and last time he chose to teach.

In the spring of 1869 Monet had installed himself in the village of Saint-Michel near Bougival. This was an increasingly popular resort on the Seine linked to Paris by the Paris-Saint-Germain railway and the stop at Chatou. This area had long been a retreat for landscapists such as Corot. Pissarro had meanwhile moved Pontoise to nearby from Louveciennes, where Renoir was staying with him. At a branch of the Seine near Croissy there was a popular floating restaurant and bathing establishment called Grenouillère (literally "The Froggerv") where Parisians would retire on day trips during the summer months to eat, drink, and swim. It was was often illustrated in gazettes. It was here that Renoir and Monet spent much of the summer of 1869.

RENOIR

La Grenouillère
Oil on canvas
1869. 66 x 86cm
Renoir and Monet painted
a series of pictures from the
same viewpoints. The
influence of Monet on
Renoir's work is evident.

In yet another begging letter to Bazille from this period Monet also mentions that "I had indeed a dream, a tableau, the bathing place at La Grenouil-lère, for which I have made some rotten sketches . . ." The "rotten sketches" that he and Renoir had been working on that summer were a turning point, they mark the first major examples of the Impressionism to come in the next decade. The conditions were right: the two artists, each working with an eve on the other's canvas, were using paint with an unheard of directness and speed to capture all the elements in view. We begin to see in his Bathers at La Grenouillère (Baigneurs à la Grenouillère) the genesis of Monet's famous advice:

When you go out to paint, try to forget what objects you have before you; a tree, a house, a field or whatever. Merely think here is a little square of blue, here an oblong of pink, here a streak of yellow, and paint it just as it looks to you, the exact colour and shape, until it gives you your own naïve impression of the scene before you.

Despite the insistence of Monet and Renoir that the Grenouil-lère paintings were merely pochades, or sketches, the distinction between sketch and finished painting was by now becoming blurred. A painting done at La Grenouillère and submitted to the Salon of 1870 (it was rejected and is now lost) appears hardly more "finished" than the pochades.

1870–1871: WAR AND THE COMMUNE

In May 1870 the new decade seemed to promise a bright future for the Second Empire. As Cobban describes it, "In the early summer of 1870, though the Empire was in a process of evolution, there seemed not the slightest danger of revolution." By 2nd July the Second Empire was in peril. Following a byzantine and mischievous piece of statecraft on the part of the Prussians, Prince Leopold of Hohenzollern was offered as a candidate for the vacant throne in Spain. France could not tolerate the idea of Prussian involvement within its southern neighbour. The scheme brought back old memories of continual war between the Hapsburg Empire and France. The Prussians withdrew the offer to Spain ten days later, but this did not satisfy Napoleon III and the belligerent Empress Eugénie, a Spaniard, who took it upon herself to demand an assurance from Wilhelm I of Prussia that no more claims would be made to the Spanish throne. The French were looking for a diplomatic victory over Bismarck, but they were outmanoeuvred when on 14th July a provocative telegram arrived from Bismarck which was calculated to infuriate the French. When the telegram was published in the press, France exploded in patriotic fervour and demanded war with the Prussians.

By August the French armies had suffered heavy defeats on all fronts. The Prussians' Krupps guns, had been used to devastating effect; the French army was ill equipped, badly led and swiftly demoralized. The Prussians, on the other hand, had built up a formidable war machine under Bismarck, who made use of the railways to transport men and artillery to the fronts. They took Alsace and Lorraine in the first week of figliting and on 1st September Napoleon III surrendered and was taken prisoner of war. The chronicler of Parisian life Edmond de Goncourt attempted to describe the chaotic scene as the bad news hit Paris:

PISSARRO

The Orchard
Oil on canvas
1870. 56.5 x 84cm
This painting was created shortly after Pissarro's move to Louveciennes. He worked consistently outdoors during the period, but also kept a studio in Paris.

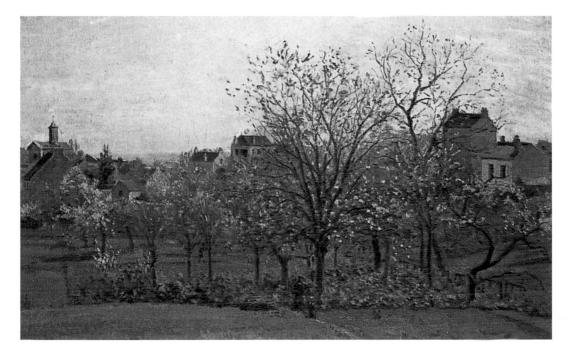

Who can describe the consternation written on every face, the crowds collecting at street corners and outside town halls, the siege of the newspaper kiosks, the triple rows of readers gathering around every gas lamp? Then there is the menacing roar of the crowd in which stupefaction has begun to give way to anger. Next there are crowds moving down the boulevards shouting "A bas l'Empire!" ["Down with the Empire!"] . . . And finally there is the wild, tumultuous spectacle of a nation determined to perish or save itself by an enormous effort, by one of those impossible feats of revolutionary times.

A republican government of National Defence was proclaimed by the moderates in the Legislative Assembly. Within three months the Second Empire no longer existed.

On 28th November, a year short of his thirtieth birthday, Frédéric Bazille was killed in battle at Beaunes-la-Rolande near Orleans. One of his last paintings, *Studio in the rue de la Condamine*, depicts some habitués of the Café Guerbois, Monet, Manet, Renoir, Zola, the musician Maître and the artist himself (painted in by Manet) in happier, more peaceful times.

Manet had remained in Paris, a lieutenant in the National Guard under the painter Meissonier. Renoir was sent to Bordeaux, in the south west and thus saw no action. In Paris Manet was to be seen swanning around in his officer's uniform, although neither he, Renoir, nor Degas were involved

in any action. Cézanne had fled back to Aix-en-Provence in the south to avoid being conscripted into a war which was largely being fought in the northeast. Pissarro had painted on in Louveciennes until the Prussians advanced towards it. Over 1,100 of his paintings (which shows how prodigious his output was) were badly damaged or destroyed when his house was commandeered by several enemy troops.

As the war raged in the east Monet was at Trouville painting a number of pictures of the beach and seafront, notably the two Beach at Trouville (La Plage à Trouville) paintings and L'Hôtel des Roches Noires, Trouville which confirm his increasingly impressionistic style. In the autumn, with the Prussians advancing westward to encircle Paris, Monet and Pissarro fled separately to London.

If the war had proved fatal for Bazille, Monet's closest friend and as promising an artist as any of the group, it provided Pissarro and Monet with the opportunity to meet Paul Durand-Ruel, an important dealer who had opened a gallery in London and was later to faithfully champion their work and stage exhibitions of the Impressionists in New York. "A true picture dealer," said Durand-Ruel, "should also be an enlightened patron; he should, if necessary, sacrifice his immediate interest to his artistic convictions and oppose

MONET

L'Hôtel des Roches Noire, Trouville Oil on canvas 1870. 81 x 58.5cm The Monets were not staying at the luxurious 150-room hotel but in a modest establishment which they left without paying. The bill was settled much later.

rather than support the interest of speculators." Living in the West End of London, Monet had been introduced to Durand-Ruel by Charles Daubigny, who was making a good living painting scenes of the Thames. Durand-Ruel in turn put Monet in touch with Pissarro who was staying with his mother in South Norwood, a quiet, picturesque village to the southeast of London.

By 20th September 1870 the Pruoiana had completely surrounded Paris, cutting it off from the rest of France. An attack by the crack Zouaves Regiment had been routed the day before.

The Bois de Boulogne had been turned into a farmyard, siege fortifications had been built in and around the city which thronged with soldiers from the National Guard. Throughout the autumn and winter and on into 1871 the war continued, food was running short and starvation was becoming rampant.

One of the few links to the outside world was via hot air balloons. On 8th October, Leon

MONET

Beach at Trouville
Oil on canvas
1870. 37.5 x 45.5cm
This sketch picture, an
important step on the road to
Impressionism, can be compared
to an enlarged detail of Boudin's
painting of the same subject. The
painter's were working together
that summer, and Mme Boudin
is perhaps the other woman in
the picture.

Gambetta, a fiery and popular orator and Minister of the Interior, had made an heroic escape to Tours in a balloon launched from the heights of Montmartre, Taking advantage of this, Nadar organized letters to be sent by balloon post. One letter from Berthe Morisot to her sister, Edma, describes the noise of the Prussian bombardwhich began ments November, the corpses lying in the streets and grim warnings from Edouard and Eugène Manet that Berthe would be better off if she lost her hand or became disfigured. On 19th January the Paris garrison attempted to break out of the city and through the Prussian lines, but failed. This attempted sortie en masse was the last significant action of the war Nine days later Paris surrendered to the Prussian army.

In February a republican National Assembly was elected to make peace with Prussia and approve massive reparations. But the National Guard was still armed in Paris and when on 18th March troops loval to the new republican government attempted and failed to seize the cannon in Montmartre, Paris - led by a coalition of revolutionaries - was at war with the Republic, On 28th March the Paris Commune was elected amid scenes of jubilation that harked back to the days of the Revolution in 1789 and the first Commune. On 2nd April the second siege of Paris began; the Commune held out until the

"Bloody Week" which began on 21st May when more than 20,000 Parisians were killed in indiscriminate reprisals as government forces overran the city.

Gustave Courbet, who had been elected chairman of the Arts Commission after the fall of the Empire, was a prominent member of the Commune and became implicated in the destruction of the Vendôme Column, which stood as a bitter reminder of Napoleonic power to the Communards. When the government "liberated" Paris he was imprisoned and later exiled to Switzerland where he died in 1877.

Amidst the dramatic events of this period Degas' eyesight had begun to deteriorate, Renoir had obtained a pass during the Commune and left to continue his landscape studies and most of the others of the Batignolles Group had fled to safety. Manet was the only member of the group concerned with depicting the war in Paris and its effects. Standing on the corner of the boulevard Malesherbes, he sketched the dead bodies lying there.

PISSARRO

Upper Norwood, Crystal Palace
Oil on canvas
1871. 40 x 51cm
This work by Pissarro was a product of
the artist's voluntary exile in England
during the Franco-Prussian war. It was
an important time as it brought Pissarro
together with Monet who had also escaped
the war by travelling to England.

DEGAS IN NEW ORLEANS

For pictures of the Commune we have to turn to photography and the topographic artists who remained in Paris to record the suffering and destruction. None of the Impressionists was interested in the ruins of the Tuileries Palace, which had stood in the heart of the city, an area they had often depicted before the war.

In the end, the war against Prussia and the Commune had little effect on the French economy. France was now a de facto republic for the third time in her history. In the climate of expansion which immediately followed the end of the troubles Durand-Ruel began to invest heavily in the Batignolles artists. He bought 30 Monets and paid Manet 51,000 francs for 29 of his paintings, a fantastic sum considering Claude Monet's income the next year was 25,000 francs. For Monet in particular things were looking up at last. From England he had gone to Holland and then to Argenteuil on the Seine near Paris where Renoir frequently joined him as before. Pissarro had returned to Louveciennes and then decamped to Pontoise where Cézanne visited him. The Café Guerbois evenings continued for another year. In November Degas and his brother René arrived in New Orleans to stay with their mother. In a letter to his friend Lorentz Frohlich, Degas described the effect the new world was having on him:

Everything attracts me here, I look at everything . . . I accumulate plans that would take a lifetime to complete. I will abandon them in six weeks to return and never again leave my home . . . My eyes are much better.

Ten days later he wrote to Henri Rouart:

The light is so strong that I have not yet been able to do anything on the river. My eyes are so greatly in need of care that I scarcely take any risk with them at all . . . Manet would see lovely things here, even more than I do . . .

Indicative of his friendly rivalry with Manet he went on:

... but not many more of them. One loves and gives art only to the things to which one is accustomed.

Among the results of Degas' period in New Orleans, chiefly devoted to painting portraits of his close family, are two very remarkable pictures, The Invalid (L'Invalide) and Portraits in an Office - New Orleans (Portraits dans un bureau à Nouvelle-Orléans) better known as The Cotton Market (Le Bureau de Coton). The former is one of Degas' most atmospheric works, conveying what Henri Lovrette calls "the stifling sense of the sickroom" in broad, swift brushstrokes; the latter, making the modern business world a legitimate subject for art, was described by Armand Silvestre as "an exceedingly witty painting that one could spend days contemplating."

This painting is perhaps as epochal as Manet's *Music in the Tuileries Garden* had been a decade earlier, After this Degas' failing eyes allowed him to paint few pictures of such acute detail.

1873: SOCIÉTÉ ANONYME

The post-war boom soon gave way to a period of economic recession which lasted for five years and affected the Impressionists, their patrons, and most especially Durand-Ruel, forcing him finally to close his London gallery in 1874. As in 1863 the Salon was hugely oversubscribed but this time the refusés succeeded in pressurizing the government to mount another Salon des Refusés. A huge Renoir painting, the Morning Ride in the Bois de Boulogne (Allée cavalière au Bois de Boulogne) had been rejected by the Salon but was shown to great acclaim at the alternative exhibition.

DEGAS

The Cotton Market
Oil on canvas
1873. 73 x 92cm
The painting was executed while
Degas was staying with relatives in
New Orleans, and he thought it
could sell in Manchester a cottonspinning centre. In fact it was
exhibited in 1878 in the French
southern city of Pau, which bought
it for its museum.

Monet's influence on Renoir, after long months working with him before and after the war, had led to a brightening of his palette and more delicate brushwork. Renoir's Pont Neuf of the previous year was one of his most impressionistic pictures to date; the briefly sketched-in figures highlighted with dabs of pure pigment betray the influence of Monet, as do the complementary colours blueviolet and vellow in the overall composition, and the bluish shadows, which create the effect of colour contrast in brilliant sunlight.

Unlike the events a decade earlier, the Salon des Refusés of 1873 was remarkably devoid of scandal. The painter most likely to cause an uproar, Edouard Manet, was showing two works at the official Salon, a portrait of Berthe Morisot and Le Bon Bock - a portrait of the engraver Bellot at a table in the Café Guerbois. The latter proved a welcome success for Manet, sensitive as ever to the barbs of the critics. The influence of Frans Hals, whom Manet had been studying during a tour of Holland the year before, as well as the deliberate lack of a scandalous subject gently reassured the Salongoing public of Manet's talent.

The Salon des Refusés did little to placate the rest of the Batignolles Group who were still desperately looking for outlets for their work

Ironically, the war had promoted a deeply conservative streak in the Salon jury which made Nieuwerkerke's ancien régime appear liberal by comparison. This conspired against an avant-garde whose influence was by now becoming widespread. With Durand-Ruel's business suffering in the recession and unable to support them they were forced to look elsewhere. The idea first mentioned by Bazille in 1867 of forming an independent organization to stage an exhibition was rekindled. A much heated discussion between Pissarro, who was for a complex association based on a social and political union, and the others in the group, including Renoir and Monet, who demanded a simpler collective, resulted in a document signed on 27th December founding the Société anonyme des artistes peintres, sculpteurs, graveurs, etc. Only Manet refused to join the new body, arguing in common with Cézanne, that still "the Salon is the true battlefield." Degas was in favour, writing to Tissot that "the realist movement no longer needs to fight with the others. It is, It exists, it must show itself as something distinct . . . So forget the money side for a moment. Exhibit. Be of your country and your friends."

THE BIRTH OF IMPRESSIONISM

SISLEY

The Seine at Bougival
Oil on cenvas
1872–77. 38.5 x 62cm
Sisley was interested at this time in the problems of depicting water and sky.
His palette was somewhat dark and sombre compared to most of the other Impressionists.

THE AGE OF IMPRESSIONISM

HE WORKS OF MONET, Renoir, Manet, Morisot, Pissarro, and Sisley, which characterized the Impressionist idiom in its most popularly recognizable form, were painted in the 1870s. Degas, who played an important role in organizing the series of Impressionist exhibitions which marked the 1870s and 1880s, remained resolutely opposed to plein-air painting. He nevertheless produced the most striking images of modern Parisian life, taking inspiration from Japanese prints and photography, and, like Manet, basing his technique on a thorough appreciation of the old masters. Towards the end of the 1870s serious rifts began to appear in the group and Monet, Renoir, and Sisley dropped out as Degas and Pissarro exerted more control over the exhibitions. The penultimate Impressionist exhibition - minus Degas - took place in 1882 and essentially represented the fragile group's last stand. The next year Manet died having completed his masterpiece Bar at the Folies-Bergère. He had remained highly supportive of the group but never exhibited with them. By 1886 the final Impressionist exhibition featured the work of Degas, Pissarro, and a new generation including Georges Seurat, Paul Signac, and Paul Gauguin.

Opposite
MONET
The Sea at
Fécamp
Oil on canvas
1881. 65 x 80cm
(detail)

1874: THE FIRST IMPRESSIONIST EXHIBITION

We were all one group when we first started out. We stood shoulder to shoulder and encouraged each other . . .

The quotation above was given by Renoir, almost twenty years after the inaugural collective Impressionist show: the *Société anonyme*'s first (and last) exhibition opened in mid-April, deliberately timed to upstage the official Salon. The exhibition was immediately a critical *cause célèbre*; not only did it provoke the aspersions of critics such as Leroy, it also rallied the

once antagonistic but very influential theorist Edmond Duranty to the Impressionists' defence. At the time, Jules Castagnary also showed particular insight in putting his finger on the fact that Monet, Pissarro, Sisley, Morisot and Renoir were: "Impressionists in the sense than they render not the landscape, but the sensation produced by the landscape."

MILLET
Haystacks in Autumn
Oil on canvas
1873–74. 85 x 110cm
Though charmingly done in their own right, Millet's haystacks are perhaps of more interest through their very obvious foreshadowing of the magnificent series by Monet.

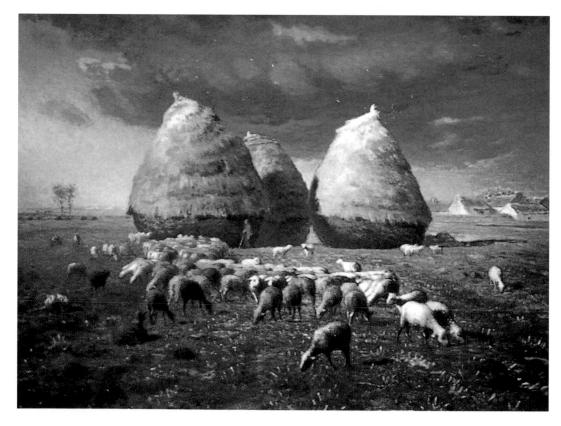

However, the exhibition was such a financial disaster that the Société was later forced to meet in December to wind up its affairs Thanks to Louis Lerov's scurrilous satire in Charivari, the group, which had laboured under several titles, none of them really appropriate - la bande à Manet, the Batignolles Group. the Realists - was now known as "the Impressionists". There were seven more Impressionist exhibitions, the last in 1886, although none of them bore the title "Impressionist", typically the participants preferring the name Expositions de Peinture, or on one occasion, an Exposition des Independents.

All but forgotten in a new world of painting, Charles Gleyre died that same year. Renoir, for one, maintained to the very end that Gleyre had taught him his *métier*.

1875: CRITICS AND COLLECTORS

The Salon of 1875 was graced with the results of Manet's work at Argenteuil where he had spent the previous sum mer with Monet and Renoir. Manet had helped Monet find new lodgings in this picturesque village on the banks of the Seine and then under the latter's influence created a series of highly impressionistic figures in landscapes. Liberated from the studio and surrounded by the most devoted of Impressionist plein-airistes,

Manet's technique underwent a revolution. Monet Painting in his Studio Boat (Monet dans son studio flotant), Banks of the Seine at Argenteuil (Les Bords de la Seine à Argenteuil) (the two figures are Camille Monet and Jean), and The Monet Family in their Garden (La Famille Monet au jardin) are remarkable for the speed of their execution and the abandonment of Manet's otherwise sombre palette in favour of strokes of pure pigment.

MANET

Banks of the Seine at Argenteuil Oil on canvas 1874. 148 x 115cm Manet's technique shows the liberating influence of Monet and Renoir; his palette is brighter than ever and his style is at last truly Impressionistic.

BOUDIN

Beach Scene, Trouville

Oil on canvas 1873. 15 x 30cm
One of many scenes of this kind by Boudin. He deplored the invasion of tourists but he could not avoid depicting them. Boudin flirted with Impressionism and indeed his work was included in the first Impressionist exhibition. Yet he was a free spirit, refusing to ally himself permanently to any specific grouping.

The respite offered by Durand-Ruel to the poorest of the Impressionists, Monet, Renoir, Pissarro, and Sisley (whose father's business had collapsed in the war) had temporarily evaporated; sales had plummeted in the recession. Even Degas was in trouble after the death of his father had entailed the Degas estate. An auction of Impressionist work arranged by Renoir and held at the Hôtel Drouot ended in farce and near riot. So derisory were the bids that the artists were forced to purchase many of their own works. Albert Wolff, the art critic of the important daily Le Figaro, had been asked by Manet to promote the sale. His answer was to write "the impression the Impressionists achieve [is] that of a cat walking on a piano keyboard or a monkey who might have got hold of a box of paints."

Gradually, however, patrons were steadily beginning to come to the aid of some of the Impressionists. An eccentric customs official called Victor Chocquet, who had devoted his life to collecting the work of Delacroix and many other objets d'art, had become enamoured of Renoir's work at the Hôtel Drouot and began to support Impressionists. Renoir the introduced him to Cézanne, also in need of more patronage and the result was a series of portraits of M. and Mme Chocquet by the two artists. Renoir's picture is executed with feathery brush strokes evoking a gentle, kindly, almost ethereal individual; Cézanne's portrait (like the later portrait of 1879–82) shows his increasing concern with structure and volume, and the paint is applied in thick patches and with the palette knife.

The second Impressionist exhibition planned for 1875 was unable to go ahead because there were no available funds to mount it. Although this decline of the *Société anonyme* was

only a temporary setback, some serious rifts were already beginning to appear in the group. In August Pissarro and his friend Alfred Meyer set up *EUnion* to carry on the work of the defunct *Société anonyme*. Cézanne and Monet objected to this upstart organization, especially the involvement of Meyer who they believed was plotting against the artistic objectives of

GUILLAUMIN

The Aquaduct at Arcueil
Oil on canvas
1874. 51 x 65cm
Among the Impressionists,
Guillaumin was one of the few to
depict the grim aspects of the
urban industrial landscape.

the Impressionists. Although L'Union had recruited several minor painters to its ranks, including Guillaumin, attracted little attention from the critics and eventually faded into oblivion. However much this singular group of artists was identified by the critics, the public and other artists as a homogenous circle their talents and personalities were formidably individual. A mutual struggle against the inflexibility of the art world brought them "shoulder to shoulder", but that alone was not enough to keep the Impressionists together for very much longer.

The death of Camille Corot in 1875, the inspiration for so many of the Impressionists, was an occasion for much sadness in the group, especially for Berthe Morisot and Camille Pissarro who had been closest to him and learnt the most from his work and artistic guidance. "We don't see in the same way; you see green and I see grey and silver," Corot once said to Pissarro, "... but this is no reason at all for you not to work at [tonal] values, for this is the basis of everything, and in whatever way one may feel and express oneself, one cannot do good painting without it." Morisot had outgrown Corot's style by the time of the first Impressionist exhibition, as her painting *The Cradle (Berceau)* indicates, but Corot's influence on Pissarro persisted well into the 1870s.

PHOTOGRAPHY AND IMPRESSIONISM

Of great interest to art historians is the fact that over three hundred photographs were found in Corot's studio after his death. These photographs are now lost, but a contemporary source described two hundred of them as being "studies from nature".

The first reliable photographic process had been discovered by Louis Daguerre and announced to the French Académie des Sciences in 1839. (In 1822 Joseph-Nicéphore Niepce had succeeded in fixing a photographic image on glass, and William Henry Fox Talbot in England was developing a rival process which could reproduce from negatives.) The daguerreotype was capable of producing a positive image fixed on a highly polished metal plate and soon became widely available. The new invention had an immediate effect on artists, especially miniature portrait painters: it was to put many of them out of business. Nevertheless the many practical applications of the new medium were apparent to major artists

THE AGE OF IMPRESSIONISM

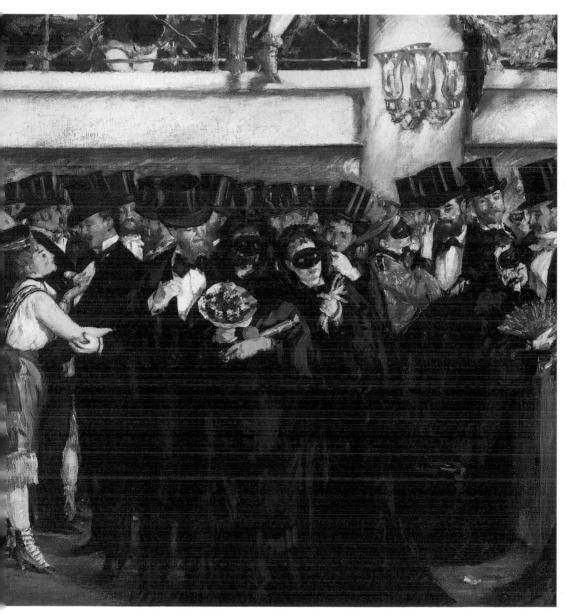

MANET
Masked Ball at the Opera
Oil on canvas
1873–74. 60 x 73cm

On the left, talking to a masked woman in white, is the composer Chabrier. This kind of entertainment was not suitable for the respectable Mme Manet or Berthe Morisot.

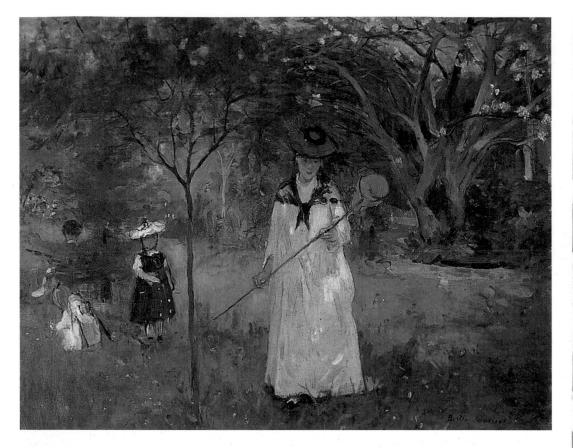

MORISOT

Chasing Butterflies
Oil on canvas
1874. 47 x 56cm
Morisot had work accepted as early
as 1864, by the official Salon, when
she was only twenty-three. It was
not until 1879 that she first showed
with the Impressionists.

such as Ingres and Delacroix. The latter made no secret of his admiration, a daguerreotype, he said:

... is a mirror of the object, certain details, almost always neglected in drawings from nature ... in the daguerreotype take on a great importance and bring the artist into a full understanding of the object's construction. There, passages of light and shade show their true qualities ...

In fact the daguerreotype was often more prone to distorting reality. Very slow exposure speeds in the 1850s meant that gently moving objects like trees were recorded on the plate in a blurred image, the light from the sky eating into the moving edges of the foliage. Corot and the Barbizon School were closely acquainted with the landscape photographers of the time who, as the historian of photography Aaron Scharf suggests, must have been setting up their tripods right next to the painters' easels in the leafy recesses of the Fontainebleau Forest and in other landscape

sites. After 1840 there is increasing and direct use of the "halated" or blurred effect in the outline of Corot's trees as well as the influence of photographic over- and underexposure in his astute handling of light and dark areas.

By the 1860s "snapshots" with fast exposure times were possible and Talbot's system of producing copies on paper from a negative had made the photograph widely available. Manet's The Execution of The Emperor Maximilian (L'Execution de l'Empereur Maximilian) is partly indebted to photographs taken in Mexico of the doomed Emperor and his aides. As a cultural expression of its time, The Execution stands poised between the instantaneous modernity of the photograph with its ability to capture current events, and the art of Gova who had painted his Third of May (1808) in the first Napoleonic era.

Describing Monet's painting in 1874 Ernest Chesneau perceptively wrote: "Never has the elusive, the fleeting, the instantaneous movement been caught in its incredible flux and fixed, as it is in this extraordinary *Boulevard des Capucines*." The previously unseen, blurred forms of moving people and objects which the camera could reveal had now become part of the vocabulary of the Impressionists, whether or not the influence was a conscious one.

In the year Corot died Degas painted the *Place de la Concorde*

(now sadly lost). Of his contemporaries it was Degas who exploited the photograph to its fullest potential, later using it to help him with studies of dancers and horses. The view of the *Place de la Concorde* with the Vicomte Lepic and his daughters frozen in motion, sliced off by the bottom of the picture, is clearly reminiscent of a snapshot and influenced by the new ways of framing made possible by the camera.

MONET

Boulevard des Capucines
Oil on canvas
1873–74. 79 x 59cm
The picture was painted in the autumn from Nadar's old photographic studios on the second floor.
The brand-new Grand Hotel is on the left.

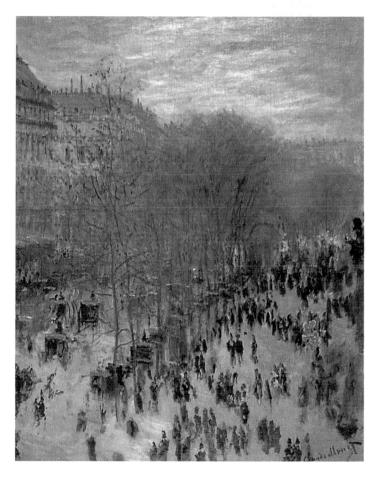

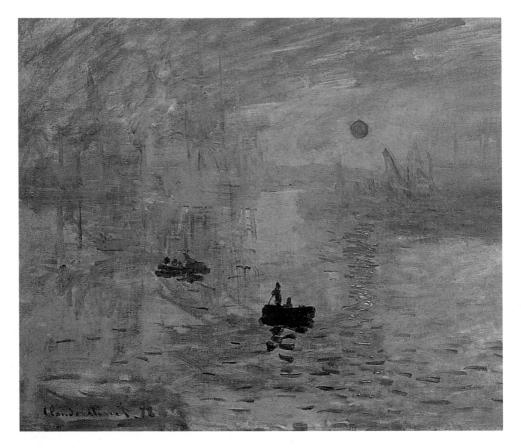

MONET

Impression, Sunrise
Oil on canvas
1872. 48 x 63cm
This is the painting which
provoked Leroy into coining
the name Impressionism at
the first of the group's joint
exhibitions in 1874.

Opposite PISSARRO

La Côte du Chou, Pontoise Oil on canvas c.1875–76. 81.5 x 65cm At this stage, Pissarro was increasingly being sought out by younger Impressionist colleagues, Cézanne in particular, for advice.

1876–1877: LA NOUVELLE PEINTURE

"None of its members show signs of possessing first-rate talent, and indeed the 'Impressionist' doctrines strike me as incompatible, in an artist's mind, with the existence of first-rate talent. To embrace them you must be provided with a plentiful absence of imagination."

HENRY JAMES

THE NEW YORK TRIBUNE

13TH MAY 1876

The second Impressionist exhibition opened in mid-April 1876 at Durand-Ruel's gallery in the rue Le Pelletier. Some of the more extreme critics had seized the opportunity of likening the group to madmen and syphilitics, so Henry James's criticism seems mild by comparison. Yet it was typical of the prevailing school of thought which still could not accept Impressionism in any form. A critical defence was needed and several writers sympathetic to the Impressionists came to their

aid. In his pamphlet *La Nouvelle Peinture*, Edmond Duranty analyzed the "new painting" in some depth. Monet, Renoir, and Pissarro were less than pleased with Duranty's tacit praise of Degas at their expense, but *La Nouvelle Peinture* offers some thoughtful insights into the Impressionists' work. This is what he had to say about the Impressionist use of colour:

Their real discovery consists in the realization that a strong light discolours tones, that sunshine reflected off objects tends by virtue of its clarity to blend its seven prismatic rays into a single. uncoloured brilliance which is light. From one flash of intuition to another, they have succeeded in breaking up solar light into its rays. its elements, and to reconstruct it as a unity by the general harmony of the iridescence they spread on their canvases. From the viewpoint of the refinement of vision and the subtle penetration of colours, it has produced an extraordinary result. The most astute physicist could find no fault with their analysis of colour.

Other critics did not agree. One of the fifteen works by Renoir at the second exhibition (several were on loan from Victor Chocquet) was the *Étude*, better known as *Nude in Sunlight*. In his satire on the first exhibition Leroy had conceded that the painter "has a certain understanding of colour"; and

Silvestre in *LOpinion* thought *Nude in Sunlight* "the work of a true colourist". Wolff, however, in *Le Figaro* made a devastating attack focused on Renoir's palette:

Would someone kindly explain to M. Renoir that a woman's torso is not a mass of decomposing flesh with the green and purplish blotches that indicate a state of complete putrefaction in a corpse . . .

Not to be outdone in similes of corrupt flesh, Louis Enault in *Le Constitutionnel* offered his readers this opinion:

It is depressing to look at this large study of a nude woman; her purplish flesh is the colour of game that has been hung for too long, and someone really should have made her put on a dress.

Despite these attacks this was, as art historian Phoebe Pool says, Renoir's annus mirabilis. Not only do two of his finest paintings, The Swing (La Balançoire) and the Ball at the Moulin de la Gazette (Bal du Moulin de la Gazette), date from this period, but he also met Georges Charpentier, who became an important patron.

RENOIR

The Greenhouse Oil on canvas Undated. 60 x 74cm Where Monet concentrated on the overall lighting in a picture, Renoir preferred the contrast of light and shade.

Mme Charpentier's salon was an important meeting place for the intellectual and social elite of the day. Renoir's later portrait of Mme Charpentier is described by Proust in *Time Regained (Le Temps retrouvé)* as being comparable to the best of Titian.

It was also around this time that a young painter of indemeans, pendent Gustave Caillebotte, became an imporforce tant amongst the Impressionists. His Floor Scrapers (Les Raboteurs de parquets) and Le Pont de l'Europe were shown at the second Impressionist exhibition. The influence of Degas and photography is discernible in the deep perspective, and whilst the style can hardly be called "impressionistic" in the sense of Monet, Sisley, or Renoir, these and several later paintings, notably the Boulevard Seen from Above (Boulevard vu d'en haut) have often been mentioned as some of the most memorable urban images of his century. Seven years younger than Renoir and Monet, Caillebotte was soon engaged in organizing the 1877 exhibition and funding the group through the extensive purchase of some of their most important works, with the intention of bequeathing them to the State. (There were sixty in all, including the two by Renoir mentioned above, now in the Musée d'Orsay, in Paris).

As Renoir's fortunes waxed for the time being, Monet's

waned. During the years between 1876 and 1880 Monet was consistently forced to rely on the largesse of others. He described himself as being penniless and destitute, although he was still earning (and spending) six times more than the average workman whilst occasionally living in some style. Nevertheless the third Impressionist exhibition held Durand-Ruel's and funded by Caillebotte, showed penury could not stop Monet's outflow of work.

In January Caillebotte had rented a small apartment and studio for Monet close to the Gare St Lazare, the main station for points west of Paris, including the Normandy coast, Argenteuil, and Bougival (in 1877 it handled 13 million passengers). With the sort of bravado only a penniless artist like Monet could summon up, he went to call on the Superintendent of the railway who assumed him to be a famous artist and offered him the freedom of the station. A series of twelve paintings was the result, seven of which were shown at the third exhibition. Greeted with astonishment, they proved to be the last of his urban landscapes. Georges Rivière, an art critic of the time held the overall view that "these paintings are amazingly varied, despite the monotony and aridity of the subject. In them more than anywhere else can be seen that skill in arrangement, that organization of the canvas, that

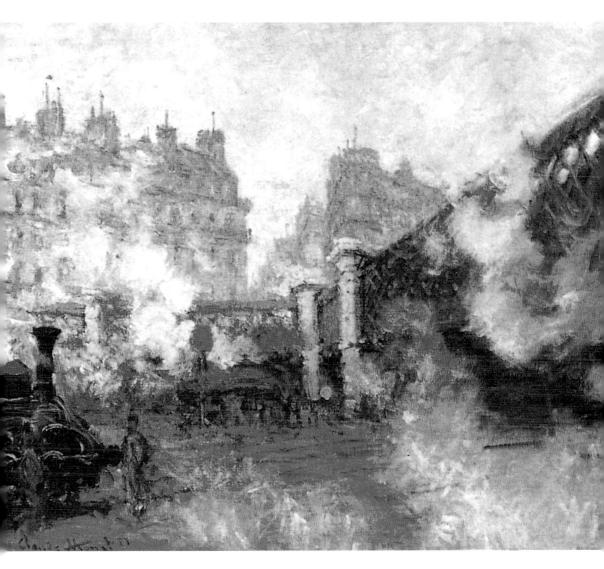

is one of the main qualities of Monet's work." Trains and the new railways were indeed an important feature in the work of the other artists, notably Pissarro, Sisley and Manet. Manet's *The Ruilway* (Lo Chemin de fer) of 1873 tells us a

great deal about the difference between him and Monet. It is primarily a figure painting the railway itself is beyond the picture and represented by a cloud of steam; the little girl stands (like Degas' double-bass) with her back to us.

MONET

Gare St Lazare, Pont de l'Europe Oil on canvas 1877. 64 x 81cm The railway bridge seen at train level, a much more animated and interesting composition than Caillebote's work.

MANET

The Railway 1872–73. 93.5 x 114.5cm Also known as The Gare St Lazare, we can hardly guess that there is a railway station behind the cloud of smoke. Most Impressionists were painting scenes with trains at this time.

Manet, unlike Monet, is not primarily interested in the rail-way as such, but in the relationship between it and his figures. As an icon of its time it is a powerful image, portraying a sense of wonderment (the girl) and banality (the woman) in the modern world.

Looking at this modern world from an entirely different perspective, Degas' contribution to the exhibition included two celebrated images of Parisian vice; In a Café (also known as The Absinthe Drinker) and Women on the Terrace of a Café in the Evening (Femmes à la terrasse d'un café soir). Of the latter, the contemporary critic Alexandre Pothev confessed, "the terrifying realism of these painted, faded creatures, exuding vice, who cynically tell each other about their day's activities and accomplishments." The scandal caused by Manet's Olympia twelve years before in the long summer days of the Second Empire had been instrumental in clearing the way for Degas' explicit depiction of prostitution and alcoholism, now tacitly acceptable in polite Third Republic society. If Baudelaire had survived he would have been delighted, for Degas was now the painter of modern life par excellence, making art of everything that went on in Paris. His interest in ballet had resulted in The Star (L'Etoile) and Dancers at the Barre, whilst the café-concert, a sort of vaudeville or music hall at the height of its popularity in the 1870s, was the trigger for several pictures on this subject, as indeed it was for Renoir and Manet.

1878–1881: BEGINNING OF THE END

We are far from the moment when we are able to do without the prestige attached to the official exhibitions.

ALFRED SISLEY, 1878

Opposite **DEGAS**

The Star
Pastel/monotype
c.1878. 60 x 44cm
Degas said, "People call me the
painter of dancing girls. It has
neter occurred to them that my
chief interest in dancers lies in
rendering movement and in
painting pretty clothes."

In 1878 an important patron of the Impressionists, Ernest Hoschedé, the director of a Paris department store, was in serious financial difficulties which later forced him to sell a sizeable collection of works he had accumulated after the first Impressionist exhibition in 1874. Monet in particular was affected by the impending fall of Hoschedé; he had made extensive use of Hoschedé's country house at Montgeron near Paris and had produced some important work for the collector. The loss of a patron was bad enough; Monet and

Camille now had a second child to support, they had recently been forced to leave their house in Argenteuil, relying on Edouard Manet to find them lodgings at Lavacourt near Vétheuil, a village over thirty miles from Paris. The Monets were already desperate, as Camille was ill with cancer of the uterus, and to make things worse, the Hoschedés were ruined, and they came, with their six children, to stay. To complicate matters Claude had been having a secret liaison with Hoschedé's wife, Alice, for some time. Thus began a strange ménage à douze. From around this time Monet began to be more and more isolated from the other Impressionists, rarely venturing into Paris.

One of the founding members of the Société anonyme who had already cut himself off from the group to a certain extent, pursuing his own aims and methods, was Alfred Sislev. He was becoming a recluse; some vears later he crossed the street to avoid Renoir who had once been one of his closest friends. Eight years earlier Sisley's father's business had crashed during the Franco-Prussian War and from this time to his death in 1899 his life was a continual struggle to support his family. His finest work dates from the mid-1870s. Sisley had lived near Argenteuil in the earlier part of the decade and between 1875 and 1877 he had gone to Marly-le-Roi to continue his landscapes. In 1878 he got his work into the Salon along with Renoir; both artists had now officially left the Impressionists. Sisley told Duret that:

It is true that our exhibitions have served to make us known and in this they have been very useful to me, but I believe we must not isolate ourselves for too long. We are far from the moment when we are able to do without the prestige attached to the official exhibitions. I am therefore determined to submit to the Salon.

Underlying this dissatisfaction was the increasing dominance that Degas (and Caillebotte) seemed to be exerting on the group. A benign example of Degas' influence can be seen in his patronage of a young American, Mary Cassatt, who had been living in France since 1866 and had shown twice at the Salon. But other, lesser artists were now to be drafted into the Impressionist exhibitions to make up for the loss of Renoir, Sisley, and later Monet himself. Clearly the Impressionist exhibitions had partially

THE AGE OF IMPRESSIONISM

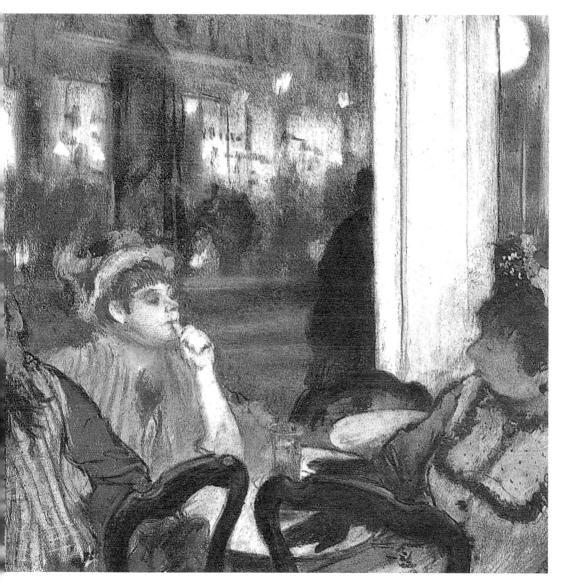

DEGAS
Women on the Terrace of a Café
in the Evening
Pastel/monotype
1877. 41 x 00cm

Both Manet and Degas were the resolutely urban painters of the group. Scenes of modern Parisian life were just the sort of thing that Baudelaire had in mind whon he demanded a new art.

succeeded in promulgating the "movement" but the Impressionists themselves could not expect to live on the proceeds. Chocquet, Charpentier, and other patrons (Manet and Caillebotte also fulfilled this role) were still vital to their livelihood, and, as frustration with the relative failure of the independent shows grew, Renoir, Sisley, and Monet in particular looked once again to the Salon. The radical Pissarro would not countenance this and in 1878, a year when there was no Impressionist exhibition, he rented a room in the Montmartre quarter of Paris to exhibit his own pictures, which were ironically less radical than ever before, to potential clients. Pissarro, like Monet, had recently lost a friend and patron, Ludovic Piette, a landscapist of some talent who had exhibited with the Impressionists and had died in 1877, depriving Pissarro of an important source of income.

"A BANAL SCHOOL"

The fourth Impressionist exhibition opened on 10th April 1879 at 28 avenue de l'Opera in Paris without Sisley, Renoir, Morisot (who was pregnant) and Cézanne, but it had works

by Cassatt, Forain, Zandomeneghi (all protégés of Degas) and an as yet unknown painter by the name of Paul Gauguin, who had been befriended by Pissarro. For once it was a success and the irony was that as the crowds flocked to see the exhibition there were precious few of the major Impressionists on view. The Salon was now the place to see works like Renoir's Portrait of Madame Charpentier and Her Children (Madame Charpentier et ses enfants) and Manet's Boating (En Bateau), both of which received considerable acclaim. That April Georges Charpentier published the first edition of La Vie Moderne, a magazine of style, science, comment, and criticism. La Vie Moderne instituted a series of exhibitions at which Renoir in 1879, and Manet and Monet in 1880, were to have hugely successful one-man shows. As Monet's work finally began to receive the praise he had longed for he was at his most isolated, declaring, "I am still and always intend to be an Impressionist – but very rarely see the men and women who are my colleagues. The little church has become a banal school which opens its doors to the first dauber that comes along."

PISSARRO
The Kitchen Garden
Oil on canvas
1879. 55 x 65cm

Whereas Renoir had a longing to be accepted by high society, Pissarro was staunchly loyal to his principles and continued to paint humble subjects.

Camille died in September 1879. As he watched her growing cold, Monet could not resist painting her portrait for the last time. 1880 marked the beginning of a new decade and the end of an era. Duranty, Flaubert, and Offenbach had died. Manet's illness was now seriously affecting him, making a trip to the Café de la Nouvelle-Athènes, which had replaced the Café Guerbois as Manet's haunt, a rare occurrence. Of the original subscribers to the Société anonyme only Degas (who had appeared in every show so far), Pissarro, and Berthe Morisot were to exhibit in the Impressionist exhibitions of 1880 and 1881. Renoir was moving in a higher strata of society and was now financially secure although an artistic crisis was looming for him. Degas' increasing grip on the Impressionist exhibitions in which he included more and more of his followers drove Pissarro and Caillebotte to beg him to allow Monet, Renoir, and Sislev back into the fold. Caillebotte finally against Degas, bitterly attacking him in a letter to Pissarro:

This man has gone sour. He doesn't hold the big place that he ought to according to his talent and although he will never admit it, he bears the whole world a grudge. One could put together a volume from what he has said against Manet, Monet, you . . .

Pissarro would not be swayed and remained faithful to Degas

to the last. The 1881 exhibition opened at the boulevard des Capucines where a new generation of Impressionists joined Degas, Morisot, Guillaumin, and Pissarro; this was the third Impressionist show for Mary Cassatt, the second for Paul Gauguin; the others included Rouart, Vidal, Vignon, and Zandomeneghi.

Meanwhile the dying Manet had been awarded the Légion d'Honneur by a Third Republic which had finally come to terms with him. The love-hate relationship between the Salon and Manet had at last resolved itself in favour of the artist. Manet had always tried to play both sides against the middle, supporting the Impressionists in their darkest hours whilst resolutely maintaining that he was neither a revolutionary nor an Impressionist. Astruc had said of him in 1867, "M. Manet . . . has no intention to overthrow the old methods of painting or to create new ones. He has merely tried to be himself and no one else." Hearing that he had won the Légion d'Honneur, Manet complained with typical barbed wit, "It would have made my future once, but now it is too late to make up for twenty years of failure."

In 1882, with the notable absence of Degas and Cassatt, the Impressionists held their penultimate exhibition in the rue Saint Honoré. Although there was another show in 1886, this was in reality their last stand.

Opposite CASSAT

Mother and Child Pastel on paper Undated. 55 x 45cm Mary Cassat, who had no children, nevertheless made motherhood and child-rearing her personal artistic domain. As this pastel shows, she was influenced by Degas, her initial mentor, and treats her subjects with the detailed observation not to be found amongst her other truly impressionistic contemporaries.

THE AGE OF IMPRESSIONISM

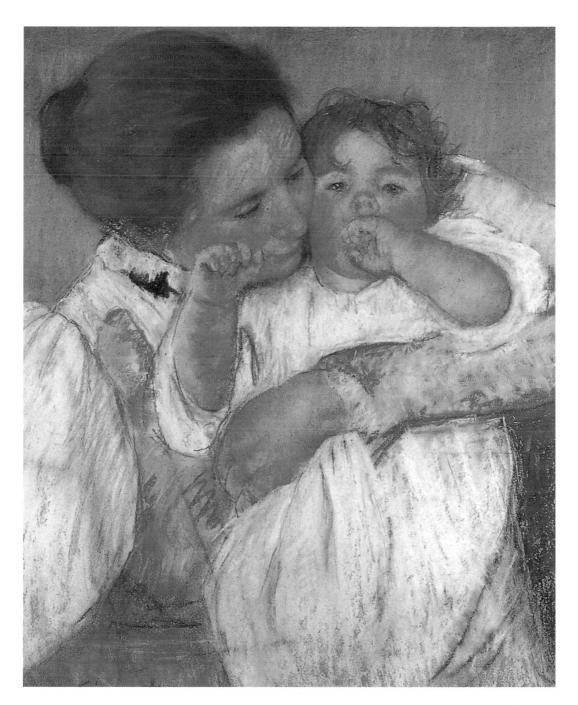

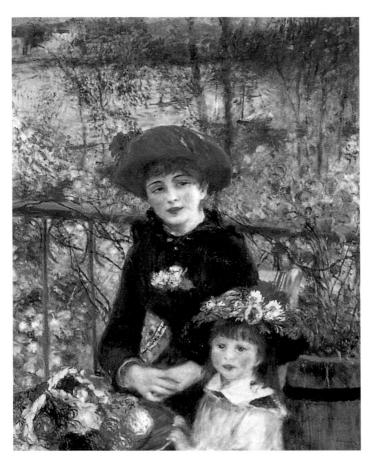

RENOIR

The Terrace
Oil on canvas
1881. 100 x 81cm
Renoir was still painting
landscapes, but portraits were
also a favourite subject.

For a final time, and with great difficulty, Caillebotte and Pissarro (with the aid of Durand-Ruel) had gathered together the work of Monet, Morisot, Renoir, and Sisley (with Gauguin, Guillaumin, and Vignon) under one roof. At the last moment Edouard Manet was struck with indecision about whether to join the group. At any rate he was now in the final stages of his illness, a form of locomotor ataxia it is believed, which was steadily paralysing him. His

appearance with the others would have been a fitting conclusion to a decade he had spent devoted to them. Nevertheless his last great masterpiece, A Bar at the Folies-Bergère (Le Bar aux Folies-Bergère) was shown at the Salon of 1882 as he received for the last time the official recognition he so desperately desired.

The painting can perhaps be seen as a summation of his adventure as a "painter of modern life". It shows a barmaid, blank faced, before a mirror reflecting the incessant nightlife of Paris; there is an improbable reflection of her and her customer to the right which touches the borders of surrealism: we might be that customer. In the top left hand corner the legs of an acrobat are bizarrely severed by the frame. A moment of staggering insignificance captured in the very heart of the City of Light.

Manet died on 30th April 1883, at the age of fifty-one. A sale of his work in 1884 realized the modest sum of 116,637 francs for 167 paintings, an average of less than 700 francs per work, far below anything paid for an official Salon painting, or even the Barbizon School which had now become highly collectable.

1883-1886: THE LAST SHOW

Renoir was in the throes of a crisis: "I had come to the end of Impressionism. I was reaching the conclusion that I didn't

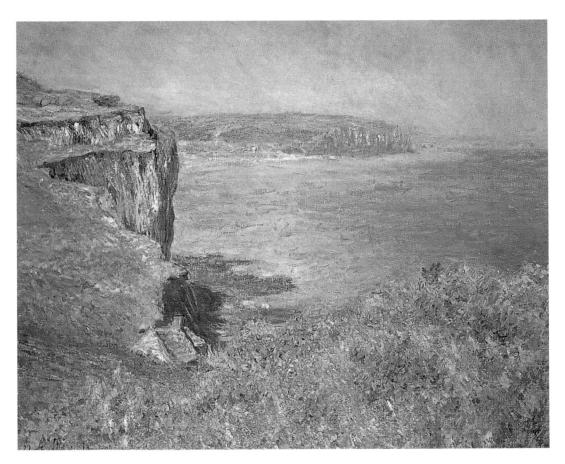

know how either to paint or draw. In a word, I was at a dead end." In 1882 he had been travelling in Italy and Sicily where he had painted a portrait of Richard Wagner; from there he had joined Cézanne at l'Estaque on the Côte d'Azur and fell seriously ill with pneumonia. His journey to Italy was mainly a quest for classical art and technique. He studied the wall paintings of Pompeii and even more so the perfect smoothness of Raphael's works in Rome,

which led him to work in a tighter, more refined and precise style for a while, before he returned to his instinctive, less disciplined brushwork. The conflict of his styles heightened a personal and artistic crisis eloquently demonstrated in his painting *The Umbrellas (Les Parapluies)*, reworked during the 1880s and left unfinished. Cézanne's powerful influence is evident in Renoir's solid handling of the umbrellas; the group on the right is painted in

MONET

The Cliffs at Varengeville Oil on canvas 1882

A favourite subject for Monet, the cliffs along the Normandy coast provided him with a spectacular mixture of landand seascape. MONET
Giverny in Winter
Oil on canvas
1885. 64.5 x 88.5cm

At this time Monet was exploring

the area where he was to live until

his death in 1926. No weather was

cold enough to discourage him.

the delicate, feathery style associated with his high Impressionist period, whilst the girl on the left shows the beginnings of a brief flirtation with classical purity of form and line. A series of *Bathers* illustrates well the more restrained rendering which he tried to apply in later years to commissioned portraits.

In 1883 Monet, Alice Hoschedé and their respective children settled in Giverny, a small village near the Seine and close to Rouen. Ernest Hoschedé had gradually been estranged from his wife and had left

the double household. After years of poverty, moving from house to house, relying on others to pay his way, Monet was now firmly established with a decent income; his pictures were fetching excellent prices, especially in America. He could now devote himself to exploring the enveloppe of light he perceived to hold the world together. For the next forty-three years he lived at Giverny, established and tended his celebrated garden, and painted more than ever before. Foreign artists, many of them American, settled nearby; others frequently visited

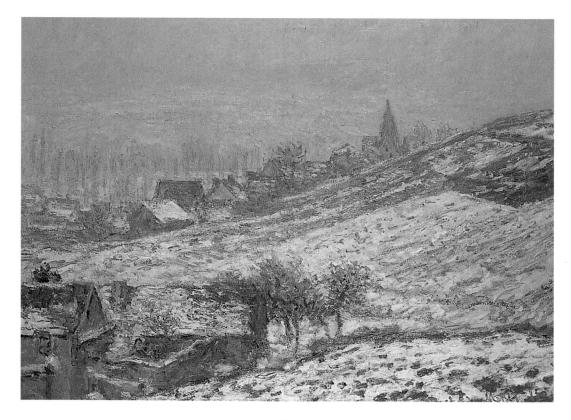

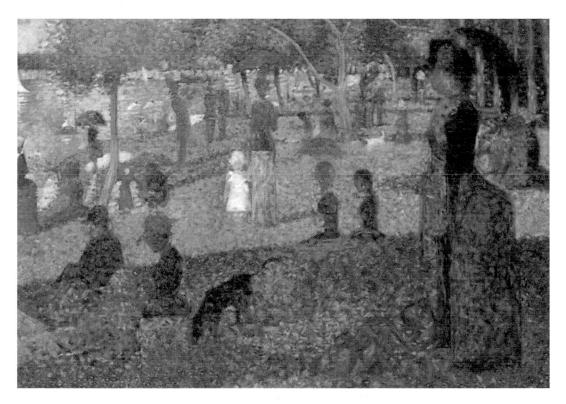

him. The other Impressionists had spread out across France: Pissarro had moved north of Paris to Osny, Cézanne rarely left Provence, and Renoir had decamped to Essoyes in Burgundy with his mistress (later his wife) Aline Charigot.

At the last Impressionist exhibition in 1886, Degas was back with his protégés, but their thunder was stolen by the Neo-Impressionists, Seurat and Signac, who had already begun to influence Pissarro. Seurat's huge painting *La Grande Jatte* caused a storm at the exhibition, and closed the decade with a new form of painting which

was as controversial as that which had begun it

The great age of Impressionism lasted barely more than a decade. By 1886 it had permeated the entire world of art, spawning Impressionist movements in the United States, Britain, Germany, and Scandinavia which were to continue for many years to come. Impressionism as an innovative force was still influential, but was also beginning to be challenged, especially by Gauguin, and in 1886 a thirty-three-yearold Dutchman, Vincent van Gogh, arrived in Paris to study at Felix Cormon's atelier . . .

SEURAT

Study for La Grande Jatte
Oil on canvas
1883. 71 x 104cm
This is one of several finely detailed
studies for the finished painting which
Seurat made.

SECTION TWO

THE LIFE AND WORKS

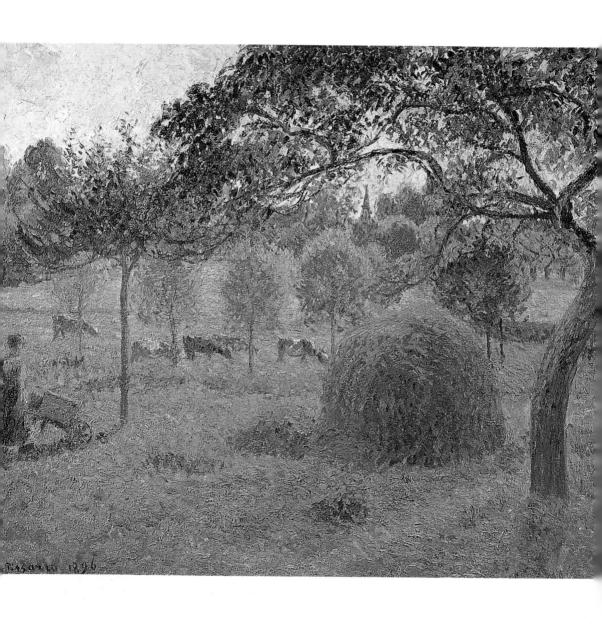

ALENTED ARTISTS as diverse as Gauguin, Cassatt, and Cézanne held Camille Pissarro in the utmost reverence as a teacher and a man of integrity. His openness enabled him to transcend his (at best theoretical) anarchist convictions and get on with the likes of the extremely reactionary Degas and the innately conservative Renoir, whilst he was a natural friend and ally to Monet and Sisley, who both struggled long and hard to secure their place in the art world. Although Pissarro was able to instil confidence in others, he was himself deeply uneasy about his own ability and only settled into a mode of expression which began to satisfy him very late in his life, following a brief but unproductive flirtation with Neo-Impressionism.

Above
CAMILLE
PISSARRO
Self portrait
1873

Opposite
PISSARRO
Sunset at Eragny
Oil on canvas
1896, 54.5 x 65cm

LIFE AND WORKS: CAMILLE PISSARRO (1830–1903)

Remember that I have the temperament of a peasant, I am melancholy, harsh and savage in my works. It is only in the long run that I can expect to please, and then only those who have a grain of indulgence.

CAMILLE PISSARRO

Camille Jacob Pissarro, "the First Impressionist" as Cézanne referred to him, was born on 10th July 1830 on the island of St Thomas in the Danish West Indies (now the U.S. Virgin Islands), the fourth son of Abraham Pissarro, a French Jew from Bordeaux, and Rachel Manzana-Pommié, a Creole from Dominica who had been widowed and was seven years older than her second husband. Abraham Pissarro ran a general store in Charlotte Amalie, the capital and port of St Thomas.

Though he and his family lived thousands of miles from France, Abraham Pissarro was keen to bring up his children in the French manner, so between the ages of twelve and seventeen Camille attended a boarding school, the Académie Savary in Passy, a suburb of Paris. M. Savary, the director of the Académie, is said to have encouraged the boy's artistic leanings by imploring him to draw coconut palms from nature when he returned to the West Indies, In 1847 Camille was back in St Thomas and he must have indeed followed M. Savary's advice in his spare time, for nine years later (in Paris again) he was painting tropical landscapes from memory.

Camille remained in St Thomas until 1853 when he took off without parental consent to Venezuela with the Danish artist, Fritz Melbye. For two years in Caracas Pissarro practised drawing and attempted his first watercolours under the thoughtful eye of Melbye. By the time he sailed to Paris to study with Melbye's brother Anton, Pissarro was an accomplished landscape painter.

The Exposition Universelle of 1855 was in its last few days when he arrived in Paris. Courbet's Realist Pavilion was creating a stir, and Pissarro introduced himself to the master landscapist. During the next couple of years Pissarro worked as Anton Melbye's assistant, and studied at the free Académie Suisse where he met Claude Monet; he was also an occasional pupil of Corot, describing himself as such in his first submission to the Salon in 1859. Pissarro passed the Salon hurdle at the first attempt. The Salon was the summit of exhibitions and Pissarro's carefully worked landscape of Montmorency had enough of Corot in it to succeed in academic terms, but it also proved that Pissarro's talent was to be uncompromising. The move

CAMILLE PISSARRO

from the exotic Virgin Islands and South America to France produced in Pissaro a lighter more naturalistic vision than that of Corot.

From his earliest drawings in St Thomas to his death in 1903. Pissarro's style and method were in a continual state of flux. As the art historian John House has said, "to chart Pissarro's stylistic evolution ... we meet in turn Corot, Daubigny, Courbet, Jongkind, Monet, Cézanne, Renoir, Millet, Seurat, Turner, and Monet again." Although he was the oldest of the Impressionists. Pissarro never ceased assimilating the work of others in an artistic evolution which is unparalleled among his contemporaries. In the late 1850s and early 1860s the Salon and the French art world were in a deep debate about the acceptability of Daubigny's sketchy plein-airisme and the consequences of Courbet's realism. Having succeeded on the much safer ground of Corot, Pissarro then began to appreciate the attempts made by Daubigny and Courbet to paint what they saw and wanted to see. At the age of twenty-nine Pissarro met Monet, ten years his junior, at the Académie Suisse and soon became part of a new generation of artists fired by the example of Courbet and Daubigny, impatient with the academic landscape.

COROT

Dardagny, Morning
Oil on canvas
1853. 26 x 47cm
Pissarro had seen the few Corots on
show at the Exposition Universelle
and a year later went to see the master
landscapist. Corot's style was a major
influence on Pissarro for many years.
This small, sketchy picture displays
the free side of Corot which suited
Pissarro's early vision.

Unlike Monet, Renoir, Sisley, and the other budding Impressionists with whom he was soon to have a remarkable relationship, Pissarro's view of the world had already become deeply politicized. The glory of the Second Empire was skin deep as far as he could see and the dehumanizing effects of rapid industrialization hidden behind the glittering façade of the Empire were not lost on him. He grew increasingly attracted to the extreme radicalism of Proudhon and Prince Kropotkin, Proudhon had said that "art should show us exactly as we are, not in a mediated fantasy that no longer represents us." The artist he had in mind for his project was Courbet; Pissarro was already well acquainted with Courbet's work in the late 1850s and had read Proudhon's huge tract On Justice in the Revolution and the Church, published in 1858. Somewhat anarchic by nature, Pissarro began to espouse some of Proudhon's anarcho-federalist ideals and was to become more avowedly anarchist as the years went by. (Proudhon was, as the art historian Ralph Shikes points out, "a passionate advocate of Justice, Liberty, and Equality, yet his Equality did not embrace universal suffrage; blacks, whom he regarded as inferior; and women, equally inferior, whose place he felt was in the home.") The task of the artist, as Pissarro was to say many years later, echoing Proudhon, "is to seek with our own senses the elements of what surrounds us. This can only be achieved by observing nature with our own contemporary sensibility. It is a serious mistake to believe that every form of art is not closely linked to its time."

In 1860 when it seemed little could shake the foundations of the Second Empire, Proudhon's views were considered dangerous but tolerated. Despite his growing convictions, Pissarro's talents clearly lay in the reality of nature and agriculture, in landscapes with figures - what one critic has called humanist landscape - not social realism, although the two could combine successfully to a certain extent in his Railway Bridge at Pontoise (Le Pont de chemin de fer à Pontoise) of 1860, and yet prove stilted and sentimental in Donkey Ride at La Roche-Guyan (Promenade à l'âne à La Roche-Guyon), what Shikes calls "the only canvas of his career with an overt social message."

Several important relationships developed for Pissarro in 1860. Working in the countryside around Paris one of his constant companions was Ludovic Piette, with whom Pissarro struck up a life-long friendship. At about the same time Pissarro became closely attached to Julie Vellay, who was his mother's maid.

There had been no Salon in 1860, but after his initial success which had beentwo years earlier the vagaries of the Salon were against Pissarro this time.

The jury was severe and rejected his entry. Pissarro continued to work in Paris, copying at the Louvre and working at the Académie Suisse where he met two important allies, Paul Cézanne, on whom he was to have a great influence, and Armand Guillaumin.

1863 was the year of the Salon des Refusés and Manet's Luncheon on the Grass (Déjeuner sur l'herbe) which launched the reluctant Manet as a figurehead of the avant-garde. In February that year the first of Pissarro and Julie Vellay's seven children, Lucien, was born.

PISSARRO

Woman Reading
Oil on canvas
1860. 26.5 x 29cm
The sitter is Julie Vellay, the maid of
Pissarro's mother. They had seven
children and married ten years later,
in 1870, while they were in London.

Julie had in fact suffered a miscarriage the year before. Pissarro was a devoted father to his children; his extensive correspondence with Lucien, who moved to London in the 1890s to set up a book illustration press, forms a large part of our knowledge about Pissarro's later life.

Two years later Abraham Pissarro died, precipitating a financial crisis for Camille Pissarro and his growing family; they now had a daughter, Jeanne. The Salon of 1864 had accepted two landscapes from the artist, described in the catalogue as a pupil of Corot and (Anton) Melbye, and Pissarro appeared in the Salon until rejected along with Renoir, Sisley, and Monet in 1867.

Despite this relatively steady success rate at the most important of art markets, Pissarro's sales were few and far between; he was already beginning to call upon the largesse of friends such as Ludovic Piette whose farmhouse in Montfoucault he had visited in 1864. At this time he also began to fall out with Corot who did not approve of the increasing influence of Courbet in Pissarro's work and thereafter Pissarro stopped calling himself a pupil of Corot. The painting Pissarro showed at the 1866 Salon, Banks of the Marne in Winter (Les Rives de la Marne en hiver) drew the praise of Zola for its modernity, whilst another critic said: "M. Pissarro is not commonplace for want of the ability to be picturesque, he has used his robust and exuberant talent to depict the vulgarity of the modern world." The influence of Corot and Daubigny in Pissarro's use of dark and subdued pigments, as well as Courbet's palette knife technique is evident here, but even at this early stage in his development Pissarro's choice and control of his admittedly banal subject stands out as an

intensely personal vision of the countryside (near Pissarro's home at the time, La Varenne-Saint-Hilaire) that he painted.

By 1867 Pissarro and his family had moved to Pontoise, a village on the river Oise near Auvers, where they remained until 1869 and then settled in Louveciennes. Pissarro worked consistently outdoors at land-scapes during these years but

kept a studio in Paris and was close to the rapidly growing movement that met in the Café Guerbois. The 1867 Salon which coincided with the Exposition Universelle was particularly conservative in its selections and Pissarro, one of the many refusés, had joined Renoir, Sisley, Monet, Bazille, and Cézanne in signing a petition demanding another Salon

PISSARRO

Springtime in Louveciennes
Oil on canvas
c.1868–69. 53 x 82cm
The Pissarros had recently moved to
Pontoise, a small town on the banks of
the Seine not far from Marly, where
Sisley lived, and Bougival where
Monet worked. This landscape is still
close in style to Corot, especially in the
rendering of the trees on the right.

des Refusés There was now talk of an independent exhibition amongst the Glevre students and Pissarro, Cézanne, and Degas. Pissarro was by now deeply involved in the emerging group and was to play an increasing role in its future development. Daubigny's inclusion on the Salon's jury the next year secured the exhibition of two of Pissarro's Pontoise landscapes, moving Zola to pronounce Pissarro "one of the three or four true painters of our day. I have rarely encountered a technique that is so sure C'est là la campagne moderne Ithis is truly the modern countryside]." Sadly this praise was of little avail to the Pissarro family, now in financial straits. Their income was so erratic that Camille was occasionally forced to join with Armand Guillaumin decorating shop fronts and blinds.

A brief period of relative calm and consolidation ensued in Louveciennes, where Pissarro's researches into landscape continued. He was joined by Claude Monet, who had been working with Renoir at La Grenouillère (Pissarro had briefly worked there as well during the summer). In the winter of 1869–70 under varying weather conditions both artists painted similar views of the road to Versailles where Pissarro's house stood.

The outbreak of war on 19th July 1870 forced the Pissarro family to move to safety, first to Piette's farm in Brittany and then in December they crossed the English Channel to a suburb of London where Pissarro's mother was already living. There he finally married Julie Vellay, already pregnant with their third child.

Monet had fled to London as well, and through the auspices of the sympathetic dealer Durand-Ruel, also a refugee in London, Pissarro made contact with him: "Monet and I were very enthusiastic over the London landscapes," recalled Pissarro in a letter of 1902. "Monet worked in the parks whilst I, living in Lower Norwood, at that time a charming suburb, studied the effect of fog, snow, and springtime. We worked from nature . . . We also visited the museums. The watercolours and paintings of Constable and Turner and the canvases of Old Crome [i.e. John Crome, 1768-1821, leading artist of the Norwich School of landscapists] have certainly had an influence upon us. We admired Gainsborough, Lawrence, Reynolds, etc., but were struck chiefly by the landscape painters who shared more in our aim with regard to plein-air, light and fugitive effects." As the art historian Phoebe Pool notes, Pissarro's initial

CAMILLE PISSARRO

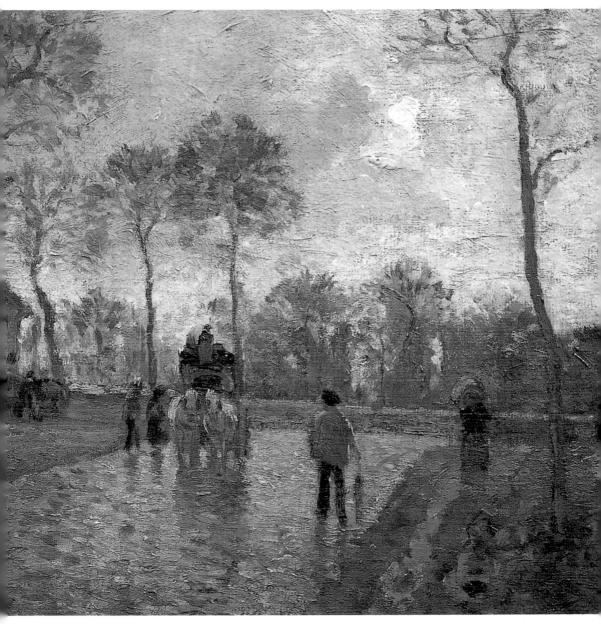

PISSARRO

The Diligence at Louveciennes Oil on canvas 1870. 25.5 x 35.7cm Pissarro had at last found his own style: the brushstrokes are less unified. The diligence was the public coach used to transport local passengers in the area. delight at the English landscapists was grudgingly tempered. In the last year of his life he wrote to Lucien saying, "Turner and Constable . . . showed us in their work that they had no understanding of the analysis of shadow, which in Turner's painting is simply used as an effect, a mere absence of light. As far as tone division is concerned, Turner proved its value although he did not apply it correctly and naturally."

The important contact with Durand-Ruel aside, Pissarro's fortunes did not improve in London; the public were not keen to buy his paintings and the Royal Academy's annual exhibition refused both his and Monet's work. Twelve paintings and some studies survive from Pissarro's time in London, ranging from the highly impressionistic Fox Hill, Upper Norwood and Dulwich College to the more highly polished The Avenue, Sydenham, which Durand -Ruel eventually bought in 1871, but which Pissarro must have hoped to sell to the London market.

The net result in artistic terms of Pissarro's exile in London, his contact with Monet and the English landscape school, was a freer handling of brighter pigments, using the swiftly applied patches of colour which Monet had been developing since La Grenouillère and was now employing to great effect in his views of the Thames. Compared to Monet, who was now beginning to

Opposite PISSARRO Dulwich College Oil on canvas c.1870. 50 x 61cm Apart from the rather systematic rendering of the branches, the careful if plain rendering of some of Corot's work has now disappeared from Pissarro's. Dulwich College was, and remains, one of the landmarks of this area of London.

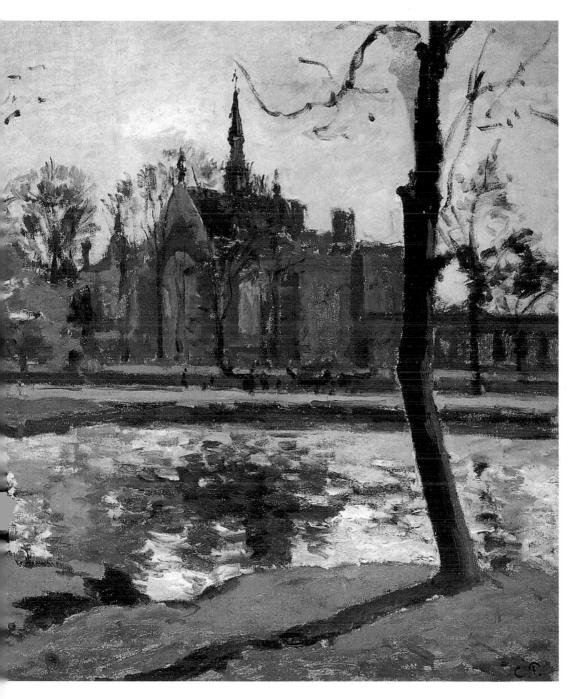

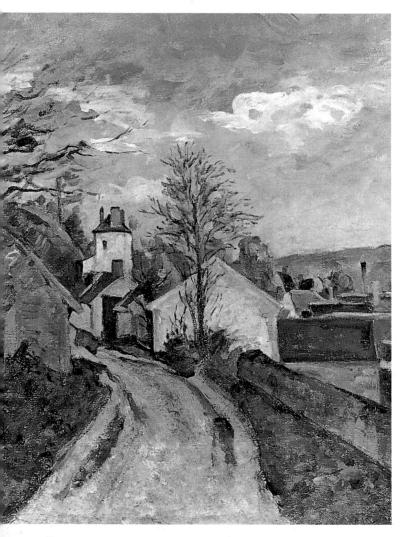

Above CÉZANNE

Dr Gachet's House at Auvers Oil on canvas

1873, 46 x 38cm Cézanne worked with Pissarro between 1872 and 1874, and his technique improved considerably under Pissarro's tuition. Here we can see how Cézanne emulates Pissarro's style, abandoning a thick impasto worked with palette knife for a lighter and more sober rendering.

Opposite

PISSARRO

Self-portrait Oil on canvas 1873. 64 x 53cm Pissarro was only forty-three when this portrait was made, but he looks much older by our standards. Renoir complained of being old at the same age.

approach Impressionism par excellence, Pissarro's ongoing debt to the first of his mentors, Corot, as well as to Daubigny and Courbet is still evident in The Avenue, Sydenham. Solidity and consonance of composition characterize his work in comparison to Monet's search for "fugitive effects" in light and water.

The fall of the Paris Commune and the end of war in 1871 allowed Pissarro and his family to return to Louveciennes. What they saw when they got there horrified them. The Prussians had commandeered their house and used it as a butchery. Of the 1,500 paintings the artist had stored there, only about forty remained; the rest had been ripped from their stretchers and placed on the ground for the soldiers to walk on. Pissarro found the abused canvases discarded on the compost heap. Undeterred, Pissarro carried on painting as prodigiously as before. In November their second son, Georges, was born. In 1872 they moved back to Pontoise where they remained until 1882. Cézanne, invited by Pissarro to continue his landscape studies in Pontoise, arrived in the winter of 1872 with his companion Hortense Figuet and their son Paul. They took up residence in a local hotel, later moving to nearby Auvers-sur-Oise. Cézanne's House of the Hanged Man at Auvers (La Maison du pendu à Auvers) from this period is greatly influenced by Pissaro.

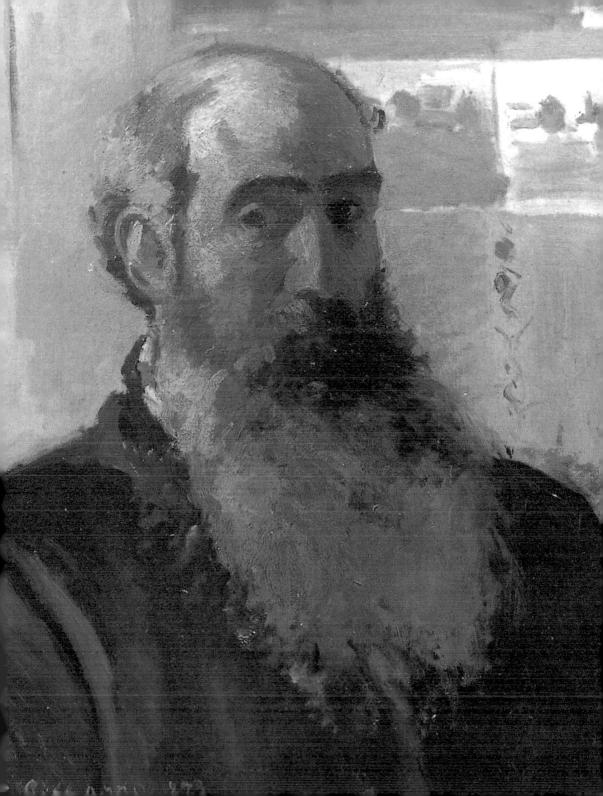

Above PISSARRO

Red Roofs
Oil on canvas
1877. 54.5 x 65.5cm
A cluster of houses at the bottom
of the Côtes des Boeufs, very
near Pissarro's house.

Opposite PISSARRO

La Côte des Boeufs at the Hermitage, near Pontoise Oil on canvas 1877. 115 x 87.5cm A similar view of the houses seen through the trees.

Pissarro's fortunes were temporarily looking up. Auctions in Paris were fetching high prices, whilst the influential, sympathetic and extremely wealthy and iournalist art critic Théodore Duret, the Comte de Brie, was beginning to champion the work of Pissarro and others in the group. The soonto-be-named Impressionists, including Pissarro, were thrashing out the details of the new Société anonyme that they

were about to form in order to launch their first exhibition. Pissarro was deeply involved in organizing the new venture, foreseeing a sort of cooperative or collective bizarrely based on the principles of the Pontoise bakers' union and the Association des artistes, peintres d'histoire et de genre, etc which he had joined thirteen years before. Renoir, Monet and the rest of the group found the complexities of Pissaro's plan too much

and eventually a joint stock company was founded with the fifteen artists as equal shareholders. Further tension was created by Pissarro insisting on Cézanne and Guillaumin joining the Société's exhibition but Pissarro had his way. Duret was against the whole idea of an independent exhibition and urged Pissarro to follow Manet's example and stick to the Salon. This Pissarro ignored and thus remained faithful to the concept of the Impressionist exhibitions; he went on to contribute to all eight.

April 1874 was an eventful, albeit traumatic month for Pissarro. In the Impressionists' first exhibition Pissarro's innovative landscapes were condemned along with the others. When the exhibition closed Pissarro was forced to appeal to Piette for help. Following his critical failure Pissarro's nine-year-old daughter, Jeanne, died the same month.

Pissarro was now almost forty-five years old. Fifteen years later in 1890 he wrote a letter to his niece, Esther Isaacson, summing up his career thus far: "I began to understand my feelings and know what I wanted in my forties - but only vaguely; at the age of fifty, in 1880, I conceived an idea of [artistic] unity without being able to render it; at sixty I am now beginning to see the possibility of rendering it." Pissarro's career was indeed a long and arduous search for the perfect method of expressing himself and his ideas. Until his sixty-second year when Durand-Ruel held a hugely successful retrospective of his work he was permanently in dire straits as his family continued to grow. Yet despite these pressures, he never begrudged anyone advice and encouragement. Younger painters, beginning Cézanne in 1872, Gauguin in 1877, and later Matisse and Picabia sought him Cézanne revered him, saying he was like a father to him, "un peu comme le bon Dieu" ("a little like the good Lord"). Mary Cassatt thought he was such a good teacher he could have taught the stones to draw.

By the time of the last Impressionist exhibition 1886 the great teacher was himself in an artistic crisis. The intervening years had seen him contribute to every Impressionist show and often cajole the other members of the group into accepting the works of vounger artists such Gauguin. He had been helped along by commissions from the successful patissier Eugène Murer, who had also bought a hotel room for him in Rouen where he spent considerable periods painting the cityscape. A printing partnership with Degas and Mary Cassatt had been successful, Durand-Ruel had supported him when and as he could, and so he had managed to get by. In 1884 the Pissarro family had moved to Eragny where they eventually bought the same house they had

PISSARRO

The Seamstress
Pastel on canvas
1881. 25 x 20cm
In this small study, Pissarro depicts
the humble life of a peasant woman
in the peace of her home.

CAMILLE PISSARRO

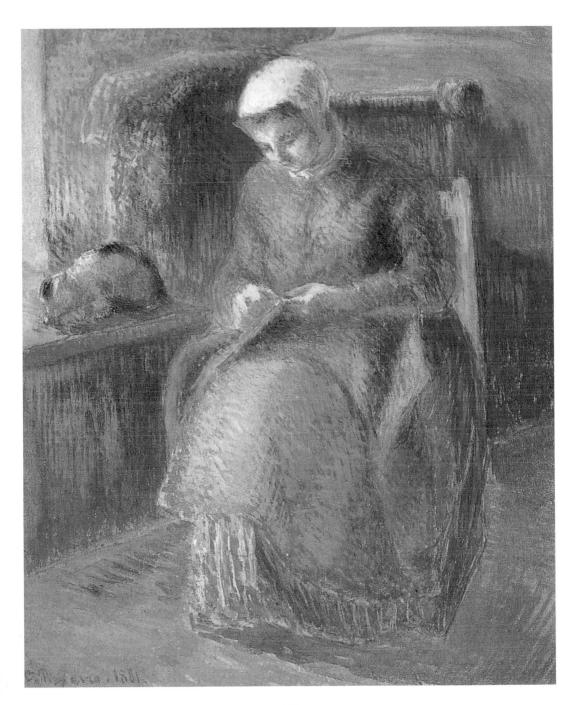

leased (with the aid of a loan from Monet which Pissarro scrupulously repaid). Meanwhile Pissarro's interest in the human figure, especially the peasant women who were so much a part of the landscape, had come to dominate his work as a fundamental expression of his humanism. As Ralph Shikes observes:

Often he paints the grubby kitchen gardens, quite understandably paintings of little appeal to a self-conscious middle class. His agricultural workers – members of the peasant family or day labourers – carry buckets of water, herd the cows, feed the chickens. They are mostly women performing lowly chores. They are not heroic figures, but simple humanity observed in the cadenced rhythm of the seasons . . . as they perform their [daily] tasks.

But the method of expressing all this had become problematical. The web of comma-like brushstrokes which had now become his trademark seemed to have reached its logical conclusion and he was casting about for new ways of painting. A harder edge was called for. Impressionism seemed to have had its day; Renoir for example had recently found himself in a similar stylistic dead-end and was developing an overtly linear, Neo-Classical style; years before, Cézanne had abandoned a softer vision of the world and was absorbed in lines, volumes and planes.

Opposite PISSARRO Haymakers, Evening Oil on canvas

While retaining his familiar subject matter, which Seurat had also treated in small studies, Pissarro is now adapting Pointillism to his own style, and the woman in the foreground has lost the soft and natural posture of his earlier figures.

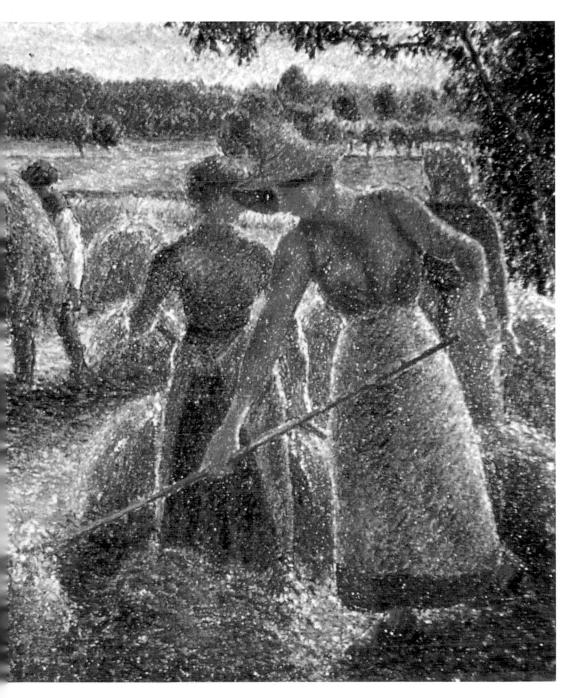

PISSARRO

Landscape at Eragny
Oil on canvas
1895. 60 x 73.5cm
Another example of Pissarro's late
Pointillism. This is an afterthought –
he had renounced the technique a
few years earlier, and it has none
of the dogmatic coldness seen in
Seurat's work.

In October Pissarro met the young Georges Seurat who was developing a new technique, Divisionism, based on several theories going back to Chevreul. Pissarro too had read the new colour theories proposed by the American colour theorists Charles Henry and Ogden Rood, and with Paul Signac he common cause in found Seurat's juxtaposition of small dots of pure pigment to create the forms of a painting. "I am totally convinced of the progressive nature of this art," he wrote to Lucien, "and certain that in time it will vield extraordinary results. I do not accept the snobbish judgments of romantic Impressionists in whose interest it is to fight against new tendencies. I accept the challenge, that's all."

At the age of fifty-five Pissarro became a Neo-Impressionist; his anarchism had also become more fervent. Writing later to Lucien, he said: "I firmly believe that our anarchist philosophy is linked to our work and therefore disagreeable to current thought." Signac and Seurat were also sympathetic to the aims of anarchism, although it is difficult to see any concrete link between these amorphous aims and their work. In any case Pissarro's Neo-Impressionism was to last barely five years, and was resisted on the one hand by Durand-Ruel who refused to buy his Divisionist works and on the other by Impressionists who were loath to exhibit in the company of Divisionists.

CAMILLE PISSARRO

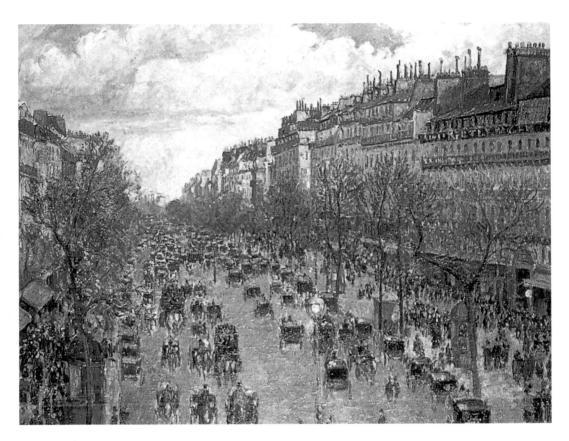

Nevertheless Pissarro secured what amounted to a separate Divisionist Room in the final Impressionist exhibition of 1886, where he, his son Lucien, Signac, and Seurat showed work which attracted both acclaim and horror.

The tedious physical process of painting in what was variously called the Neo-Impressionist, Pointillist, or Divisionist technique of dots took its toll on Pissarro and reduced the number of canvases (normally high) which he could finish. In May 1889 his mother died at the age

of ninety-four. The same year Pissarro began to suffer from an eve infection, forcing him to work indoors, but not inhibiting his flow of work. He abandoned the limitations of Divisionism the next year and began a phase of painting urban and quayside landscapes in Paris, Rouen, Le Hâvre, and Dieppe, as well as in London. The years between 1889 and 1900 were perhaps the most productive of his life; in 1896 he was earning sufficient sums to begin paying back the money he had borrowed from Monet.

PISSARRO

Boulevard Montmarte, Paris
Oil on canvas
1897. 72 x 91cm
Dissatisfied with Pointillism,
Pissarro looked instead for a
different kind of subject and
produced many cityscapes in his
later years, most of them seen from
windows of rooms high up above
Paris, Rouen and Dieppe.

Truly anarchic to the end. Pissarro became more committed to the cause as he approached his seventies. Back in the days of the Café Guerbois he had once suggested burning down the Louvre; now, in 1894, his anarchist sympathies forced him to spend four months in Knocke, Belgium after the knifing to death of President Sadi Carnot by an Italian anarchist During the Drevfus Affair. which practically tore fin de siècle France apart, he came out staunchly on Zola's side and against the entrenched anti-Semitism of the French military which had clumsily framed an innocent lewish captain-of-theguard and led to his exile and imprisonment.

Camille Pissarro died in Paris on 13th November 1903 of blood poisoning caused by an abscess of the prostate: his homeopathic doctor attempted to cure it without operation. His last years were marked by international honour and widespread public acclaim. Of all the Impressionists he was perhaps the best loved and respected by friends, fellow artists, and protégés. After Pissarro's death Gauguin said of him, despite the severe criticism he had received from Pissarro: "Ce fut an de mes maîtres. Je ne le renie pas." ("He was one of my masters. I cannot renounce him.")

Opposite PISSARRO

Boulevard Montmarte by Night Oil on canvas 1897. 53.5 x 65cm
Both this and the previous picture were painted from the Hôtel de Ruisse, at the corner of the boulevard des Italiens and of the rue Drouot in Paris, an area familiar to the Impressionist group. The night view presented a challenge which seems to have stimulated the artist, and Pissarro gave life to the flicker of street lights and to the reflection of the rain on the pavement in a decidedly Impressionistic vay.

masset

DOUARD MANET WAS the figurehead of a generation of artists who saw him as a champion of experimental and non-conformist art. As a friend of Baudelaire, he was at the very forefront of the artistic avant-garde, yet he remained personally conservative and eager to please. It was his ability to create something new from the most conventional of subjects that ensured his continuing fame as well as a deeply felt ambivalence amongst his critics, who until recently have expressed contradictory views that he was both a genius and lacking in imagination. His achievements lay in the unrivalled originality with which he portrayed the Paris of his day, as epitomized in the *Bar at the Folies-Bergère*.

Above
EDOUARD MANET
By Fantin-Latour
1867

Opposite
MANET
The Walk
Oil on canvas
1880, 92.5 x 70.5cm

Life and Works: Edouard Manet (1832–1883)

... a revolutionary painter who loved society and had always dreamt of the success only Paris can offer – the flattery of the ladies, the warm embrace of their salons, a life of luxury hurtling through admiring crowds.

EMILE ZOLA

Edouard Manet was born in Paris on 23rd January 1832, the oldest son of August Manet, Head of Personnel at the French Ministry of Justice, and Eugénie Désirée Fournier, a diplomat's daughter.

Manet could have become a successful lawyer, which is what his father had in mind for him, but it was perhaps the influence of his artistic mother Eugénie and his uncle Edmond Fournier, a great connoisseur of art, that quashed the idea early on. From the age of fifteen Manet and his friend at the exclusive Collège Rollin, Antonin Proust, received special drawing lessons and were taken on instructive tours of the Paris museums by Edmond Fournier. At sixteen Manet rebelled against his father's wish to enter him in the Faculty of Law, declared his desire to be an artist, forced a compromise with his father (it was more of a ruse than anything) and joined the Navy. He failed the Naval entrance examinations but set sail nonetheless on 9th December 1848 at the age of sixteen as an officer cadet on the ship Le Hâvre et Guadeloupe bound for Rio de Janeiro.

On his return to France the

next year Manet failed the Naval examinations once again and finally swayed his father to his artistic ambitions. The baggage Manet brought back from the Americas was crammed with drawings to prove his vocation.

In the Paris of the 1850s there were several independent ateliers where a budding artist could study, and Manet chose one of the most celebrated, that of Thomas Couture in de Laval (now the rue Victor-Massé). Couture had beguiled the Salon of 1847 with his epic painting The Romans of the Decadence and was famous both as a painter and as a teacher. Manet remained at Couture's from 1850 to 1856, studying the master's teaching, copying (amongst other things a Velazquez) at the Louvre and occasionally causing trouble in the atelier, as Antonin Proust remembered: "On Mondays, the day when a pose was to be struck for the rest of the week, Manet would invariably fight with Couture's models . . . Mounting the podium they would assume their traditional and exaggerated poses. 'Are you incapable of being natural?' Manet would cry, 'Is that how you stand when

MANET

The Parents of the Artist Oil on canvas 1860. 110 x 90cm
The austere M.Manet does not look like the sort of father a son could confide in about his illegitimate offspring. Manet never told his father about Léon, born to his twenty-year-old piano teacher Suzanne Leenhoff, and only married her after his father's death.

you're buying a bundle of radish at the greengrocer's?" " Proust described another incident which sheds some light on Manet's developing wit and his relationship with Couture: "One day Manet had managed to make Gilbert (a model) assume a natural pose, half dressed. Couture walked into the atelier and threw a fit in front of the clothed model. 'So vou pay Gilbert to keep his clothes on? Who is responsible for this stupidity?' 'I am,' said Manet. 'Come now, my poor boy,' said Couture, 'you will never be anything but the Daumier of vour time.' "Later Manet is supposed to have told Antonin, "The Daumier of my time! At least that would be better than being the Coypel of it." (Covpel was not a fashionable painter at that time.)

Despite these frivolities Manet was greatly indebted to Couture, an opponent of the all-pervading academic style and its constrictions. Couture's advice to his students was: "Make sure first of all that you have mastered material procedures; then think of nothing and produce with a fresh mind and hearty spirit whatever you feel like doing." This was exactly what Manet was to do, building on a complete mastery of technique and a deep appreciation of the old masters in order to make his revolutionary (or evolutionary) mark. A foretaste of what was to come is supplied by Antonin Proust, who remembered Manet drawing a picture

MANET
The Absinthe Drinker
Oil on canvas
1859. 117.5 x 103cm

Absinthe had far too bad a reputation to be an acceptable subject for the Salon. Manet found his low-life models in the Batignolles area where he lived. The model here is the rappicker Colardet.

in 1851 which showed the identification of bodies in the Montmartre cemetery, victims of the December coup d'état by Louis Napoleon. Manet was already a fierce republican; he had written to his father from Rio de Janeiro: "Try to keep a good republic for us against our return; I'm afraid Louis Napoleon is not a very good republican." How right he was; the corpses in Montmartre proved that Manet's fears for the Second Republic were well founded - it had lasted barely two years after his return from South America.

In January 1852 a son, Léon, was born to Suzanne Leenhoff, Manet's twentyvear-old piano teacher with whom he had been having an affair since 1850. Eugénie Manet knew of the illegitimate birth, but she and Manet conspired to keep this from the austere and conservative Auguste Manet, passing the child off as Suzanne's brother and Manet's godson, even after Suzanne and Manet's marriage. Manet's strict adherence to form held sway, as it would in other matters, and Suzanne, like so many other mistresses, companions, and courtesans, was set up in an apartment to keep her out of harm's way until it was safe for her to emerge into society.

Manet left Couture's atelier around Easter 1856 and moved into a studio in the rue Lavoisier with another painter,

Albert de Balleroy. He then made a tour of Holland. Germany, Austria, and Italy ending in Venice, visiting museums and studying the old masters. In 1859 Manet made first submission, Absinthe Drinker (L'Absinthe) to the Salon. It was summarily rejected on several counts, notably those of immorality and vulgarity; only Delacroix voted for it. The next year Manet made the acquaintance of the poet and art critic Charles Baudelaire, eleven years his senior, who had published his masterpiece, a collection of poems called Les Fleurs du mal (The Flowers of Evil) in 1857. The poems had caused outrage and several were banned. Flaubert's Madame Bovary had suffered a similar fate in 1856. The early years of Louis Napoleon's reign were difficult ones for literature and the avant-garde, of which Manet was rapidly becoming an important if somewhat reluctant member. He was now moving in two social milieux; upper middle-class salon society and the Bohemian demimonde of Baudelaire and his friends where revolutionary new ideas were inspired and thrashed out. Baudelaire, with whom Manet became very close, died in agony of the effects of aphasia and syphilis in 1867. His anguished romanticism can be heard in these lines from Les Fleurs du mal:

 Ô douleur! ô douleur!
 Le Temps mange la vie,
 Et l'obscur Ennemi qui nous ronge le coeur
 Du sang que noes perdons crôit et se fortifie!

 O agony, agony! Time cats away at life,
 And the obscure Foe which gnaws on our hearts
 Grows ever stronger on the blood we lose! Manet's close friendship with Baudelaire inspired his art in other ways, however It is noticeable that after *The Absinthe Drinker*, and Manet's encounter with the extraordinarily decadent Baudelaire, the artist avoided further images of rank dissolution. The less decadent side of Baudelaire, his penetrating art criticism and demand for an urban "painter of modern life" was of more interest,

MANET

The Old Musician
Oil on canvas
1862. 187.5 x 248.5cm
This large scale painting shows the
roused figure of The Absinthe
Drinker, standing on the right, and the
gypsy Jean Lagrène in the centre as the
old man. The composition has a stillness
typical of many of Manet's works.
All the people are poor, but Manet
does not depict them in a romantic or
sentimental manner but rather displays
a detachment from his subjects which
later brought accusations of coldness
and impersonality.

in fact, to Manet than the last torments of a dying genius.

Manet's early interest in politics did not abate and he remained keenly aware of current events throughout his life. In June 1864 he went to the port of Cherbourg to witness a bizarre incident of the American Civil War playing itself out. A corvette of the Union Navy, the Kearsarge, was attacking and pursuing a Confederate privateer, the Alabama, which had been detained in the French docks. Manet painted a gripping picture of the scene. Three years later he painted the first version of The Execution of the Emperor Maximilian. The painting was banned as being too sensitive a political subject for exhibition at Manet's pavilion in the place d'Alma during the 1867 Exposition Universelle. Indeed, from the scandal of Luncheon on the Grass at the Salon des Refusés of 1863 onwards Manet was constantly (and it must be said unwillingly) at odds with the authorities, both artistic and political. Manet's subject matter was at the forefront of modernity and strained the limits of the acceptable. He had side-stepped the social realism of Proudhon and Courbet and worked initially under the aesthetic veil of *l'art* pour l'art (Art for Art's Sake), as exemplified in its most frivolous literary form by these two stanzas from a poem by Théophile Gautier.

Opposite

MANET

Maximilian
Oil on canvas
1867. 195 x 259cm
In this advanced study, the firing
squad is wearing Mexican outfits
and the faces of the victims are
featureless. The news of the execution
had just reached Paris and to Manet
the incident illustrated all too well the
the bankruptcy of Napoleon III's
regime.

The Execution of the Emperor

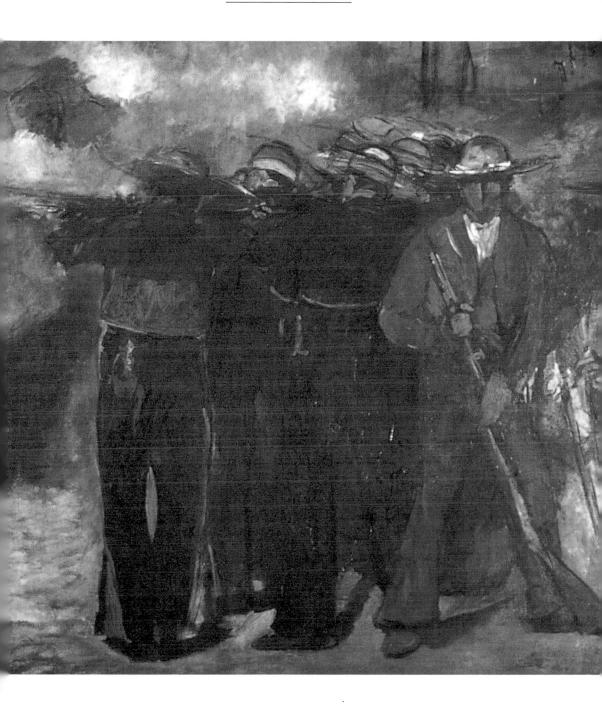

Que tu me plais dans cette robe Qui te déshabille si bien, Faisant jaillir ta gorge en globe, Montrant tout nu ton bras païen! Frêle comme une aile d'abeille, Frais comme un coeur de rose-thé Son tissu, caresse vermeille, Voltige autour de ta beauté.

How you please me in this dress
Which undresses you so well,
Letting your breast burst forth,
Showing quite nude your
pagan arm!
Fragile as a bee's wing,
Fresh as the heart of a tea-rose,
Its tissue, a vermillion caress,
Flutters about your
beautiousness.

A une robe rose (To a Pink Dress)

FROM EMAUX ET CAMÉES, 1852

Apart from its concision brevity was becoming Manet's own stylistic watchword - and its eroticism, A une robe rose also gives a taste of just how small the Bohemian world of Paris was; the poem is dedicated to Apollonie Sabatier, delectable courtesane, and the Présidente of the infamous Club des Hashishins frequented by Baudelaire and Gautier, an object herself of extreme (and unrequited) passion from Baudelaire who immortalized her in a cycle of poems within Les Fleurs du mal (She was also given permanent fame in other ways; the sculptor Clésinger made a cast of her body and then modelled it in marble

to the delight of the 1847 Salon.)

The influence of Baudelaire's ideas in the early part of Manet's career can be seen in his painting, Music in the Tuileries Gardens, which answers the call for a painting of modern life by doing just that; depicting the bourgeoisie outdoors on a summer's day together with a smattering of Bohemians. Baudelaire and Gautier are among the strollers.

By 1865 Olympia turned the art world upside down, and Manet was the focus of the younger artists' admiration. In that year he began to frequent the Café Guerbois, where contempoaccounts testify Manet's sang-froid and incisive wit in the midst of his colleagues Bazille, Whistler, Nadar, Astruc, Renoir, occasionally Degas, Monet, Cézanne, and Pissarro. But his personality and his aims (if he had any other than simply to paint as well as he could) remain unclear. He was full of disingenuous advice to younger painters along the lines of "paint what you see as soon as you see it," but his technique was in a class of its own. Few artists could wield a brush with as much nervous energy and accuracy as Manet; few artists (apart from Degas) would dare to choose the subjects he did; few artists had the thorough grounding of five years at Couture's and countless hours

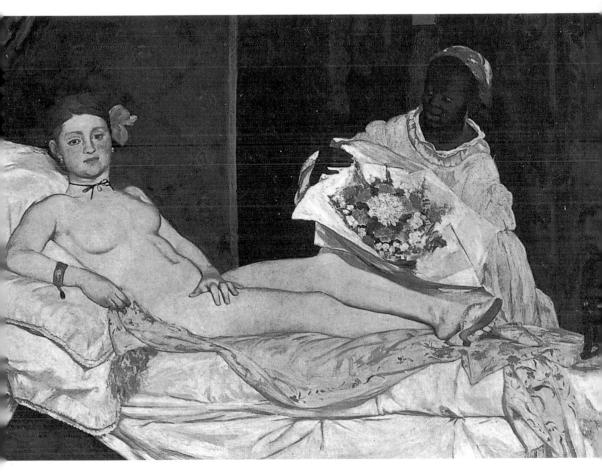

copying in the great museums of Europe; few artists had the leisure to paint (his father had left him a more than generous inheritance); ultimately few of his contemporaries (except Degas again) had the ineffable, ambiguous sense of a picture that Manet had. He was modest in triumph, self-effacing in defeat and did not have the inclination of a Pissarro to teach. What went through his mind is difficult to discern.

MANET

Olympia
Oil on canvas
1863. 130.5 x 190cm
The older Courbet was critical of
Olympia: "She looks like a Queen of
Spades on a playing-card; not enough
modelling." Manet himself declared
"There is only one important thing: put
down what you see the first time. If that's
it, that's it." Manet painted with the light
in his studios falling from behind him,
which flattened the volumes of the figures
in the painting and brought the artist
violent criticism.

However we do know that in some respects Manet was highly sensitive. In 1860 he moved his studio to the rue Victoire after the young boy who cleaned the brushes for him, the subject of Child with Cherries (L'Enfant aux cerises), hanged himself in the atelier, sending Manet into depression. The artist had threatened to send the boy back to his parents. In the next two or three years as Manet's personal fame and ability to create scandal increased he found himself the subject of an irritable reprimand from Baudelaire. The poet had supported him lovally through the Luncheon on the Grass episode in 1863, but when the Olympia scandal erupted in 1865, Manet was at the end of his tether, desolated by the unheard of ferocity of the critics towards him. The year before Baudelaire had drawn the artist's attention to the fact that Christ's Tomb depicted the Saviour's spear wound on the wrong side of his body. He wrote to Manet: "You will have to change the position of the wound before the the exhibition opens. And don't give those spiteful people a chance to laugh at you." During the Olympia scandal Manet wrote to Baudelaire in despair:

I wish you were here my dear Baudelaire; they are raining insults on my head . . . I should have liked your sane verdict on my pictures, for all these cries have set me on edge . . . something must be wrong . . .

Opposite MANET

Madame Manet at the Piano Oil on canvas c.1868. 38 x 46.5cm Mme Manet was an accomplished pianist and the couple often organized musical evenings with their friends. Now a bourgeoise, officially respectable since her wedding, she accepted her huband's passing affairs.

EDOUARD MANET

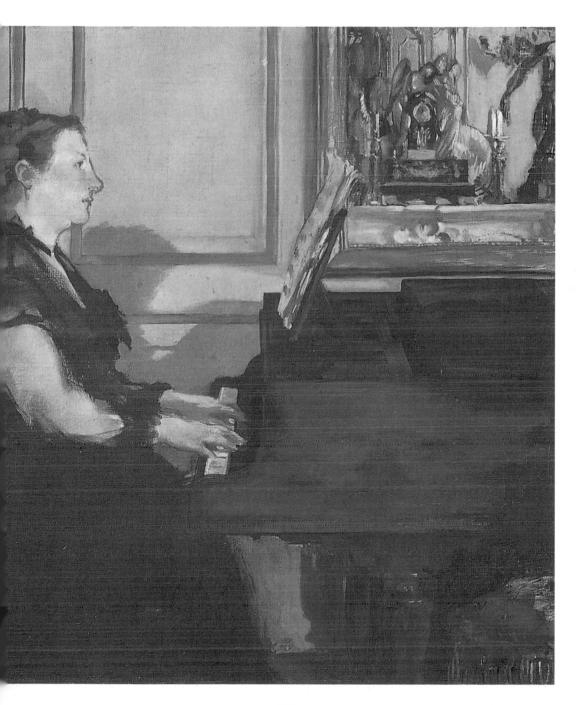

THE LIFE AND WORKS

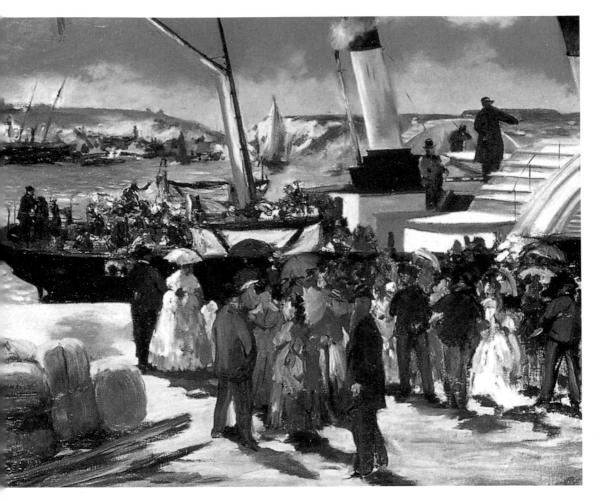

MANET

The Folkestone Boat, Boulogne Oil on canvas 1869. 60 x 73cm

Manet spent the summer in Boulogne with Degas, and painted six landscapes, the only ones he executed outside Paris in the 1860s. The scene shows passengers about to cross the English Channel.

EDOUARD MANET

MANET

Madame Manet and Hor Son Léon at Arcachon Watercolour 1871

A sketch of peaceful domesticity, the soothing atmosphere Manet needed to restore his spirits. The crushing of the Commune had been merciless and bloody, and most people in Paris were affected by these tragic events.

Baudelaire's withering rejoinder reads:

"I am afraid I am again forced to speak to you about yourself. I shall have to apply myself to demonstrating to you just what your value is. What you ask is quite ridiculous. People are making fun of you, you say; their jokes set you on edge, etc. etc . . . Do you think you are the first man who has ever been in this position? Are you more of a genius than Chateaubriand or Wagner? Have people made fun of them, I wonder? They have not died of it. And in order not to inflate you with too much pride, I would add that these men are models, each in his own field, in a rich world, and that you, you are simply the foremost in the decrepitude of your art. I do hope you won't take this amiss. You know how dear you are to me. I wanted to have M. Chorner's personal impression [of Olympia and Christ Mocked, at least insofar as a Belgian can be considered a person . . . What he said tallies with what several intelligent men have said about you: 'There are faults, weaknesses, a lack of aplomb, but there is an irresistible charm.' I know all this, I was the first to understand it. He added that the picture of the nude, the Negress and the cat (is it really a cat?) was far superior to the religious picture."

Opposite

MANET

Couple Boating
Oil on canvas
c.1874. 97 x 130cm

The man is Manet's brother-in-law
Rodolphe Leenhoff, wearing the outfit
of a fashionable sailing club.

Manet showed the painting at the
Salon of 1879.

EDOUARD MANET

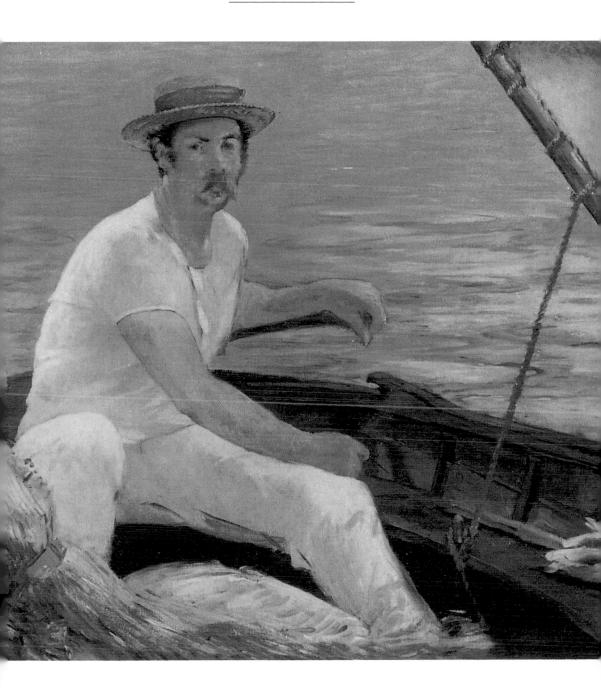

MANET

The River at Argenteuil
Oil on canvas
1874. 61 x 100cm
Manet was much less interested in the effects of light than Monet and Renoir. Manet's brushwork is smoother and more controlled than the other two artists'.

Opposite MANET

Nana
Oil on canvas
1877. 150 x 116cm
Nana did not scandalize the public
as much as Olympia had previously,
but the painting was also refused by
the jury of the Salon, for much the
same reasons. The model was the
actress Henriette Hauser, mistress of
the Prince of Orange.

Manet's technique, as poor M. Chorner observed, and Baudelaire knew, was the least of his worries. Since his years at Couture, when he would draw objects perfectly but upside down for fun, he had developed peinture claire, described by the art historian Bernard Denvir as:

A method of painting . . . which creates a high-key colour configuration by first applying loose-flowing and *grasse*, or fat, pigment onto the canvas, and then, whilst the paint is still wet, adding the half-tones and darker passages . . . the reverse of the accepted Academic process. The resulting effect is one of sparkle and vitality.

The problem for contemporary critics was that he had applied this bold and innovative technique to a fundamental reinterpretation of some of the icons of western art. By reinventing the nude in Luncheon on the Grass and Olympia, with explicit reference to past masters, he had appeared to rupture a series of seemingly inviolable traditions. To the budding Impressionists he was an iconoclast; to his own mind he was simply carrying on in the tradition he was falsely accused of breaking.

EDOUARD MANET

Above MANET Study for the Beer Waitress Oil on canvas 1878–79. 77.5 x 65cm The model is a waitress Manet knew, but she would only pose in the presence of her boyfriend, who is seated. In this study the woman is also aware of an external presence, and looks at us.

Opposite MANET

The Beer Waitress
Oil on canvas
1878–79. 97 x 77.5cm
Manet has enlarged the composition
to place the two sitters in a wider
environment and we can see more of
the performer on stage. The setting
was the cabaret Reichshoffen, on the
boulevard de Rochechouart but the
painting was done in Manet's studio.

By the age of thirty-eight, and the outbreak of the Franco-Prussian War in 1870, Manet had painted several masterpieces and as Zola had said in 1866 in L'Evènement: "Our fathers laughed at M. Courbet so we went into raptures over his work. Now it is we who laugh at M. Manet and it is our children who will be in raptures at his canvases." Manet was now probably the most famous (and infamous) artist of his day, but by the end of the Commune his nerves were shattered and he went to Boulogne in August 1871 to recover. Despite his ubiquitous fame he had sold very few paintings in the 1860s. This was scarcely a problem financially, but his self-esteem demanded buyers for his work, and success at the Salon. Durand-Ruel, the saviour of Monet, Pissarro, Renoir, and Sisley now stepped in and (with as great foresight as ever) bought 50,000 francs worth of paintings. Manet refused, however, to part with Music in the Tuileries, Luncheon on the Grass, Olympia, and The Execution of Maximilian, which Durand-Ruel had valued together at a total of 76,000 francs, an astronomical sum. Olympia was eventually purchased for the French nation by a subscription organized by Monet in 1890, seven years after Manet's death. For seventeen vears the Louvre refused to hang the picture until Monet sought the aid of Président Clemenceau in 1907 and had it transferred from the Musée de Luxembourg to the Louvre – the whiff of scandal lingered around the painting for decades.

In December 1874 Manet's close friend Berthe Morisot married his brother Eugène. Thereafter there were no more languorous paintings of her pictured as she is in The Balcony (Le Balcon) or The Sofa. Whatever their relationship had been before - it had certainly been intense - she sat for him no more. In 1876 Manet met Méry Laurent, on whom Marcel Proust's character Odette Swann was based, a formidable courtesan and the lover of the poet Stéphane Mallarmé. It is possible that Manet had an affair with her: certainly they were devoted to one another in the last years of his life and she is the subject of his last work. The Symbolist poet Mallarmé and Manet had become friends in 1873 and developed a close and constant friendship to rival that with the late Baudelaire. Mallarmé was far removed from the decadence of Baudelaire (who was forced to borrow money from Manet and still owed him 500 francs when he died). He held salons on Tuesday nights crammed with the literary and artistic lions of his day, including Manet and the Impressionists. Manet's association with Mallarmé resulted in illustrations for the poet's translation of Edgar Allan

EDOUARD MANET

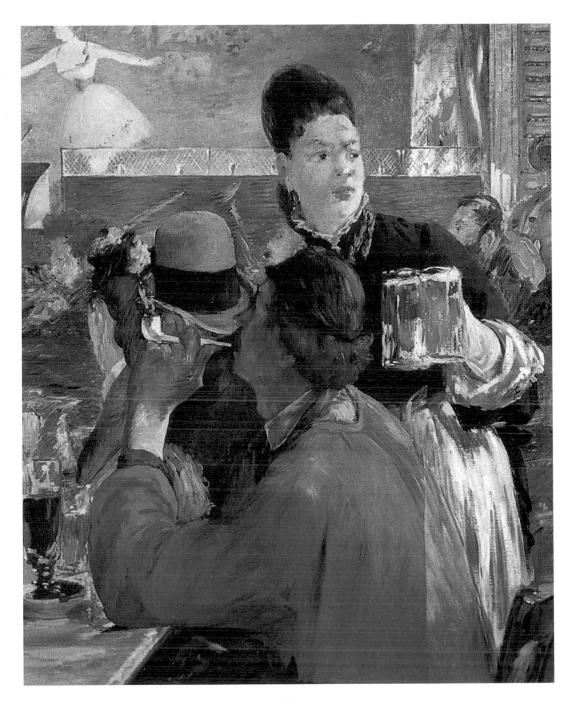

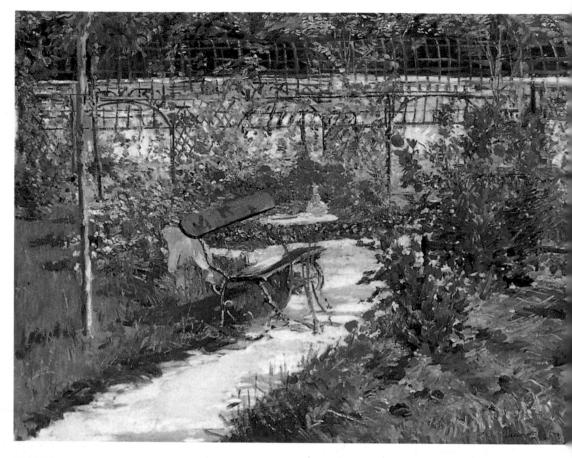

MANET

The Artist's Garden
Oil on canvas
1881. 65 x 81cm
In bad health, Manet rented a villa in
Versailles during the summer of 1881,
intending to paint the classical gardens
of the castle, but was not able to fulfil
his project.

Poe's *The Raven* as well as a remarkable portrait of Mallarmé showing the increasing influence of his Impressionist friends. The summer he had spent with Monet and his family at Argenteuil in 1874 had released Manet's rather sombre style into a much more colourful, impressionistic idiom.

His paintings of Claude Monet, Camille, and Jean in the open air are some of the liveliest documents of the heyday of Impressionism. Manet's new-found interest in light and colour continued to produce sparkling canvases when he visited Venice in the following year of 1875.

MANET

At the Café-concert Oil on canvas 1879. 47 x 39cm

The young woman holding a cigarette and the man are like many characters of the time, not quite chic but relatively elegant. We also find an early example here of a reflection in a mirror, which was to be most strikingly exploited in the later Bar at the Folies-Bergère.

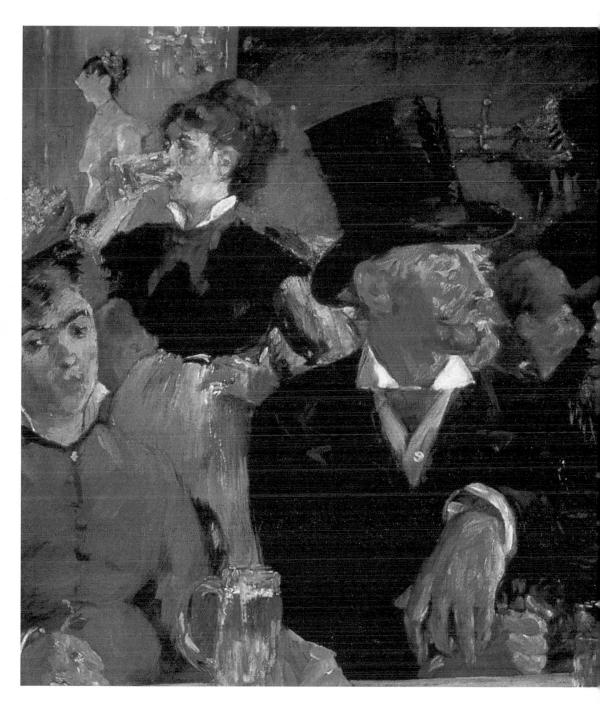

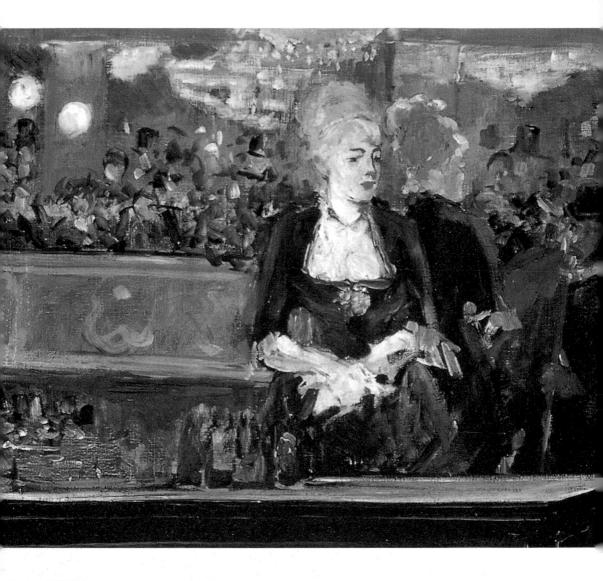

MANET

Study for Bar at the Folies-Bergère Oil on canvas

1881. 47 x 56cm

In this large sketch, nearly half the size of the finished work, the waitress is off centre, looking sideways and the mirror seems to be immediately behind her while the male customer is very small.

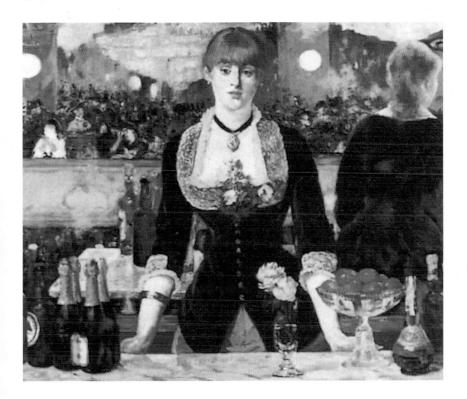

By the end of the 1880s Manet was beginning to feel the effects of the disease locomotor ataxia, which was to kill him before long. The official recognition he so strongly desired was still eluding him; yet he was still capable of causing a stir. In 1876 Nana had been rejected by the Salon on the grounds of impropriety and in 1881 he was damned with faint praise when the Salon awarded him a seconde médaille for his Portrait of Pertuiset. Finally his childhood friend Antonin Proust, who had

risen to the rank of Arts Minister, secured Manet the Légion d'Honneur. Although he was working flat out on his last masterpiece, the Bar at the Folies-Bergère, he was in much pain, finding it increasingly difficult to hold a paintbrush. On 6th April 1883 he could no longer walk and was confined to bed. Two weeks later his left leg was amputated to stop the spread of gangrene.

He died on 30th April and was buried in Passy cemetery on 3rd May.

MANET

Bar at the Folies-Bergère
Oil on canvas
1881–82. 96 x 130cm
In the finished painting, Manet
returns to his instinctive preferences
and the waitress is now facing us,
but seems to look right through us.
The foreground forms a beautiful
still life, but Manet was criticized
for his handling of the woman's
back and the customer reflected in
the mirror. It is indeed inaccurate,
but does it matter?

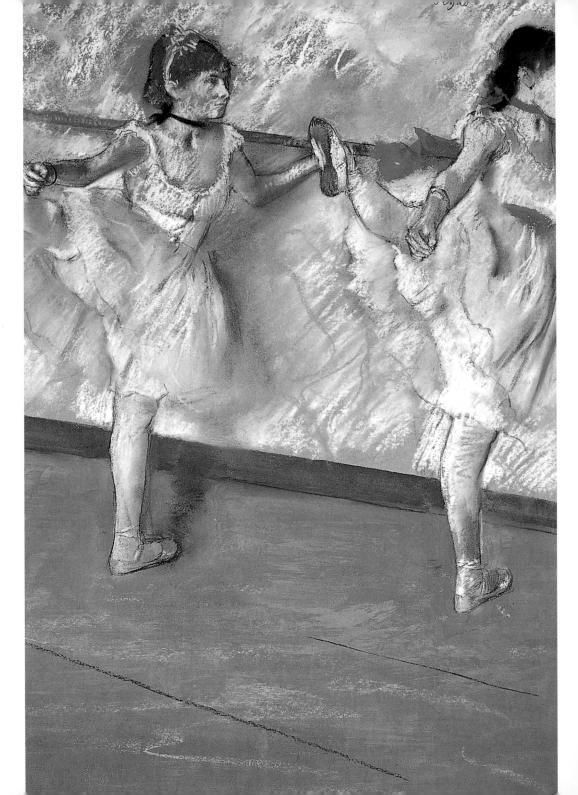

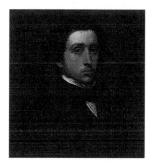

Dey as

N A FAMOUS STATEMENT, Edgar Degas likened his art to the perpetration of a crime; "make counterfeits," he said "and add a touch of nature." Degas never painted *en plein-air*, preferring to make sketches of his subjects and use whatever means at his disposal, including photography, to ensure the accuracy of his observation before working in the studio. Thus, until his later experiments with pastel and gouache, Degas had very little to do with the Impressionism of Monet, Renoir, or Manet. Despite his uncompromising refusal to espouse the style of his Impressionist colleagues, Degas was instrumental in the foundation of the *Société anonyme* and all the subsequent Impressionist exhibitions except one.

Above EDGAR DEGAS Self-portrait c.1855

Opposite
DEGAS
Dancers at the Barre
Pastel on paper
c.1877, 66 x 51cm

LIFE AND WORKS: EDGAR DEGAS (1834–1917)

A painting is a thing which requires as much trickery, malice, and vice as the perpetration of a crime; make counterfeits and add a touch of nature.

EDGAR DEGAS

Edgar Degas, like Manet, was born into the higher echelons of Parisian society; in fact he came into the world on 19th July 1834 above a branch of his family's Neapolitan bank in the rue Saint-Georges. But unlike Manet, Degas did not have to fight his parents to become an artist. Amongst the Degas' friends were several eminently wealthy art collectors and government officials who encouraged Edgar, already self-taught, by allowing him to study and copy their art treasures. The Valpincons, for example, owned Ingres' Odalisque au turban, a source of enduring delight and inspiration to the young Degas; and Achille Devéria, Keeper of the Cabinet d'Estampes, the Prints and Drawings Room at the Bibliothèque Nationale, allowed Edgar to peruse the collections and copy the works in them. By the time he was eighteen Degas had obtained permission to copy at the Louvre. In a comfortable family environment, free of untoward pressure, with a father devoted to him (his mother died when he was fifteen), Edgar Degas was able to indulge his talents with the help of the finest public and private collections in Paris.

In 1854 he was to visit wealthy uncles, aunts, and cousins in Naples and Florence where, as one biographer puts it, he undertook an orgy of museums and copying the old masters – Raphael, Mantegna, Bellini, Pollaiuolo, Botticelli, and Giotto. "Draw lines, young man, draw lines," Ingres is said to have advised his young devotee in 1855 when Edouard Valpinçon took Degas to visit the French master, and this he did, and continued to do.

By July 1856 Degas had finished his brief academic studies, having gained a place at the Ecole des Beaux-Arts the vear before, studying with a disciple of Ingres, Louis Lamothe. Degas' ability was by now considerable; deep immersion in old masters of every conceivable school, but particularly the Italians, was producing polished results. He then set off for an extended tour of Italy which lasted until April 1859, where he continued to devour the old masters and paint family portraits. In November 1858 Degas' father Auguste, having just received a packing case from his son, wrote to him in Florence with some pride:

I have unrolled your paintings and

INGRES

Odalisque
Oil on canvas
1826. 32 x 25cm
This is the purity of line that Degas admired. Friends of the Degas family had an Odalisque similar to this which fascinated and delighted the young Degas.

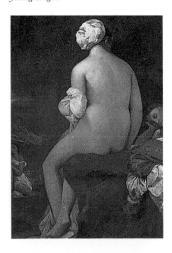

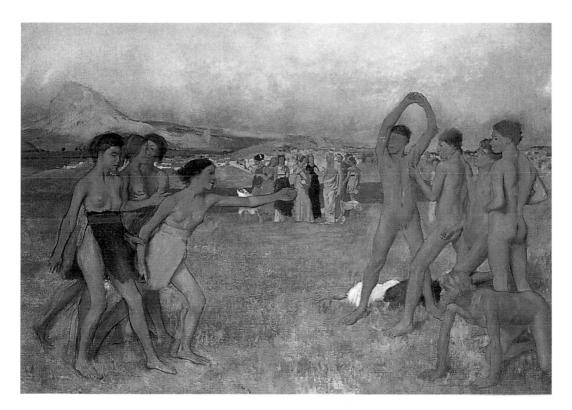

some of your drawings. I was very pleased, and I can tell you that you have taken a great step forward in your art; your drawing is strong, the colours are right. You have rid yourself of the weak, trivial, Flandrinian, Lamothian manner of drawing and that dull grev colour. My dear Edgar, you have no reason to go on tormenting yourself, you are on the right track . . . You have a great destiny ahead of you . . . Auguste Degas seems to have had the measure of his son's potential; the portraits, self-portraits, genre paintings, copies of frescos and old masters produced in Degas' youth bespoke a solid if somewhat unexciting future for the artist. The abundance of self-portraits at such an early age testifies to Degas' single-minded obsession not only with art, but with himself; he resolutely remained a bachelor for the rest of his life.

On his return to Paris, Degas continued his steady self-improvement by copying in the Louvre, gaining permission to do so by listing his friend Emile Levy as his fictitious master. That was where Edouard Manet first met him in 1862, interrupting him in the process of copying Velazquez's *Infanta Margarita* onto a copper plate. At this time Degas was trying to

DEGAS

Young Spartans
Oil on canvas
c.1860. 109 x 154.5cm
Degas was inspired by his reading of classical authors for this unusual subject. In contrast to more academic painters, he deliberately left out classical elements such as Greek buildings.

DEGAS

On the Cliff-top Pastel on paper c.1869. 30.5 x 45cm Although Degas was a virulent anti-plein-airiste he painted around a hundred landscapes in brief periods during the 1860s and the 1890s.

THE LIFE AND WORKS

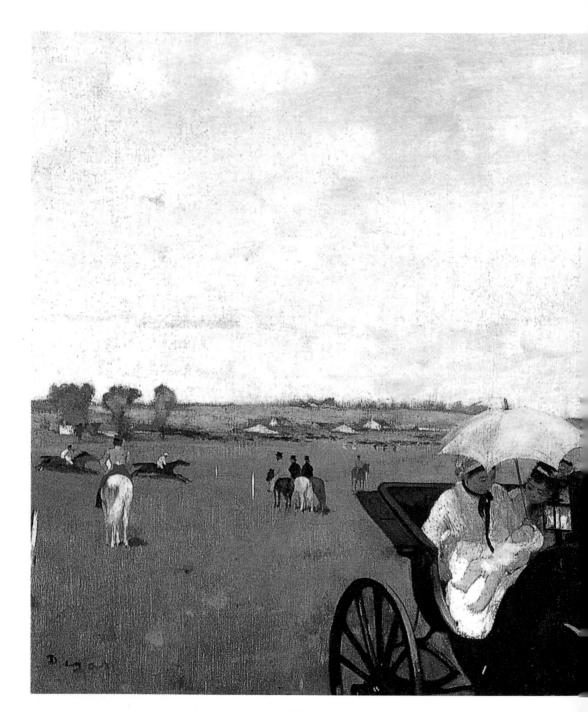

EDGAR DEGAS

DEGAS

Races in the Country
Oil on canvas
1869. 36.5 x 56cm
This is a portrait of Degas'
boyhood friend Paul Valpinçon,
with his wife leaning over the
nurse who holds their newborn
son. Degas did several portarits of
his family and friends and often
stayed with them in Normandy.

finish his first important history painting, Semiramis Building Babylon, and, with the usual friendly rivalry which marked their relationship, Manet was to jest a decade later in the Café de la Nouvelle-Athene that "Degas was painting Semiramis when I was painting modern Paris." Manet had certainly completed The Absinthe Drinker, Music in the Tuileries Gardens, and the epochal Luncheon on the Grass by this time and was practically reinventing art, as his critics saw it, but Degas, only two years vounger than Manet, was not far behind: The Gentleman's Race: Before the Start, with its highly original composition, dates from 1862.

The relationship between the two artists is described in several tantalizing anecdotes by their friends (and enemies), but remains clouded in a certain amount of mystery. We do know that they admired each other greatly and were in frequent contact; at one point in 1869, for example, Manet wrote to Degas asking for the return of two volumes of Baudelaire. One incident in particular tells us a great deal about their strange relationship. Between 1868 and 1869 Degas painted a double portrait of Manet with his wife, Suzanne, at the piano. It survives with a piece of canvas attached to the place where half of Mme Manet used to be before M. Manet slashed it off in a fit of pique. In 1924, with dubious accuracy, but with much wit, the dealer Ambroise

Vollard recounted the tale Degas had told him in this way:

Vollard: Who slashed that painting?

Degas: To think it was Manet who did that! He thought that something about Mme Manet wasn't right. Well, I'm going to try to restore Mme Manet, What a shock I had when I saw it at Manet's ... I left without saving goodbye, taking my picture with me. When I got home I took down a little still life he had given me. "Monsieur," I wrote, "I am returning your Plums."

Vollard: But you saw each other again afterwards?

Degas: How could you expect anyone to stay on bad terms with Manet?

By the early 1870s Degas had emerged from his deep and intensive involvement in the past and its forms and, following the example of Manet, he was beginning to apply himself to painting the world of modern Paris, in particular its people (and horses) in motion. Unlike the Impressionists with whom he was to be deeply involved, Degas had shown little interest in landscape. Vollard remembers him wryly pronouncing: "If I were the government, I would have a squad of gendarmes to keep an eve on those people painting landscapes from nature. Oh! I don't wish anyone dead. I would, however, agree to spraying them with a little bird-shot, for starters!"

Opposite: **DEGAS**

The Dancing Lesson Oil on canvas 1873-75. 85 x 75cm Degas' dance pictures are set in the old Opera House, which burnt down in 1873. He made numerous studies of the dancers, this one shows Ballet Master Jules Perrot addressing his pupils.

But his landscapes of the late 1860s are delicate, imaginary pastels which were done in the studio, whilst the monotypes of the 1890s are even more imaginary, appearing to be almost completely abstract.

The range of the subjects he tackled in the ensuing years is formidable: ballet dancers in rehearsal and before, during, and after performance; racehorses – before, during, and after the race; café-concerts and their singers in performance; the opera; acrobats; prostitutes; businessmen; milliners; a pedicurist, musicians; a billiard room. No nook or cranny of Paris in the 1870s and 1880s was immune from his fastidious gaze or his notebook. These notebooks, which have survived, allow us an important insight into the artist's mind. "Draw all kinds of everyday objects," reads a note from 1876, "placed, accompanied in such a way that they have in them the life of the man or woman - corsets which have just been removed, for example, and which retain the form of the body, etc. etc." Another note reads:

On bakery, *Bread* – series on baker's boys, seen in the cellar itself, or through the basement window from the street – backs the colour of pink flour – beautiful curves of dough . . . Studies in colour of the yellows, pinks, greys, whites of bread . . . 2 panels on birth – delicate mother, fashionable – food – large wet-nurse – large behind – enormous ribbons. Lilac coloured dress fluted like a pillar.

He had inherited both the dark and corrupting Paris of Baudelaire with its accursed denizens –

You who wander, stoic, without complaint,
Across the chaos of the living city,
Mothers with bleeding hearts,
courtesanes or saints,
Whose names in former times were on
the lips of all

(from Les Fleurs du Mal)

- and the sparkling life of la ville lumière, the only place he really felt at home, with its ordinary working people, with its everincreasing number of cafés, concerts, operas and ballets, stars and starlets.

Above all Degas was concerned with the female form: women dancing, women singing, women ironing, women before, during, and after the bath, women sleeping, combing and braiding their hair.

Degas has another comprehension of life, a different concern for exactitude before nature. There is certainly a woman there, but a certain kind of woman, *without the expression of a face*, without the wink of an eye, without the décor of the *toilette*, a woman reduced to the gesticulation of her limbs, to the appearance of her body, a woman considered as a female, expressed in her animality . . .

This is what the contemporary critic Gustave Geffroy thought of Degas' female subjects. It underlines the profound difference between Degas and Manet, who had presented the

Opposite DEGAS

The Absinthe Drinker
Oil on canvas
1875–76. 92 x 68cm
The sitters are the actress Ellen
Andrée and the painter Marcellin
Desboutin, both friends of Degas.
When Walter Crane saw it in 1893,
he said it was a study in human
degradation, male and female.

EDGAR DEGAS

THE LIFE AND WORKS

DEGAS

Edmond Duranty
Pastel and tempera on paper
1879. 101 x 100.5cm
Duranty was a wealthy literary and
art critic. Degas made three
preliminary drawings for this picture,
which was executed a year before
Duranty's death.

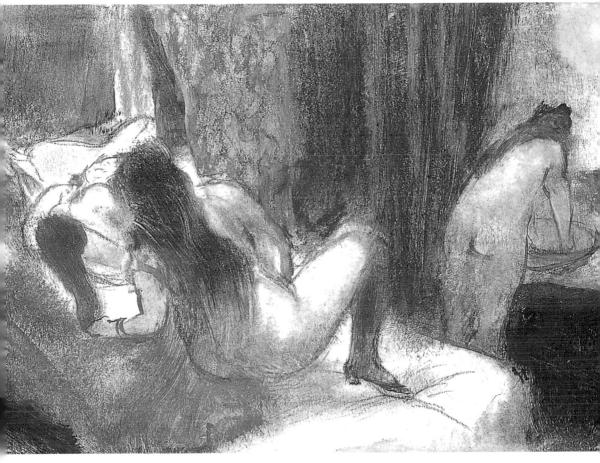

DEGAS

Brothel Inmates
Pastel/monotype
c.1879. 14 x 20.5cm
Degas did about fifty such works,
which have always puzzled his
admirers and critics as well as
scholars, who offer various
interpretations for this choice
of subject and the manner
in which it is treated.

Above DEGAS Study for Miss La La in the Cirque Fernando Patel on paper 1879. 61 x 48cm Degas attended performances at the circus in Fanuary 1879, and made several studies, of which this is the last.

Opposite

DEGAS

Miss La La in the Cirque Fernando Oil on canvas 1879. 117 x 77.5cm The cirque Fernando was located in Monmartre and later became the Medrano circus. Miss La La was renowned for the strength of her teeth.

female nude and the semidressed Nana as provocations to accepted notions of art. Similarly Degas' late nudes bear only a passing resemblance to Renoir's in their rotundity. Renoir depicts his women "with the expression of a face", and all that implies. Increasingly Degas' women at their toilette are, as the 1890s wear on, studies of line and colour; indeed the coloured line, possible with pastels, opened up new avenues for experimentation. As he put it to Sickert, "They [his contemporaries, the Impressionists] are all exploiting the possibilities of colour. And I am always begging them to exploit the possibilities of drawing. It is the richer field." And none could draw with the mastery, and ultimately the abandonment, of Degas.

Degas' sheer energy, his urge to capture fleeting movement in its countless nuances resulted in a prodigious series of paintings, pastels, monotypes, drawings and eventually wax sculpture. Apart from the portraits it is almost impossible to find a Degas where movement and action are not inherent, vet his method was the exact opposite of the Impressionists. He did not attempt to capture the moment in a quick stroke of the brush there is nothing impulsive about Degas. Everything is studied, planned and executed in the studio in controlled conditions - "I assure you no art is less spontaneous than mine. What I do is the result of reflection and study of the great masters. Of inspiration, spontaneity, temperament, I know nothing." On another occasion and on a slightly different note he said: "It is all very well to copy what one sees, but it is much better to draw what one remembers. A transformation results in which imagination collaborates with memory. You will reproduce only what is striking, which is to say, only what is necessary. That way, your memories and your fantasies are liberated from the tyranny of nature."

Degas approached his involvement with the Impressionists from the point of view of a Realist and saw the first Impressionist exhibition in the rue des Capucines as an opportunity to promote what he called "a Salon of Realists." It should be noted that the terms Realism and Naturalism were confused and interchangeable at the time. Realists-Naturalists could also be Impressionists as far as the critics of the day were concerned; the term Impressionism subsumed a great deal that was deemed to be new or revolutionary. Thus Degas and Manet, by virtue of their age and status, were wrongly thought to be leaders of the Impressionist movement, when these titles have been awarded to Monet and Pissarro. It is clear that Degas had no interest in the plein-airisme being explored by Monet, Pissarro, Renoir, Sisley, and Morisot in the 1870s; his subjects were

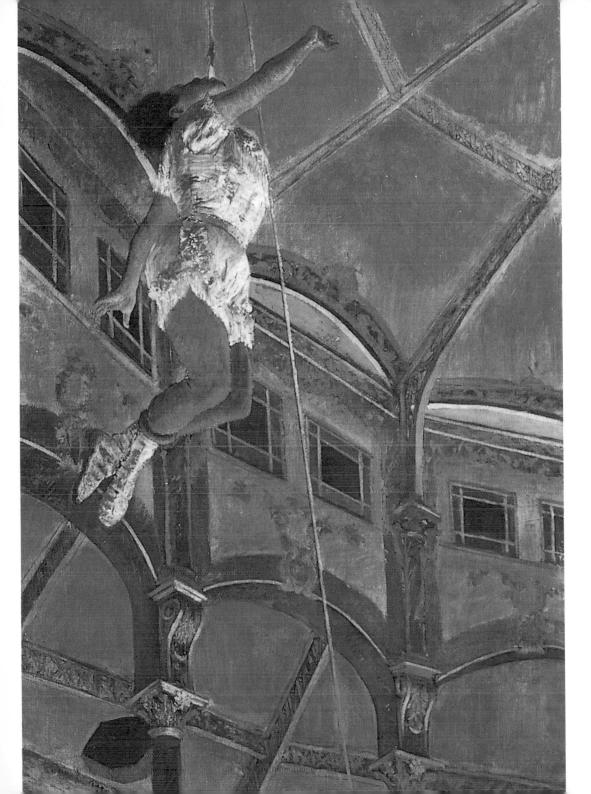

exclusively Parisian, from racehorses to prostitutes. Moreover, he was experimenting with new techniques and revitalizing neglected media such as pastel, gouache, and even distemper (used for painting scenery) in an attempt to transcend what were now appearing to be the limitations of oil paint. Abandoning oils meant he could paint rapidly on a paper support which could be infinitely extended by sticking separate pieces of paper together as required. In another vein he was experimenting with alternatives to the traditional gilt frames. Having revolutionized framing of subjects within the composition, he now addressed himself to the immediate environment of the picture, even including the decor and lighting of the exhibition room itself.

Degas' interest in modern life embraced not only those who lived it but also the technological innovations of his day, from a new electric method of drypoint etching to Eadweard Muybridge's extra-ordinary photographic discoveries about the nature of human and animal locomotion. Degas himself was a keen photographer. Manet and the Impressionists had all been influenced to varying degrees by the new window on the world photography offered, but Degas, the scientific Realist, absorbed Muybridge's discoveries with particular relish.

DEGAS

The Millinery Shop
Oil on canvas
c.1882–86. 100 x 110.5cm
This is the largest of a series of
millinery shop paintings which
are characterized by their
unusual and ingenious
composition.

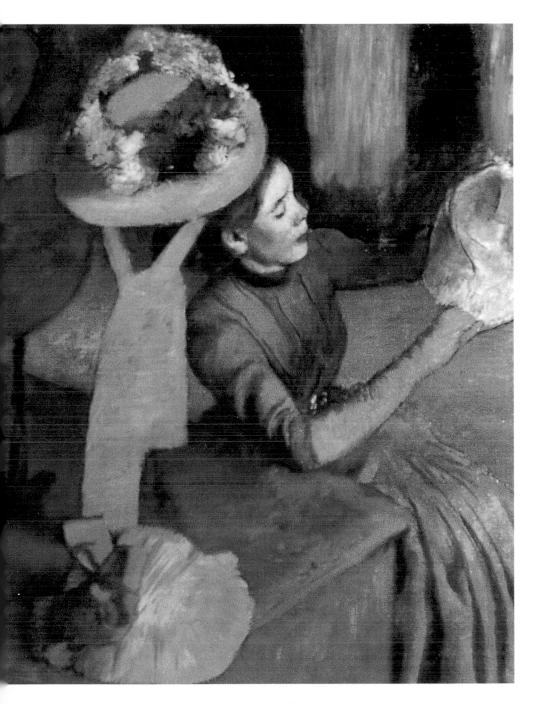

Above DEGAS

Woman Drying Her Foot Pastel on buff paper c.1885–86. 54.5 x 52.5cm Degas painted numerous bathing scenes, and asked his models to adopt a great variety of poses. Of drawing Degas said "Drawing is not what one sees, it is what one can make others see."

Opposite **DEGAS**

Ballerina and Lady with a Fan Pastel on paper 1885, 66 x 51cm

This is a good example of Degas' sophisticated compositions: the woman in the foreground with her fan is in shadow while the dancer is brightly lit. In the background, as in a framed photograph, fragmentary dancers rendered in subdued tones do not distract from the star.

In 1872 Muybridge, an Englishman working for the U.S. government, had begun to experiment with a photographic process which captured the movement of a horse in motion in order to discover whether all four hoofs left the ground simultaneously during the trot, canter, and gallop. With the financial assistance of Leland Stanford, the Governor of California, Muybridge eventually succeeded, between 1877 and 1878, in using a battery of cameras and trip wires that exposed frames at one thousandth of a second of a moving horse thus settling the argument once and for all. The first news of Muybridge's experiments had reached Paris as early as 1874 but until the publication of Muybridge's Animal Locomotion in 1887, the punctilious Degas was still drawing his horses' gait in the received manner, which is to say incorrectly. Degas set about studying and making pastel copies of Muvbridge's photographs and after 1887 his horses all show the influence of the new information, including a series of wax sculptures of horses jumping and rearing.

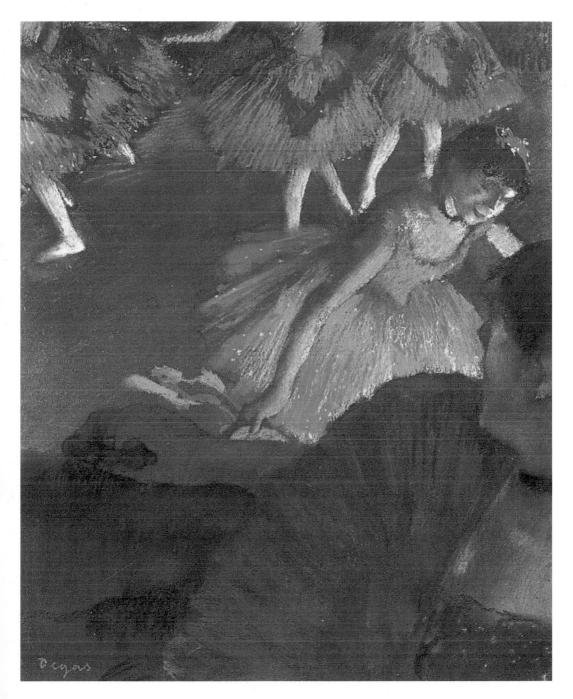

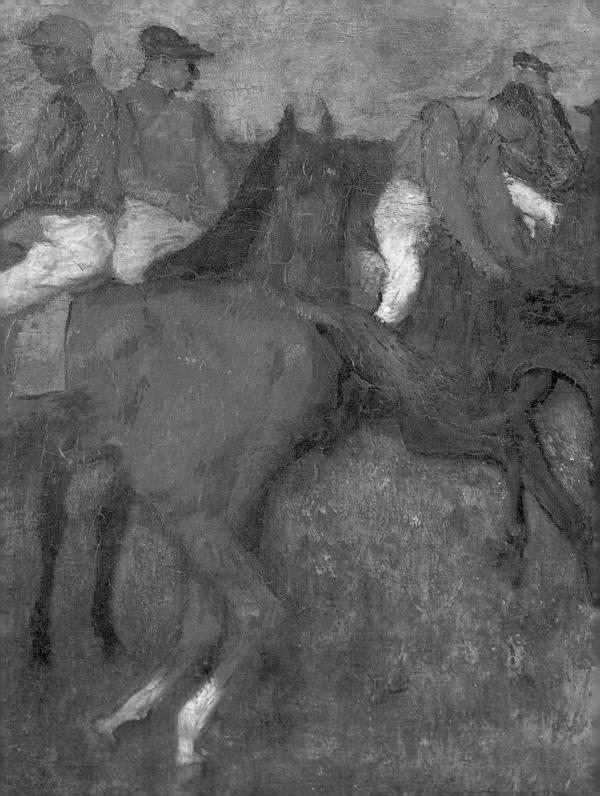

DEGAS

Jockeys Oil on paper c.1886-90. 26 x 36cm Race horses are a subject to which Degas frequently returned throughout his career. They are usually depicted just before or after the race itself, allowing for a variety of movement. Degas was an intense observer and had a well-trained visual memory which enabled him to produce all these works in his studio, using notes made at the scene of the action.

In his personal life Degas was a confirmed bachelor but a devoted friend to those who could conquer the barrier of prickliness he erected around himself. His relationship to the Impressionists was marked by an energetic involvement in their cause, even though he himself was uninterested in plein-airisme as such. Like Renoir, he was profoundly anti-Semitic and sided vociferously with the anti-Drevfusards, even though he worked closely with Pissarro and his childhood friend, the novelist and dramatist, Ludovic Halévy. In his last vears his evesight, which had troubled him all his life, began to fail. "Since my eyesight has diminished further my twilight has become more and more lonely and more and more sombre. Only the taste for art and the desire to succeed keep me going," he wrote in the last vears of the century. He kept going until his death on 27th September 1917, turning increasingly to sculpture to express himself and producing, ironically, in his last years, his most impressionistic and colourful works in pastel.

DEGAS

Three Russian Dancers
Pastel on paper
c.1910. 62 x 67cm
Degas produced a series of
about seventeen Russian
dancers, of which this is
probably a later example.

EDGAR DEGAS

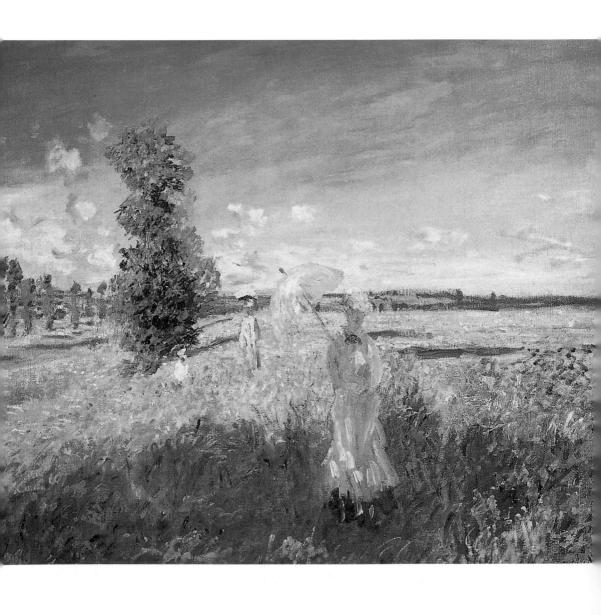

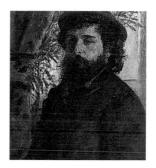

Many Many

HE NAMES OF CLAUDE MONET and Impressionism are nearly synonymous. It was, after all, one of his paintings that gave the movement its title, and he was the most consistent, the most prolific and the most uncompromising of his generation. There was never enough of anything for him: enough of the right quality of light, enough money, enough time, enough appreciation. To be a friend of Monet in the early days meant a drain on one's financial and emotional resources, as the kindly Bazille discovered. However, in the last few decades of worldwide success and lionization, the once impecunious painter of "tongue-lickings" was fetching thousands of dollars for his paintings, and he always made sure he got the right price.

Above
CLAUDE MONET
By Renoir
1875

Opposite
MONET
Walk in the Country
Oil on canvas
1875. 60 x 80cm

Life and Works: Claude Monet (1840–1926)

... the more I go on, the more I see that a lot of work has to be done in order to render what I seek: "instantaneity", above all the enveloppe, the same light spreading everywhere, and more than ever I am disgusted by easy things that come without effort ...

LETTER FROM MONET TO GUSTAVE GEFFROY, 21ST JULY 1890

Claude Oscar Monet, the voungest of two sons, was born on 14th November 1840 in Paris. Five years later Adolphe Monet took his family to live in Le Hâvre, a seaport on the Normandy coast, where he joined the busy firm of wholesalers and ship's chandlers run by his relations, the Lecadres. At an early age Claude showed an aptitude for drawing and when he was old enough to attend the Collège du Hâvre he began to study under the eye of Charles Ochard who himself had studied under the great Neo-Classicist, and painteradvocate to Emperor Napoleon I, Iacques Louis David.

"I more or less lived the life of a vagabond," said Monet in 1900 recalling his early years. "By nature I was undisciplined; never, even as a child, would I submit to rules. It was at home that I learned the little I know. School seemed like a prison and I could never bear to stay there, even for four hours a day, especially when the sunshine beckoned and the sea was smooth."

By the age of fifteen Monet was by his own account known all over Le Hâvre as a caricaturist, a pastime he had developed by drawing caricatures of his teachers "in the most irreverent fashion." However the more serious side of his talent was encouraged by his aunt, Mme Lecadre, an amateur painter who took Claude's artistic development to heart, especially after the death of his mother in 1857. Monet's devotion to art worsened his relationship with his father who wanted Claude to stay at school and take his baccalaureate. Mme Lecadre was acquainted with the painter Armand Gautier and together they persuaded the reluctant Adolphe Monet to let his son pursue a career in art. Thus the voung Monet got his own way and skipped the examination, leaving school with no qualifications save an abundance of energy and an uncompromising belief in himself.

Monet's talents needed to be channelled in the right direction, however; he could not be

CLAUDE MONET

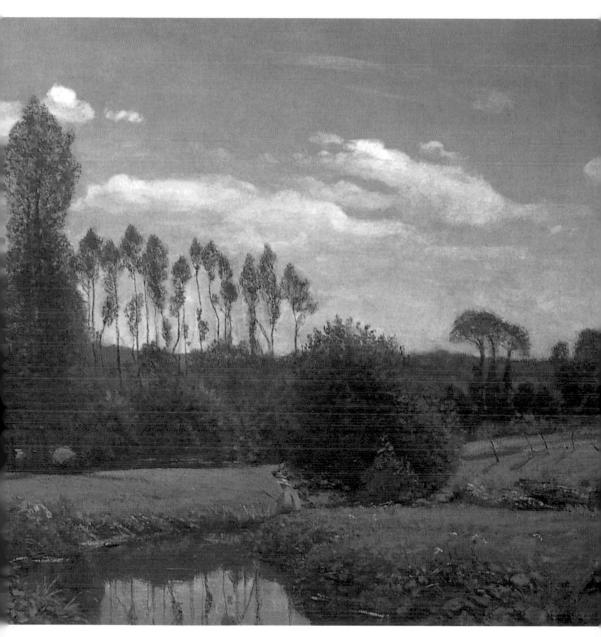

MONET

View of Rouelles Oil on canvas 1858 46 x 65cm Belived to be the first of Monet's landscapes. We find in this corner of Normandy some of the themes which would later dominate Monet's openair work: water, poplars and a good deal of sky.

MONET

Still Life with Bottles
Oil on canvas
1859. 41 x 60cm
Still lifes and nude studies were
very much part of an artist's
training and Monet, who rarely
depicted this kind of subject. shows
here that he could already produce
solid, if not exceptional, studies.

expected to progress in the art world without formal training of some sort, although this was much against his nature. An early turning point came when Gravier, the frame-maker, in whose shop Monet often displayed his drawings, introduced him to the local landscapist Eugène Boudin. Monet had been avoiding this meeting - he thought Boudin's landscapes were "horrible, used as I was to the false and arbitrary colour and fantastic arrangements of the painters then in vogue"but Boudin eventually persuaded Monet to accompany him on a landscape expedition. It was a revelation: "I understood," said Monet, "I had seen what painting could be, simply by the example of this painter working with such independence at the art he loved. My destiny as a painter was decided."

Having failed to obtain a grant to study art in Paris from the municipal authorities in Le Hâvre, Monet gathered up his savings - income from the caricatures - and went to Paris in the spring of 1859 armed with letters of introduction from Boudin to several artists including Troyon and Gautier. Troyon thought Monet showed promise and advised him to enrol at Thomas Couture's atelier (where Edouard Manet had studied). Monet dismissed this idea out of hand, even though Couture was known to be one of the more enlightened masters in Paris at the time, and returned to Le Hâvre. He was back in Paris again the next winter drawing the models at the free Académie Suisse, where his first encounter with Pissarro took place.

In 1861 Monet was called up for military service (which normally lasted seven years). Young men had to submit their names and be selected by chance. Families with the means, however, could buy their sons out of the lottery. Adolphe offered to do this if Monet would renounce art and join the family business. Instead, Monet defiantly enlisted. He joined the Chasseurs d'Afrique in the French colony of Algeria (where he was deeply impressed by the qualities of light and space), but was home in a year suffering from typhoid. Then he met his first "true master . . . the final education of my eve," Johan Jongkind, a

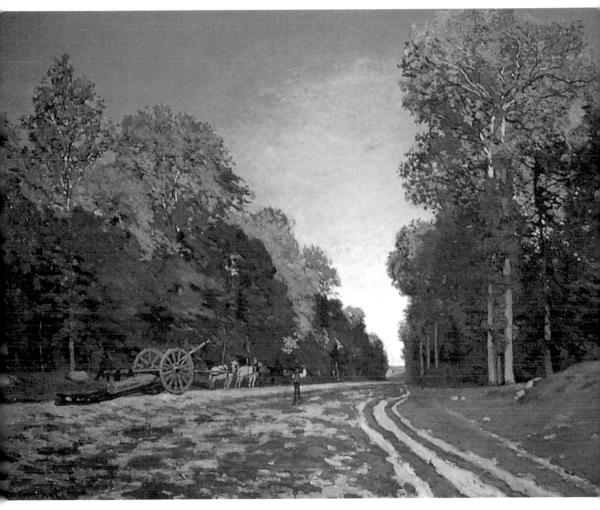

MONET

Route de Chailly, Fontainebleau
Oil on canvas
1864. 98 x 129cm
Chailly was a village near Barbizon,
dear to the landscapists of the
previous generation such as Corot,
Courbet and Daubigny. Monet wrote
to Bazille about one of his landscapes
saying that it might remind people of
Corot but insisted that it was not a
deliberate attempt to copy the style of
the older artist.

Dutch land- and seascapist who was to prove a seminal influence.

Mme Lecadre, who was convinced of Monet's potential, offered to buy him out of the army and a deal was struck with Adolphe whereby Monet would go to Paris with an allowance to study art on the condition that he joined a recognized atelier and undertook formal tuition. Monet agreed and Charles Glevre's atelier. Glevre was noted for his interest in landscape and had trained many students for the Prix de Paysage Historique. He also charged only for models and equipment, not his teaching, which was an added incentive to Monet, whose father thought him irresponsible with money and was keeping him under tight financial reins.

Thus it was in 1862 that he began his studies at Glevre's atelier and met Renoir, Bazille, and Sisley and within months was leading them off on landscape painting expeditions to the Fontainebleau Forest and the countryside around Paris. By 1863 French art was in turmoil; Edouard Manet had outraged visitors to the Salon des Refusés with his Luncheon on the Grass (Déjeuner sur l'herbe). Unknown and unnoticed Monet was forging ahead with his own programme of energetic selfimprovement, having rejected Glevre's teaching. When Glevre was forced to retire in 1864 Monet was twenty-four and at liberty to pursue his career as

he saw fit, though still at the mercy of his father on whom he relied greatly for financial support. Bazille began to help out with money, companionship and by sharing a studio with him between 1865 and 1866, in the rue Furstenberg. Bazille's unti-mely death in the Franco-Prussian War was a grave blow to Monet.

By the Salon of 1865 Monet had enjoyed some limited success and gained a few commissions. That year the Salon accepted and exhibited two of his landscapes to a mixed reception. One critic thought him "a young Realist who promises much," another compared his work to a child's scrawl. Despite the critics, the artist's intense engagement with the effects of light and colour was clearly emerging Monet's focus: he was still under the influence of Boudin, Jongkind, Manet, and even Courbet, although his work showed no sign of turning into overt Realism. Monet's experiments with large-scale figure paintings at this time are the beginning of the end of his interest in people as a subject for painting. His own Luncheon on the Grass which was never completed was to have been a major integration of light effects and figures in a total composition which would, as Forge says, "monumentalize the language of a plein-air sketch."

It was an audacious attempt doomed perhaps to failure. Monet had neither the time, the

Opposite MONET

Luncheon on the Grass Oil on canvas 1865-66. 248 x 217cm Spurred by Manet's Luncheon on the Grass, Monet decided to paint his own version of the subject, which he did as a plainly contemporary scene using his friends as models. including his girlfriend Camille. We see the concern of the artist for clothes but mainly for light which falls from behind the figures and is rendered in bold patches. Monet said later that this picture marked the beginnings of his experiment with the principle of the division of colours working at effects of light and colour which ran counter to accepted conventions.

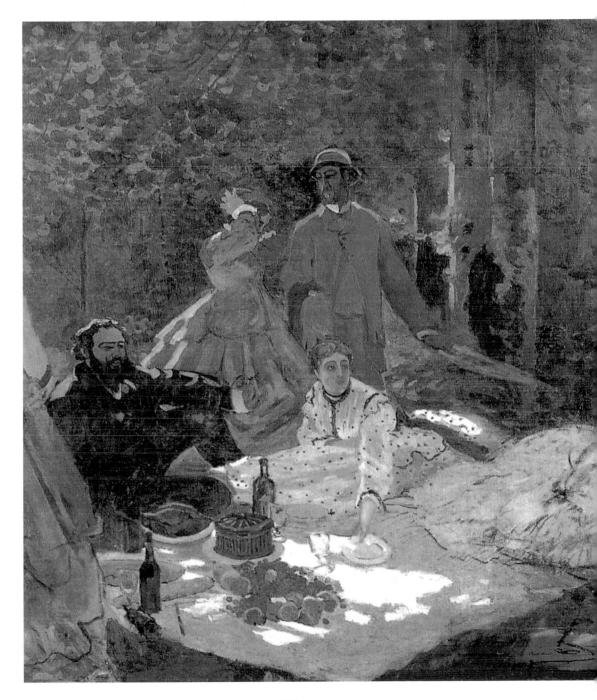

MONET

Beach at Honfleur
Oil on canvas
c.1867. 60 x 81cm
Monet took full advantage of this
summer to travel down the coast,
painting a series of beach scenes in
which his main preoccupation was
the variable aspect of the light on
the sea and in the sky. It is now
impossible to mistake his work for
that of Boudin, Jongkind or any
other painter.

studio space nor the money to devote himself to its completion. In 1865 he had injured his leg and was laid up for some time, unable to work on the painting. Bazille, who had abandoned his medical studies to become a painter, made good use of his medical skills and rigged up a contraption which dripped water onto Monet's leg to ease the pain. A touching portrait by Bazille shows an irritated Monet lying in bed at the Cheval-Blanc Inn in Chailly where he had spent the summer working on the ambitious picture, impatient for Bazille to come and model. Bazille's Monet after His Accident (Monet après son accident) is also an eloquent testimony to the devotion of Bazille to his awkward friend.

Monet was in increasing trouble with his father and Aunt Lecadre. He had a girlfriend, Camille-Léonie Doncieux, who had posed for several figures in Luncheon on the Grass and a new large-scale picture, which was ultimately rejected by the Salon, Women in the Garden (Femmes dans un jardin). The lovers fell foul of their respective parents. In 1867, Monet was being chased by creditors, Camille was pregnant and the 800 francs Monet had made from the Salon of 1866 had long since run out. Aunt Lecadre, in league with Adolphe Monet, forced Claude to retreat to Sainte-Adresse on the Normandy coast. In his absence Monet's son, Jean, was born that July in Paris. We know

from a letter Monet sent to Bazille in May 1867 that Camille herself was "ill, bedridden and penniless" and that he did not know what to do, except remind his friend he owed him fifty francs by the first of the month. Bazille had come to Monet's rescue by buying Women in the Garden for 2,500 francs to be paid in monthly instalments. In June he was asking Bazille for 100 or 150 francs; by August he was writing a pitiful letter to Bazille saving how much it pained him to think of his child's mother having nothing to eat. The letter ends on a desperate demand from Monet - "Really, Bazille," he says, "there are things that can't be put off until tomorrow. This is one of them and I'm waiting."

The enforced sojourn at Sainte-Adresse enabled Monet to produce several beach scenes which showed an increasing maturity of vision. Sadly the whole episode contributed to more disaster. In the autumn Monet was suffering from evestrain caused by the brilliant sunlight at Sainte-Adresse and was obliged to stop painting during that season. The next year, despite selling a full-length (and very sober) portrait of Camille called Woman in the Green Dress (Femme en vert) to the editor of *L'Artiste*, Arsène Houssave, as well as a commission for a portrait of Mme Gaudibert, the wife of a Le Hâvre notable, Monet had his paintings seized by creditors at

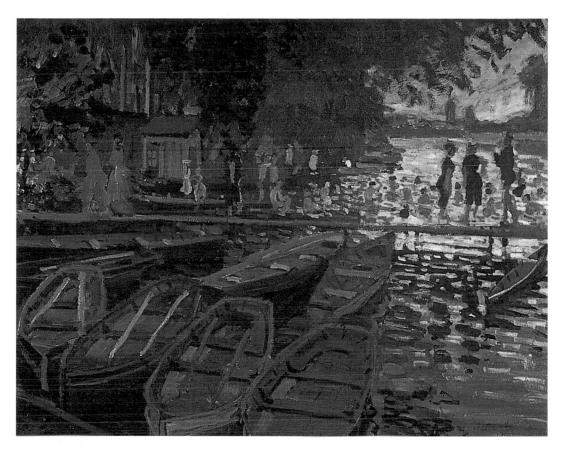

an exhibition in Le Hâvre. The strain on his relationship with Camille, who had a new baby to look after, must have been severe. The had times rapidly alternated with the good. In June 1868 Monet, Camille, and Ican had been thrown out of a country inn; Monet had attempted suicide and said so to Bazille in a letter. Whether the hardy Normand was capable of suicide is obscure - his liberal use of bathos in all his begging letters to Bazille is obvious. By December Monet was ecstatic; he wrote to Bazille from Etretat on the Normandy coast where he and his family were installed in a little cottage thanks to the patronage of M. Gaudibert, saying how happy he was surrounded by his family and able to work in peace. He adds with reference to his work: "The further I get the more I realize that no one ever dares give frank expression to what they feel."

In the summer of 1869 this is exactly what Monet began to do in earnest when, working in the company of Renoir at La

MONET

Bathers at La Grenouillère Oil on canvas 1869. 73 x 92cm La Grenouillère was now so popular that oven the Imperial couple once stopped to visit it. Set on a small island on the Seine, it consisted of two barges moored under trees and roofed with awnings. Gangplanks linked the barges to a tiny artificial islet nicknamed the "camembert". The series of paintings of La Grenouillère marks a turning point in Impressionism, although Monet thought that he had only produced "rotten sketches".

Opposite

MONET

The Bridge at Argenteuil
Oil on canvas
1874. 60 x 81cm
Argenteuil had much to offer a
painter like Monet: open country, a
garden full of flowers, the Seine with
its pleasure boats. The new bridge
rebuilt after the war, and the train
were all modern elements which
interested the Impressionits, in
contrast to the Barbizon landscapists
of the previous generation.

MONET

Train in the Snow Oil on canvas 1875. 53 x 72cm Monet's house was opposite the station and he pictured it several times. This is one of many snow scenes, a subject he never tired of depicting. Grenouillère on the Seine, he produced what are the first truly Impressionist paintings. Monet called them "rotten sketches" but signed them nonetheless. They were indeed sketches for a finished work which is now lost (but survives in a rather indistinct photograph) and which appears to show the existing Grenouillère pictures are not dissimilar to the completed version. At this point in the history of Impressionism in general, the distinction between sketch and completion was beginning to lose its importance. Monet was now using paint with increasing confidence in swift, bold brushstrokes, painting wet-in-wet in places to create fluid and subtle mixtures of colour. This technique was developed in the work produced the next summer in Trouville on the Normandy coast, and reached new heights during his exile in London of 1870–71 and his subsequent trip to Holland.

Monet had just married Camille when he had to flee to London to avoid being called up to fight the Prussians. Although his time in London was fraught with difficulties – "I endured much poverty," he recalled in 1900 it meant he was in the company of Pissarro, Daubigny, and the dealer Paul Durand-Ruel, who were all exiles from the war

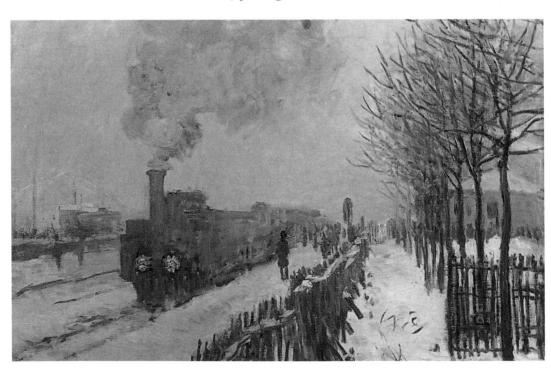

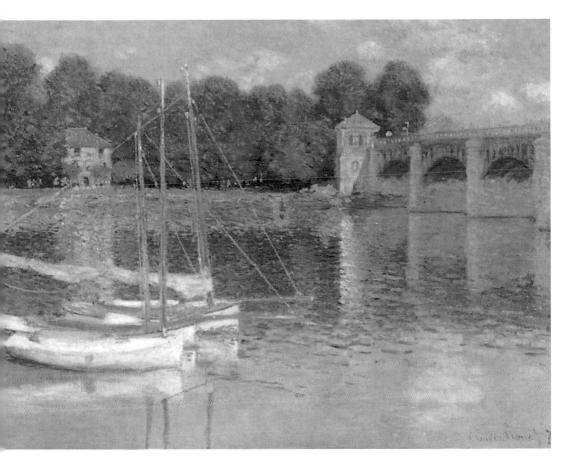

The all-important business relationship he struck up there with Durand-Ruel was to last the rest of his life despite many ups and downs. London itself its mercurial climate, prodigious mists and fog, its river, parks and buildings – provided a new set of atmospheric problems for Monet to solve. He was to rediscover the vagaries of English weather to his delight and horror when he returned to London over thirty years later.

In 1871, after the war and

the Commune, Monet returned to France and set up home with his family in Argenteuil on the Seine near Paris. There they remained in occasionally frugal stability for seven years. Settled in the growing but as yet rural town of Argenteuil, but near enough to Paris to make possible frequent trips there on the railway, Monet could now concentrate on transferring to the canvas the *enveloppe* which his unique vision disclosed. The subjects that now fell within his

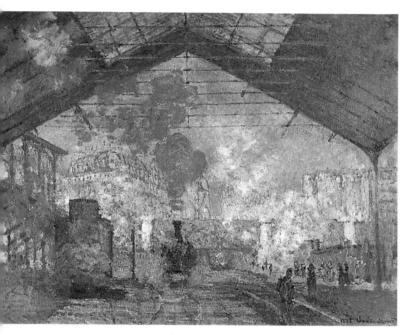

MONET
Gare St Lazare
Oil on canvas
1877. 75.5 x 104cm
In this view of the station,
the Pont de l'Europe is seen
in the distance.

view ranged from Argenteuil and Paris streets, to the river and the railway, as well as his house and the surrounding countryside. Working out of whenever possible, Monet began the system which was to serve him until his death of having several canvases on the go at once, always ready to capture some fleeting atmospheric effect. He began to produce more varied views of the same subject as seen in different weather conditions. These culminate in his last Paris pictures - the series of Gare St Lazare paintings which treat the station, its massive structure and swirling clouds of steam as intricate webs of colour, truly urban landscapes.

It is perhaps fitting that it

was a picture by Monet, Impression, Sunrise, which gave the Impressionists their name, for during the 1870s he forged tirelessly ahead and came to exert a powerful influence on his fellow artists. Edouard Manet's summer season at Argenteuil alongside Monet resulted in Manet's decisive shift towards the Impressionist style of swiftly applied bright pigment. Renoir and Pissarro were also visitors to Argenteuil. For a relatively brief period Monet was at the heart of the Impressionist enterprise, contributing to the Impressionist exhibitions, joining in the discussions at the Café Guerbois in Paris, borrowing money from an increasing circle of friends - including Manet and Zola. The substantial amounts he was now earning were spent on, amongst other things, servants for the large house at Argenteuil. Monet also made important contacts with patrons such as Hoschedé and Chocquet.

In the end circumstances and the solitary, ambitious nature of Monet's personal endeavour drew him further away from the other Impressionists. The fall of his patron Hoschedé, a decline in Monet's modest fortunes, Camille's second pregnancy and, soon after, her worsening illness, led to the two families living together in a new home in Vetheuil, further along the Seine from Argenteuil. Eventually Ernest Hoschedé left the Monet-Hoschedé

household, and, after the death of Camille in 1879, Monet, Jean, Camille's new baby Michel, Alice Hoschedé and her six children were left to carry on with life together as best they could.

The turmoil in his personal life, the real threat of poverty with a family of nine to support, and the withering of Monet's links to the other Impressionists, formed an inauspicious start to the 1880s. He had been too poor and depressed by the time of the

fourth Impressionist exhibition in 1879 to want to exhibit, however, and the good Caillebotte, who had rented the studio where Monet had finished the Gare St Lazare pictures, had himself collected twentynine works from Monet and sent them in for him. The next vear Monet absented himself from the fifth Impressionist show. To the extreme disgust of Pissarro and Degas, Monet decided instead to submit to the Salon for the first time in many years

MONET

Sunset at Lavacourt
Oil on canvas
1880. 101.5 x 150cm
This picture forms a sequel to the famous Impression, Sunrise.

MONET Cliff Walk, Pourville Oil on canvas 1882. 65 x 81cm Monet frequently went to the same coastline of Normandy to paint, usually alone. He stayed nearly six months in the area, experimenting in depicting the changing light with increasing accuracy. He had started to use boxes specially designed for him, capable of holding freshly painted

canvases.

Monet's relationship Durand-Ruel now took on a new importance. Durand-Ruel had found him reasonably bankable in a time of economic depression and Monet was the first of the Impressionists to have a one-man show at the dealer's gallery in 1883. During the 1880s Monet at last began to make a comfortable income from his work and in 1883 he was able to move to Giverny, his last home. But his dedication to expanding his vision was untrammelled.

The search for new inspiration now took him on a series of extended travels in search of problematical landscapes. He went first to the Normandy coast, usually leaving Alice and the children behind, and then to more distant climes - the south of France, northern Italy and Norway. The intrepid artist often found himself battling with the elements. A letter to Alice from Etretat in 1885 recounts how he was working at the Manneporte, a spectacular rock formation off the northwestern coast and the subject for several paintings, when he failed to observe a huge wave which smashed him against the cliff and dragged him down in its undertow: "My first thought was that I was done for . . . My boots stockings and coat were soaked through . . . the palette . . . had hit me in the face and my beard was covered in blue and yellow, etc . . . the worst thing was that I lost my painting which soon disintegrated along with the easel."

For an artist such as Monet who had developed an incredible sensitivity towards colour in a northern French landscape, which is subdued at the best of times and in the winter mournfully so, one might well imagine what the intense Mediterranean and landscape could sun unleash in his mind. The bright blues of the sea and sky were at first, he said, "appalling" and "beyond me": in the end of course he mastered them. During the 1880s Monet's palette was finally liberated from any lingering attachment to naturalistic colour; the Rocks at Belle-Île (Rochers à Belle-Île). and the Poppy Fields at Giverny (Champs de pivots à Giverny)

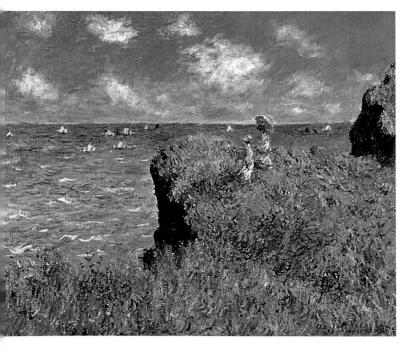

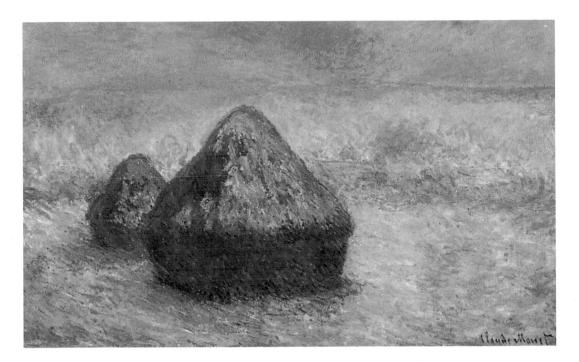

are worked and re-worked (in the studio) with thick, startlingly livid pigment. They go beyond the mere impression of colour values and have now become a mode of defining the complex emotional relationship of the artist to the scene in terms of colour.

In 1892 Ernest Hoschedé died, enabling Monet and Alice to marry. The artist had now cut down on his travels and began to devote himself once again to the landscape around his home. Continually searching for a way to paint the elusive moment, the "fugitive effect," as he put it, Monet had embarked on a multi-canvas series of subjects, the first of which, the *Meules* or *Grain*

Stacks (not "hay stacks", they are stacks of wheat or oats), was begun in the mid-1880s. When the series was due to be exhibited at Durand-Ruel's gallery in 1891 Pissarro was moved to complain to his son Lucien: "All people want at the moment is Monets, apparently he can't paint enough to meet the demand. The worst thing is that they all want grain stacks at sunset! Always the same story, everything he does goes to America at prices of four, five, and six thousand francs."

The series of *Meules* was thus a stunning success, both financially and artistically. Moreover, the series now represented a record, in a disturbing totality, not only of the subject

MONET

Grain Stacks, Sunset
Oil on canvas
1891. 65 x 100cm
The Neo-Impressionists found Monet's
works "old hat" by now, because he
was merely evolving rather than
radically changing direction.

MONET Rouen Cathedral Oil on canvas 1894. 100 x 73cm

Opposite MONET

The Cathedral Fog Oil on canvas 1894. 106 x 72.5cm under varying conditions, but Monet's response to it over time. Speaking of the *Meules* series, which he saw in 1895, the painter Wassily Kandinsky said: "Painting took on a fabulous strength and splendour... unconsciously, the object was discredited as an indispensable

element of the picture." True enough, contemporary viewers were initially perplexed by the need to see the whole through its parts. The "discredited object" - in other words making the object abstract by repeating it in various states - is a major consequence of Monet's series paintings. The Poplars series of 1891, the Rouen Cathedral series of 1894, and the Mornings on the Seine of 1896-97 continue this serial preoccupation. In the late 1890s and early 1900s Monet went on his last travels to London (where he had painted over 100 views of the Thames by 1904) and his last expedition to Venice in 1908.

As Monet's work was now selling for substantial amounts he could afford to realize his dream of creating a large flower and water garden, achieved by buying a plot adjacent to the house, diverting the stream which ran through the land and forming a water-lily pond with a Japanese bridge over it. It was in this garden that he spent the last decades of his life. Over the years the garden expanded into a wonderland of flowers of all varieties. "What I need most of all are flowers, always, always," he said. His artistic attention now turned to the waterscape offered by the lily pond. A prodigious series of Nymphéas, or Water Lilies, now followed, taking Monet into new realms of vision. As he told Geffrov in 1908: "These landscapes of water and reflection have become

CLAUDE MONET

an obsession. It's quite beyond my powers at this age, but I need to succeed in expressing what I feel." The consequence of this obsession was the Nymphéas, paysages d'eau (Water Lillies, Waterscapes) a series of forty-eight canvases exhibited at Durand-Ruel's in 1909. This later became a monumental concept for a huge decoration to be donated to the State and installed in a public building in Paris. The plan, encouraged by the politician Georges Clemenceau, was audacious and at times it seemed as though it

would never happen. In 1911 Alice Monet had died and to add to his grief his son, Jean, died in 1914. Cared for by his step-daughter Blanche Hoschedé -Monet and with the support of Clemenceau, the seventy-four-year-old artist was able to persevere with the project for the massive decorations.

To realize the decorations Monet proposed the building of a new studio specially to house the work in progress. As World War I raged around him, Monet supervised the construction of the studio and worked on the

MONET

The Japanese Bridge at Giverny Oil on canvas 1893. 97 x 117cm

Monet had a Japanese-style bridge built over a pond in his garden. He had already undertaken a great deal of gardening, although no water lilies are growing in the pond yet. He depicted this pond tirelessly until his death in 1926.

Opposite MONET

deteriorating.

Poplars
Oil on canvas
1891. 101 x 66cm
The series of poplars followed immediately after the grain stacks.
By then Monet's eyesight was

Nymphéas in the old studio. He had developed cataracts which made it increasingly difficult for him to discern colour, vet he carried on remorselessly. When the new studio was finished in 1916 he began what was almost a decade of unremitting work on the decorations. His failing evesight meant he was frequently uncertain of what he was doing and, in despair, he destroyed several canvases. An operation in 1923 eventually restored enough of his sight for Monet, now eighty-three and dving of cancer caused by habitual cigarette smoking, to near completion of the decorations. The immense work was designed to be housed in a circular or oval room and to this end the Orangerie near the Louvre was designated to house it, but not without political and personal complications on a huge scale. Monet died on 5th December 1926, a month after his eighty-sixth birthday, with Clemenceau at his side. He had lived just long enough to see the completion of the decorations, his troublesome masterpiece of a gift to the French nation. As Gustave Geffrov said of the lilv pond, the inspiration for his last great works:

There he found, as it were, the last word on things, if things had a first and last word. He discovered and demonstrated that everything is everywhere, and that after running round the world worshipping the light that brightens it, he knew that this light came to be reflected in all its splendour and mystery in the magical hollow surrounded by the foliage of willow and bamboo, by flowering irises and rose bushes through the mirror of water from which burst strange flowers which seem even more silent and hermetic than all the others.

Monet was famed throughout the world and his work fetched enormous prices; his persistence and stubborn devotion to his art had made his fortune. He had also outlived two wives, a son, the Second Republic, the Second Empire and all of his contemporaries including Pissarro, Degas, and Renoir.

Six months before his death he wrote: "... in the end the only merit I have is to have painted directly from nature before the most fugitive effects, and it still upsets me that I was responsible for the name given to a group, most of whom had nothing Impressionist about them..."

A series of paintings of the Japenese bridge and the garden at Giverny are among Monet's last works apart from the decorations. The last canvases are covered by violent, feverish brushstrokes with an inferno of colour; the last challenges to sunlight of one of the first great impressionists.

CLAUDE MONET

MONET

Nymphéas (detail)
Oil on canvas
Undated. 132 x 84cm
Monet painted hundreds of pictures
of the water lily pond in his garden at
Giverny during the last decades of
his life.

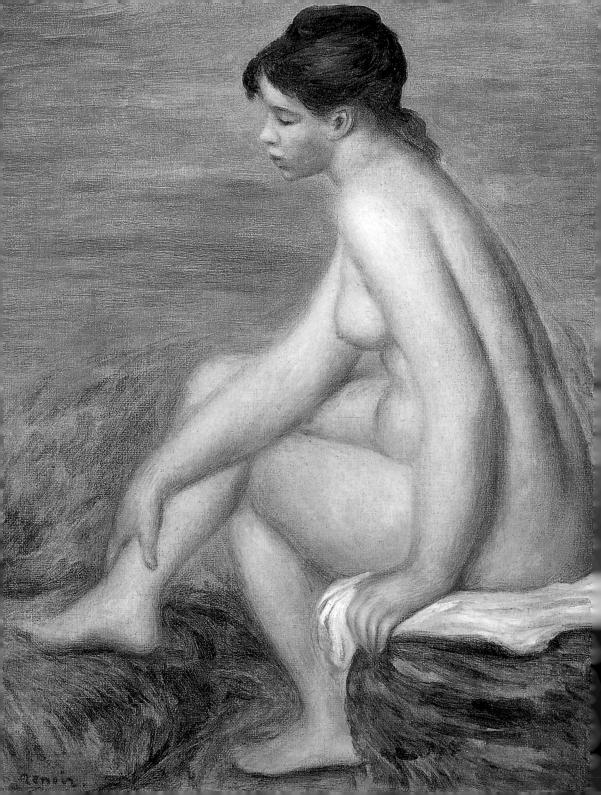

nenoiz

EORGE MOORE, AN ENGLISH writer who was reasonably close to the Impressionists during the Batignolles days, thought Pierre-Auguste Renoir possessed a certain "vulgarity", a feeling expressed, though not of course explicitly, by Renoir himself, whose eventual fame sat uneasily on the head of a self-confessed artisan. Renoir was existentially nervy, a source of perpetual motion who would whistle incessantly whilst painting and fall into utter depression when idle.

His dissatisfaction with the extraordinary surface effects of his "high Impressionist" period culminated in a search for classical simplicity in line and volume which lead him back to the work of Raphael, and to the experiments of Cézanne. In the end he found his métier in the female figure.

Above
PIERRE-AUGUSTE
RENOIR
Self-portrait
c.1875

Opposite
RENOIR
Seated Bather
Oil on canvas
c.1885, 54,5 x 42cm

Life and Works : Pierre-Auguste Renoir (1841–1919)

Artists do exist. But one doesn't know where to find them. An artist can do nothing if the person who asks him to produce work is blind. It is the eye of the sensualist that I wish to open.

PIERRE-AUGUSTE RENOIR

RENOIR

Bazille at Work
Oil on canvas
1867. 105 x 73.5cm
Renoir has produced an honest
portrait of his close friend, but has
not yet found the style to which
he owes his fame.

Pierre-Auguste Renoir's father Léonard "Raynouard", as the land register of the time called him, was a tailor from Limoges who had moved to Paris in

1844 with his family. Renoir's mother, Marguerite was a dressmaker and Pierre-Auguste, born on 25th February 1841, was the sixth of seven children, two of whom died in infancy. At the age of fourteen Renoir was apprenticed in the traditional way to M. Levy, a porcelainpainter. To improve his skills he also studied drawing at a free school and when Levy's firm could no longer compete with the machine-produced porcelain-ware taking over the market and closed down in 1858, Renoir then painted fans for his brother, Henri, copying the work of Watteau, Lancret, Boucher, and Fragonard, and blinds for a M. Gilbert until he entered Charles Glevre's atelier in 1861. A year later he met Monet, Bazille, and Sislev there. His capacity for self-improvement was formidable, and in 1862 he won a, place at the Ecole des Beaux-Arts where he studied as a pupil of Gleyre's until 1864. He had also gained permission to copy in the Louvre and the Cabinet d'Estampes. In later years, when he and his friends were famous, Renoir was the only one to recognize the efforts of the good Charles Gleyre: "It

was under Gleyre that I learnt my trade as a painter," he said, and in the 1880s he was to return to the techniques Gleyre had taught him. At the time, however, his relationship with Gleyre had its humorous moments. On one occasion Gleyre inspected some of Renoir's work and wryly advised him that painting shouldn't be done for one's own amusement, to which the plucky Renoir replied "If it did not amuse me I wouldn't paint."

Renoir's career at the Ecole des Beaux-Arts was hardly spectacular; on one occasion he came fourth with an honourable mention in the perspective drawing examination, but generally his results were undistinguished. Not so his formative relationship with the other Glevre students. In 1862 he was already accompanying them on landscape painting expeditions to the Fontainebleau Forest. "When I was young," he said nostalgically many years later, "I used to go to Fontaincbleau with Sisley, with just my paintbox and the shirt on my back. We would wander round until we found a village, and sometimes come back a week later when we had run out of money." Monet, Bazille and Sisley had soon become important allies. They were all from the prosperous middle class, though Renoir, from the skilled working class, an ouvrier de la peinture as he called himself, had to earn a living by undertaking decorative work. As the

art historian John House observes in his study of "Renoir's Worlds", when Bazille, comfortably supported by his parents, shared his studio with his friends, Monet played

RENOIR

Lise
Oil on canvas
1867. 181.5 x 113cm
This portrait of the artist's
mistress was shown at the
Salon in 1868.

the role of a bohemian who had rejected parental authority, whereas Renoir simply had to seek the cheapest way he could find to live. Renoir strove to become a bourgeois through his art and his friends. His first successful submission to the Salon in 1865 was a portrait of Sisley's wealthy father, and the greater part of his career was to depend on patronage by and portraiture for the bourgeoisie. Yet the question of class troubled him throughout his life; his later affair with and marriage to a laundress, Aline Charigot, was kept secret from his friends Renoir was terrified that they might think of her as a lowly peasant.

By nature Renoir was a restless soul and in this respect he was later to be compared to Watteau, one of his early influences. He was also highly impressionable. Unsympathetic analyses of his work held up the considerable influence of his contemporaries, firstly Monet and later Cézanne, as proof that he was ambivalent and confused as to his own identity as an artist. To a certain extent this is true, but his talent was both convincing and original, chiefly in his portrayal of the modern life of Paris for which he is most admired.

In 1868 Renoir and Bazillc moved into rooms with a studio in the Batignolles quarter of Paris. As a member of the group of future Impressionists who had gravitated towards the Batignolles and the Café Guerbois where Edouard Manet held court, Renoir was now becoming involved in the struggle for recognition. Following the Salon's rejection of his painting Diana the Huntress (Diane chasseresse) in 1867, he had signed a petition calling for another Salon des Refusés and was soon to be a prominent member of the Société anonyme which launched the first Impressionist show. In 1868, he received considerable acclaim at the Salon for his painting Lise with a Parasol (Lise au parasol), which Zola thought "a successful exploration of the modern". The critic Duret had bought a previous Lise, also known as The Gypsy Girl (La Gitane), and Renoir's name was increasingly to be heard mentioned in connection with the avant-garde whilst his style remained subtly tailored to the Salon, Lise Tréhot, the subject of Lise and many more paintings to come, was the sister of Clemence Tréhot, the mistress of Jules Le Coeur, a painter and close friend of Renoir and Sisley. In 1865 Le Coeur had bought a house at Marlotte in the Fontainebleau Forest where Renoir, Sisley, and the Tréhot sisters would frequently spend the summer months. Nearby was the famous Cabaret de la mère Anthony, a country inn frequented by artists, writers, and bohemians of every hue. The Cabaret is the subject of an early picture which Renoir remembered with great pleasure. "It is not that I find the

Opposite RENOIR

La Loge Oil on canvas 1867. 80 x 64cm This now famous picture passed unnoticed at the first Impressionist exhibition, as did the artist's other works. It has since been widely acknowledged as a masterpiece. A work of charm and candour, the mismatching of the sitters to the setting adds to the painting's appeal. The woman was the model Nini Lopez, who does not have the allure of a high society woman. The man was Renoir's brother, Edmond, a willing accomplice in many of the artist's works.

PIERRE-AUGUSTE RENOIR

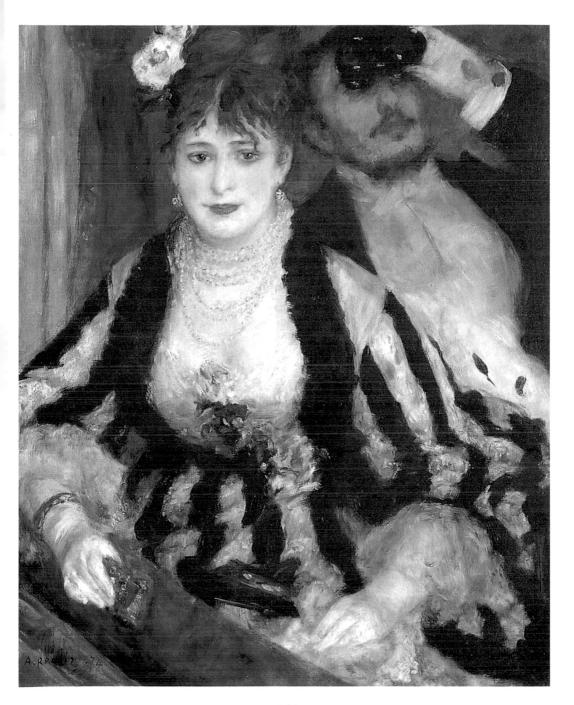

picture itself particularly exciting, but it does remind me of good old Mother Anthony and her inn at Marlotte. That was a real village inn!"

During the late 1860s Renoir's style was at a crossroads. The rapidly executed Skaters in the Bois de Boulogne (Patineurs au Bois de Boulogne) of 1868 showing the marked influence of Monet, contrasts with the sobriety of the touching double portrait of Sisley and his wife-to-be, The Engaged Couple (Les Fiancés) of the same year. In 1869 Renoir spent the summer living with his parents in Louveciennes. Nearly every day he travelled the few miles up the river to Bougival where Monet was living and together they went to paint at the popular bathing establishment known as La Grenouillère (The Froggery) on the Île-de-Croissy in the Seine. To many minds this is where Impressionism was born. The two artists worked side by side at the same views with practically the same palette and brushstrokes. A comparison of the results of that summer shows that Renoir had tried to apply a great deal of Monet's approach. The short, rapid brushstrokes and high-keyed colours employed by Monet are echoed by Renoir, but in a more uncertain fashion. Renoir's approach to the subject concentrates more on the crowd of figures in the scene.

Opposite RENOIR

The Path in the Grass Oil on canvas c.1875. 60 x 74cm

The composition of this painting is reminiscent of the Poppy Field painted by Monet two years previously; though Monet's work includes a greater depth of sky and his horizon is firmly marked by a row of trees. Here the path is clearly the axis of the picture, balanced by the vertical tree off centre. The vegetation is detailed in Renoir's fluttering style.

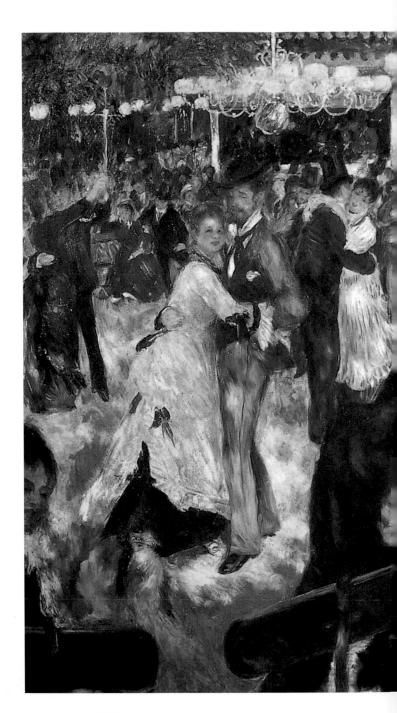

RENOIR

Ball at the Moulin de la Galette Oil on canvas 1876. 131 x 175cm In order to paint this composition, Renoir called on some patient friends. The three men on the right are Pierre Franc-Lamy and Norbert Goenette, both painters, and the writer Georges Rivière. On the bench are two sisters, Estelle and Jeanne, the latter was Renoir's new model, who also posed for The Swing. The dancer in pink is Margot (Marguerite Legrand) with the Cuban painter Solarès. The girls were all from the working classes and the men were younger friends of the artist.

PIERRE-AUGUSTE RENOIR

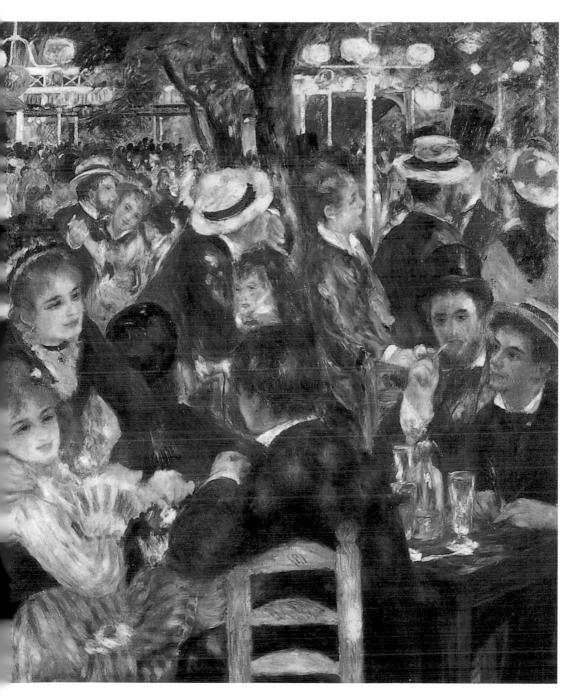

With the outbreak of the Franco-Prussian war in July 1870, Renoir joined the Tenth Cavalry Regiment and was posted to Libourne in the Bordeaux region. There he succumbed to a severe attack of dysentery and was rescued by his uncle who took him to the town of Bordeaux to recuperate. By the end of February 1871 he was back with his regiment and his record states that he "conducted himself well for the duration of the war." By the time in April when he had been demobilized and returned to Paris, the Commune was in power and the city was under siege. Nothing could stop him painting though, and he obtained a pass from the Prefect of Police and was able to leave Paris on painting expeditions and to visit his parents in Louveciennes.

Between 1871 and 1874 Renoir continued his close association with Monet, visiting him at Argenteuil during the summers, as well as becoming more intimately involved in the fledgling Société anonyme; he now had a studio in Montmartre in the rue Saint-Georges where the Société anonyme often met in 1873 to plan its first exhibition. His style was beginning to mature; his view of the Pont Neuf of 1872, though the choice of the subject was influenced by Monet, presents a highly original use of colour and contrasts strongly with a rather dour view of a similar subject, the Pont des Arts done

Opposite RENOIR

Madame Charpentier and Her Children
Oil on canvas
1878. 154 x 190cm
In 1876, Renoir had the good fortune to meet the Charpentiers, a wealthy and influential couple. Marguerite commissioned her own portrait and, using her connections, made sure that it was prominently displayed at the Salon.
However, this did not spare the work from criticism, some of which could be applied to much of Renoir's work: a gifted colourist but lacking in draughtsmanship.

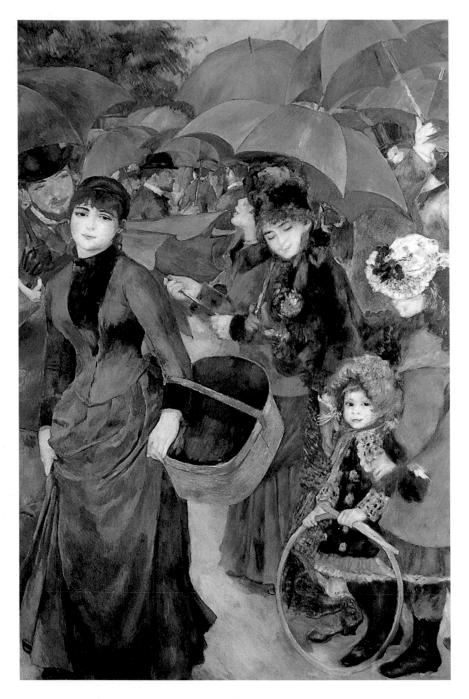

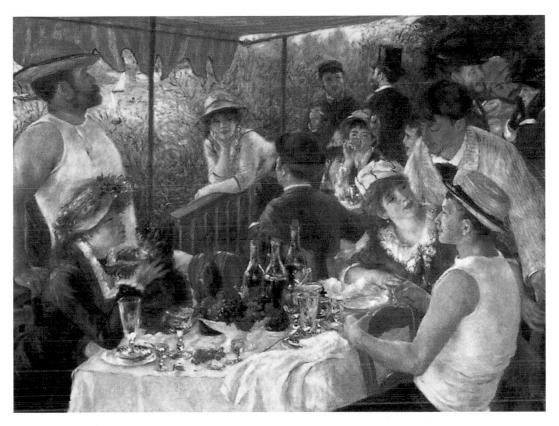

in 1867. Renoir's brother Edmond, a journalist, had an interesting anecdote about how the Pont Neuf was painted. The two brothers would take up residence at a little café and for ten centimes each they could sit with two coffees for hours. Whilst Auguste painted, Edmond scribbled, occasionally venturing onto the bridge to engage passers-by in conversation so that Auguste could sketch them in situ. In another vein the Morning Ride in the Bois de Boulogne (L'Allée cavaliére au Bois de Boulogne) of 1873, an enormous canvas eight and a half by seven and a half feet, is an attempt by Renoir to paint a large-scale work with the Salon in mind. Despite this ambition, it was rejected and appeared at the Salon des Refusés.

When the accounts for the first exhibition of the *Societé* anonyme were drawn up after the disastrous exhibition of 1874 each member of the society owed 184 francs 50 centimes; few paintings had been sold, although Renoir had somehow managed to avoid

RENOIR

Luncheon of the Boating Party
Oil on canvas
1880–81. 130 x 173cm
On the left is Aline Charigot, Renoir's
future wife. The painter Lhote leans
forward to talk to the actress Jeanne
Samary. The painter Caillebotte, is
seated in the foreground wearing a
straw hat. This was Renoir's last crowd
scene and one of his most popular works.

Opposite **RENOIR**

The Umbrellas
Oil on canvas
c.1885. 180.5 x 115cm
Many painters begin with a tighter
style which gradually loosens up as
they gain self-confidence. The opposite
was true in Renoir's case.

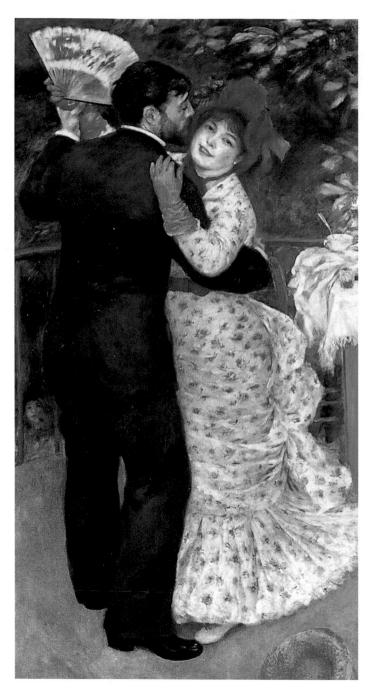

most of the hysterical criticism aimed at colleagues such as Monet, Pissarro, and Degas. One of the pictures Renoir exhibited, La Loge, the first of several paintings on this theme and now considered one of the leading icons of Impressionism, was later bought by Père Martin, a rather dubious small-time dealer, for the sum of 425 francs. This was not an insubstantial amount for an impecunious artist - in any case Renoir owed it in rent - but a Salon picture by Meissonier, for example, could fetch 40,000 francs. In December the Société terminated, with Renoir as the chairman. The next year, resourceful as ever, he had the idea of a joint auction with Monet, Sisley, and Morisot to be held at the Hôtel Drouot. The newly named Impressionists were by now so infamous that there were demonstrations when the paintings went on show in March. Renoir sold twenty works for an average of 112 francs, with some going for as little as 50 francs. Thankfully Renoir's precarious position was now helped by the fortunate arrival on the scene of the collector Victor Chocquet who commissioned several portraits of his family which kept the artist financially afloat.

In 1875 Renoir had rented for a hundred francs a month the dilapidated outbuildings of an old folly with a garden in the rue Cortot as a studio. The next summer his friends Pierre Lamey, Frédéric Cordey, and

PIERRE-AUGUSTE RENOIR

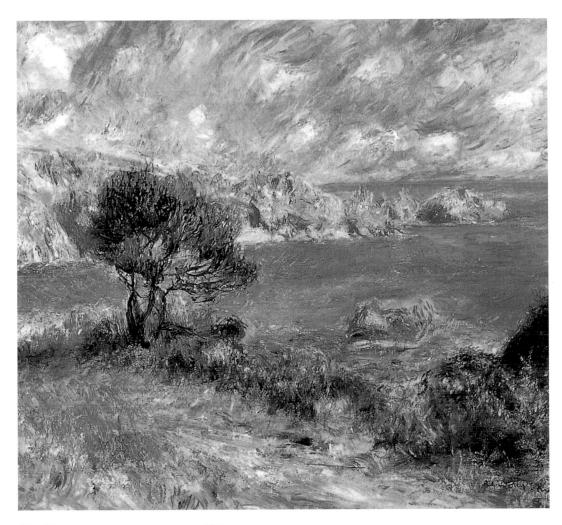

Opposite

RENOIR

Dance in the Country Oil on canvas 1882-83. 180 x 90cm Renoir painted three nearly life-sized

dancing couples between 1882 and 1883. The relaxed and happy woman is Aline Charigot and her dancing partner is Renoir's old friend Lhote, who appears in several other pictures.

Above

RENOIR

Landscape at Guernsey Oil on canvas

1883. 46 x 56cm

Renoir and his family spent a month on the Channel Island of Guernsey in the late summer of 1883, where he painted around fifteen pictures, many of them intended as sketches to be used for studio compositions later on.

Georges Rivière often joined him in outings to a popular haunt, the Moulin de la Galette – a dance hall and café beneath one of the last remaining windmills of Montmartre. According to Georges Rivière, in the mornings he and the others would help Renoir carry his canvas and easel round the corner to the dance hall where the artist spent the summer painting a large scene of the crowds there now known as the Ball at the Moulin de la Galette - one of several masterpieces he was to produce that summer. Although he certainly worked on it in situ. posing his friends and acquaintances, including Rivière, it was prepared with sketches and finished in the studio in the rue Cortot. Nevertheless, it is Renoir's first large-scale figure painting to deploy the swift technique he had been perfecting since the summer of 1869 at La Grenouillère with Monet. The dappled sunlight is a particular feature of this period, as is the abandoned use of colour in the shadows. The painting shown at the third Impressionist group exhibition the next year when a critic under the pseudonymous name of Flor O'Squarr said of Renoir's painting:

The painter had caught perfectly the raucous and slightly bohemian atmosphere of this open-air dance hall, perhaps the last of its kind in Paris. The harsh sunlight is filtered through the greenery, sets the blonde hair and pink cheeks of the girls aglow and makes their ribbons sparkle. The joyful light fills every corner of the canvas and even the shadows reflect it. The whole painting shimmers like a rainbow and makes one think of the dainty Chinese princess described by Heinrich Heine: her greatest pleasure in life was to tear up satin and silk with her polished jade-like nails and watch the shreds of yellow, blue, and pink drift away in the breeze like so many butterflies.

This summer also produced the equally famous The Swing (La Balançoire), thought to have been painted in the garden at the rue Cortot. A young woman living in the neighbourhood, Jeanne, posed on the swing (and is also present in *The Ball*). The same dappled light is more intensely expressed here and imbues the picture with that insouciant charm of which only Renoir (who had of course once copied Watteau for a living) was capable. Zola was so taken with the painting that he used it in his novel Une Page d'amour of 1878, where the heroine is "standing on the very edge of the swing and holding the ropes, with her arms outstretched . . . she was wearing a grev dress decorated with mauve bows . . . That day the sunlight was like light-coloured dust in the pale sky . . ."

Towards the end of the 1870s Renoir began to be less involved with the Impressionists as a group. After the third Impressionist exhibition in 1877 he forsook the group and began to concentrate on the Salon as an outlet for his work.

Opposite **RENOIR**

The Apple Seller Oil on canvas c.1890. 66 x 54cm In this rustic scene, Aline poses with a young girl and probably her son, Pierre, seated to the right. This is the most elaborate of three pictures Renoir painted on the same theme.

PIERRE-AUGUSTE RENOIR

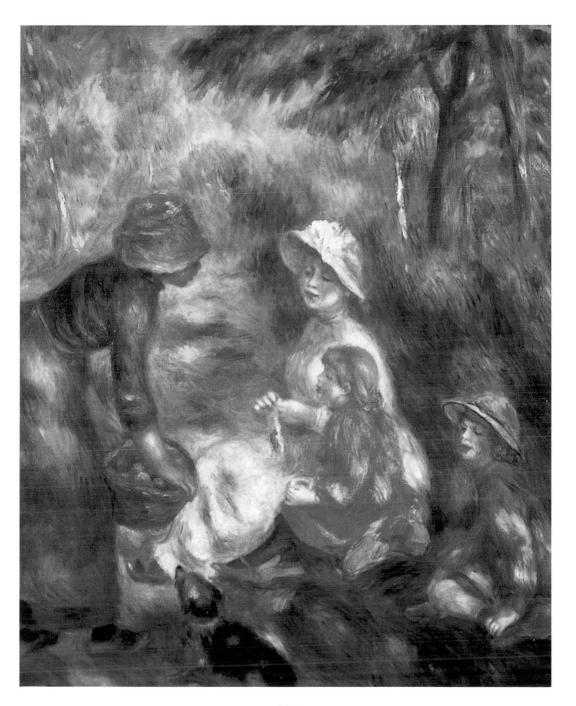

His new patrons the Charpentiers were now beginning to commission portraits as well as decorations for their town house in Paris, and Renoir scored a relative success at the Salon of 1879 with the Portrait of Madame Charpentier and her Children. Marcel Proust includes a long description of the painting in Le Temps retrouvé (Time Regained) and likens it to "Titian at his best". The most favourable reviews concentrated on Renoir's use of colour. which was by now quite brilliant. The steady development of what became known as his rainbow palette can be seen in perhaps its most scintillating and impressionistic form in Boating on the Seine (Canotage sur la Seine), (also known as The Skiff, or The Seine at Asnières, though it was probably painted at Chatou), produced around the same time as the The Charpentier portrait. painting shows an almost textbook application of Chevreul's principles of simultaneous colour contrast. Renoir uses only seven pigments and white, applying them to the canvas in bold, practically unmixed patches to convey an impression of sheer luminosity.

It is ironic and typical of Renoir's nature that at a time he was producing veritable icons of Impressionist art he was also beginning to have serious doubts about his own ability. The financial need to paint an increasing number of society portraits no doubt aggravated the strain on his own artistic judgment of himself. To make matters worse, in 1880 he and Monet had fallen out with Degas, who they suspected was highjacking the Impressionist exhibitions and populating them with his protégés. A trip to Algiers, his first abroad, in the spring of 1881 reassured him of the direction he was taking as an Impressionist and he was soon back in France at Chatou and Bougival painting masterpieces such as Luncheon of the Boating Party (Le Déjeuner des with canoteurs) rekindled vigour. But by October he had left for Italy, writing to Mme Charpentier: "I have suddenly become a traveller and I am in a fever to see the Raphaels . . ."

Renoir had gone to Algeria in the Romantic footsteps of Delacroix, but he now approached Italy seeking the formal classicism of Raphael, which he was to find in the great decorations at the Villa Farnesina. He was also profoundly influenced by what he called "the grandeur and simplicity" of the ancient Pompeian wall paintings in Naples. It was some time, however, before these new influences could reconcile themselves in his work:

"... it's all a mess. I'm still making a mess and I'm forty years old," he wrote to Durand-Ruel from Italy in November 1881

Renoir returned to France in 1882 and joined Cézanne at L'Estaque in the south of France where the two went on

Opposite **RENOIR**

Girls at the Piano
Oil on canvas
1892. 116 x 90cm
Renoir, at last an
established artist, was
asked by the French
government to provide a
substantial painting for
the national collection, for
which he was to be paid
4,000 francs.

PIERRE-AUGUSTE RENOIR

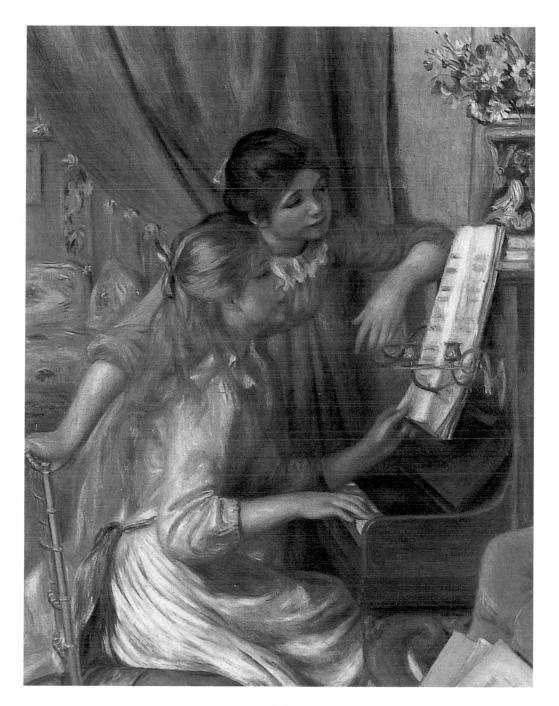

RENOIR

The Artist's House at Essoyes Oil on canvas 1906. 31 x 40cm

Renoir's late style became increasingly loose, which is partly explained by his failing eyesight and the crippling arthritis which in the end confined him to a wheelchair.

Opposite **RENOIR**

Bather, (Eurydice)
Oil on canvas
1895–1900. 116 x 89cm
This nude is not any nude, but Venus
in the nude. Renoir had by this time
returned to his "soft" style which he
attempted to control only when he was
painting commissioned portraits.

landscape expeditions and Renoir caught pneumonia. He had also caught something of Cézanne's vision of the hidden structure of planes and lines in nature. The confusion of the diverse influences at work on Renoir can be seen in The Umbrellas (Les Parapluies), which shows him struggling to reconcile a linear style with Impressionist brushwork. More importantly, in the mid-1880s there is a new concentration on the female nude as a vehicle for expressing light, colour and form. Renoir's fellow Impressionists and the dealer Durand-Ruel were mystified by the new linear style, but Renoir persisted in his experiments with a series of Bathers, culminating in the monumental Bathers (Baigneuses) of 1887. His interest in the female form had also taken a new turn in 1885 when his mistress, Aline Charigot, bore his first son Pierre, prompting the artist to produce the Raphael-inspired Maternity, developing the simplified theme of the Bathers.

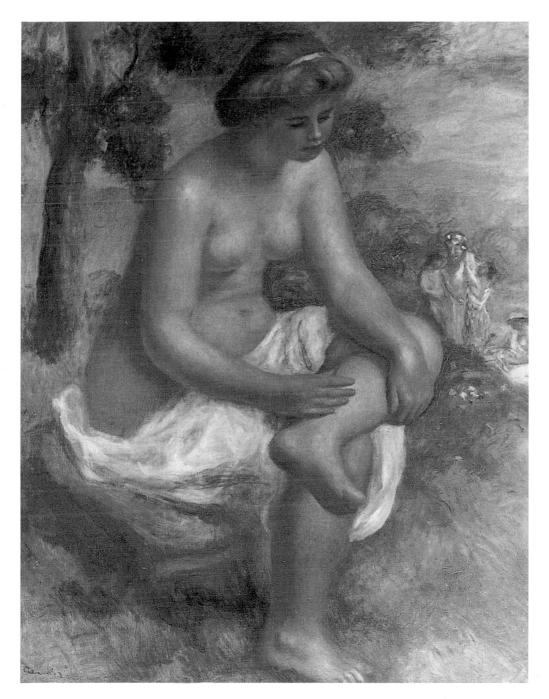

Renoir's "manière aigre" ("sour period") as he called it, came to an end in the late 1880s. After a trip to Spain in 1892 he drew new inspiration from Velazquez. The insistence on line gradually softened but his concern with the human figure remained overwhelmingly important.

In 1902 Renoir and Aline moved to the south of France where the warm climate eased the severe arthritis which was making it difficult for him to paint, and the nerve in his right eye was partially atrophied. Undaunted by his illness he embarked on a series of sculptures echoing the nude figure paintings.

Aline died in 1915 of a heart attack and Renoir died on 3rd December 1919 and was buried next to her in Essoyes. In 1900 he had been made a Knight of the Légion d'Honneur and in the last year of his life, he became a Commander of the Légion d'Honneur, a triumphant honour for a humble "ouvrier de la peinture".

RENOIR

The Bathers
Oil on canvas
1918–19. 110 x 160cm
With this work, the ailing painter was
determined to make a final statement,
showing nude women in a landscape,
two of his favourite subjects. Crippled
by illness, he had the easel set up in
such a manner that he could reach any
part of this large canvas. Renoir thought
he had summed up in it the research
of his whole life, though to many the
painting is more often seen as the
final work of a weakened artist.

PIERRE-AUGUSTE RENOIR

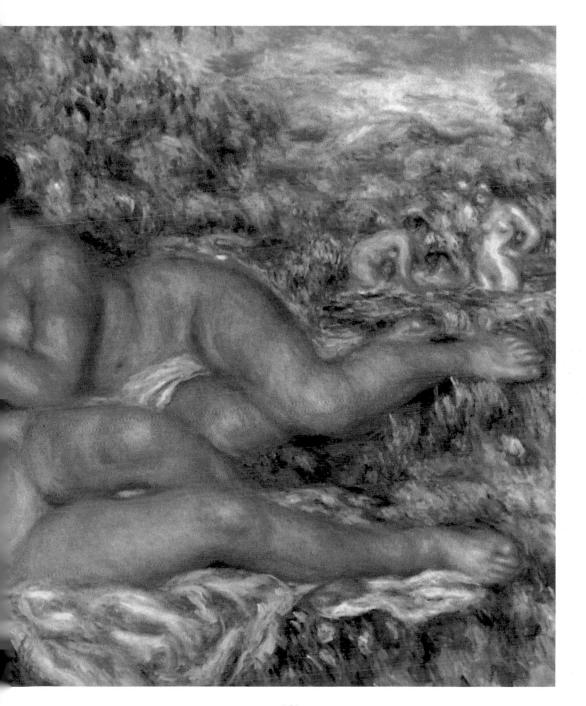

5,516%

ROM COMFORTABLE BEGINNINGS as the son of a successful English businessman in Paris, Alfred Sisley's story is one of tragic decline and late success. After the crash of his father's firm in the Franco-Prussian War, Sisley and his family were reduced to a state of penury which persisted almost to the end of his life when cancer of the throat killed him at the age of sixty. Part of Sisley's lack of wordly success is mainly due to the subdued and unspectacular landscapes which were his almost exclusive preoccupation. Had he been interested in the colourful effects of dazzling sunlight or violent seascapes he may have enjoyed more attention than the belated admiration of a small number of collectors.

Above
ALFRED SISLEY
By Renoir
1874

Opposite SISLEY

The Road from Mantes to Choisy-le-Roi Oil on canvas 1872. 46 x 55cm

Life and Works: Alfred Sisley (1839–1899)

The light of glory will never shine on his work in his lifetime.

GUSTAVE GEFFROY ON SISLEY, 1894

Alfred Sisley was born in Paris on 30th October 1839 to affluent English parents. His father, William, ran a business exporting artificial flowers to South America and his mother, Felicia, was well known as a society lady interested in the arts and music. At the age of eighteen Alfred was sent to London to prepare for a career in business, but his four years there were not solely devoted to the commodities market; he spent a great deal of his time in the art galleries and museums dreaming of being an artist. The works of Constable and Turner attracted him especially, and it was in landscape that he was to make his name.

In 1862 Sisley returned to Paris from a trip and persuaded his parents to consent to his pursuing a career as an artist and in October he joined Gleyre's atelier. By December he was enjoying a dinner party given by Bazille at which the other guests included Monet and Renoir. By the next Easter the budding Impressionists had all left Gleyre's, and Sisley and his friends were to be found on the edge of the Fontainebleau

Forest at Chailly painting landscapes *en plein-air*. And this is what Sisley was to concentrate on for the rest of his life, combining the English tradition of landscape painting with the new techniques evolving amongst the young Impressionists.

By 1866 Sisley was exhibiting two works at his first Salon. He had been working in close contact with Monet, but unlike Renoir, who was to incorporate much of Monet's technique into his early work, Sisley had already developed a more subdued palette, which in many ways suited his calm and reserved temperament. Shortly after the 1866 Salon he married a voung Parisienne, Marie Lescouezec, who was to bear him two children, Pierre and Jeanne. Two years later, when the Sisleys were living in the rue de la Paix in the Batignolles, Renoir painted a large-scale double portrait of them which conveys something of the gentleness of Sisley and his devotion to his wife. In the late 1860s Sisley was increasingly part of the Batignolles Group meeting in the Café Guerbois, and like Bazille he was essential-

ALFRED SISLEY

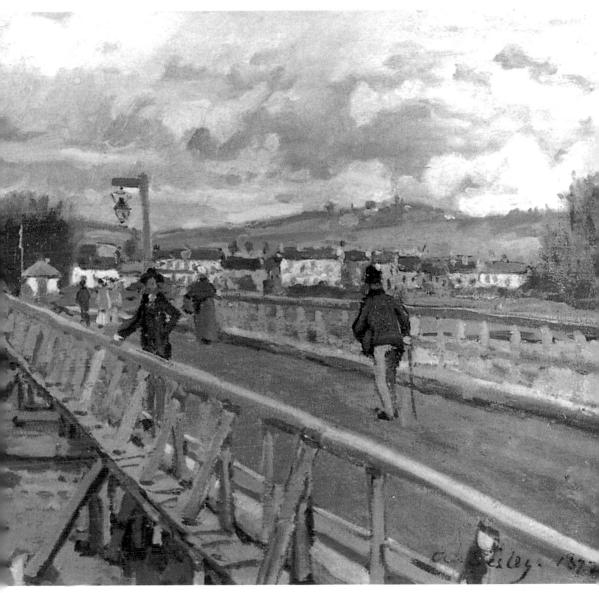

SISLEY

The Bridge at Argenteuil
Oil on canvas
1872. 39 x 60cm
Argenteuil is closely associated with
Monet, who lived there and made well
over 175 pictures of the area.

ly a man of leisure, painting when and as he liked and under no pressure to achieve financial success with his Nevertheless he was to be a founding member of the Société anonyme in 1873, by which time his life had taken a drastically different course.

The Franco-Prussian War of 1870-71 proved to be the downfall of William Sisley and inaugurated a long period of struggle for his son, Alfred, and his young family. Sisley's father had been taken ill and his business had crumbled; when he died in 1871 the family was ruined and Sisley was now forced to paint for a living. Fortunately Monet and Pissarro, who had met sympathetic dealer Durand-Ruel in London during the war, introduced him to Sisley in 1872 and he was assured of a moderate number of sales, but not enough to regain his previous leisured lifestyle. Sisley's post-war output increased exponentially as he painted the landscapes around his home in Louveciennes

When the first Impressionist exhibition opened in 1874 Sisley was represented by five paintings. Perhaps fittingly, for Sisley did not court scandal, they were overshadowed by the "tongue-lickings" of Monet and the other "scandalous" paintings. Monet's influence was in fact discernible in Sisley's work; he was beginning to use brighter pigment in the broken patches which characterized the

Opposite SISLEY

The Road at Louveciennes, Winter Oil on canvas

1874. 38 x 46.5cm

As with Pissarro and Monet, Sisley liked to paint snowy landscapes, and indeed his style at the time was close to that of Pissarro and Guillaumin. plain and simple compared with most of Monet's works.

ALFRED SISLEY

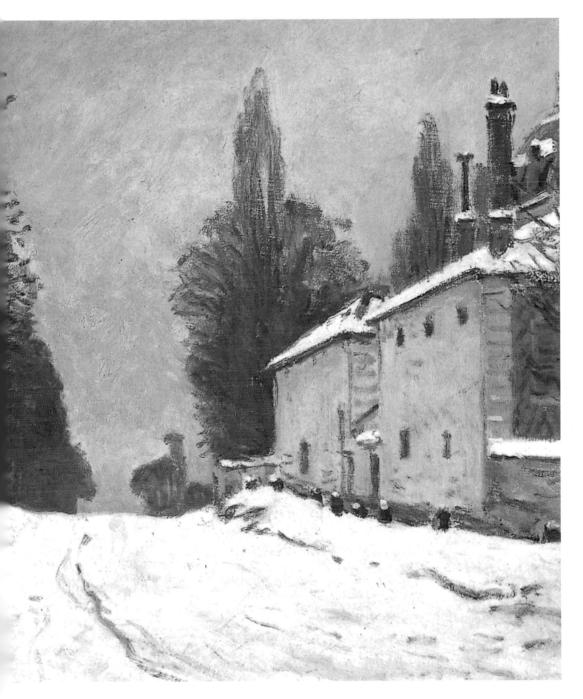

SISLEY

The Road to Versailles Oil on canvas 1875. 47 x 38cm This road, linking Marly to Versailles since the seventeenth century, was a fovourite theme for Pissarro, Renoir, and Sisley.

Sisley continued to exhibit with the Impressionists in 1876, 1877, and 1882. Between 1874 and 1877 he lived with his family at Marly-le-Roi, and it was here that he produced a series of his finest paintings of the floods which periodically inun-

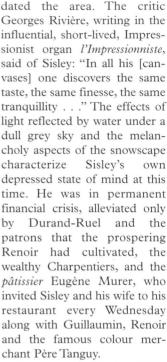

By the end of the 1870s Sisley was still as desperate as ever for money. Several arrangements whereby would be paid in advance for a number of canvases helped him eke out a living, but in 1879 he decided to renounce the Impressionist exhibitions and try his luck with the Salon once again. "I am tired," he wrote to Théodore Duret, "of vegetating as I have been doing for so long. The moment has come to make a decision. It is true that our exhibitions have served to make us known, and as such they have been very useful, but I think we ought not isolate ourselves much longer. The time is still far off when we can do

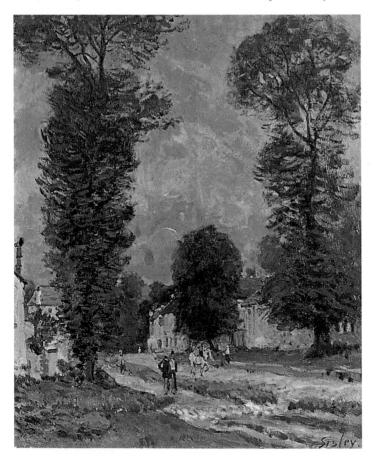

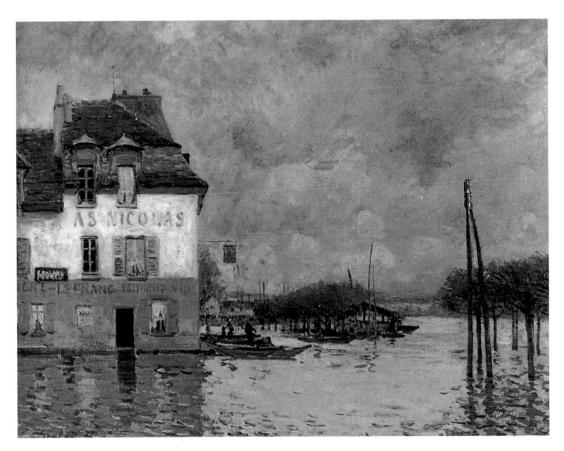

without the prestige which the Salon offers. Thus I have resolved to submit to the Salon. If I am accepted, and there is still a chance this year, I think I will be able to get things sorted out.

But Sisley was rejected by the Salon and then evicted from the house in Sèvres where the family had been living since 1877. With the help of Charpentier other lodgings were found and throughout the 1880s, when the Sisley's lived in the Fontainebleau area, the artist's fortunes slowly began to revive. Never very keen on selfpromotion, Sisley had worked quietly in the country. His landscapes were, however, greatly admired by his friends and critics, as well as several dealers; and by the early 1890s he was able to find a growing, if modest market for his work. This now featured series of paintings of the same subject, particularly the church at Moret where the family finally settled. In the mid-1890s, when Monet and Renoir were selling at huge

SISLEY

Flood at Port Marly
Oil on canvas
1876. 60 x 81cm
One in a series, this is not
an alarming scene of
distressed people trapped in
their homes but a peaceful
and bucolic one in which
the water is seen as a
soothing element in which
the houses are reflected.

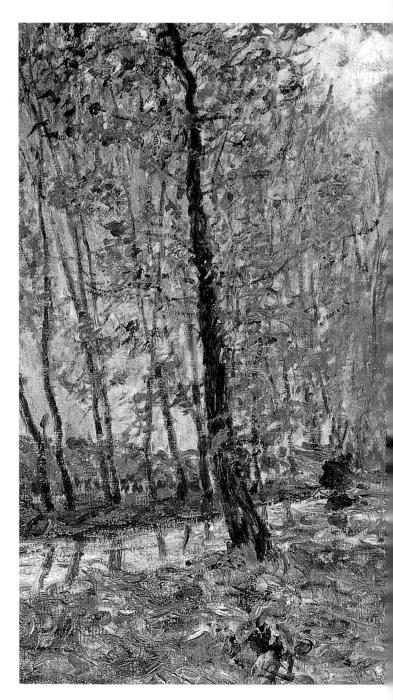

SISLEY

Landscape with a River Oil on canvas 1881. 54 x 73cm The light, lively brushstrokes in this landscape were not typical of Sisley's style and show his attempt at diversity.

ALFRED SISLEY

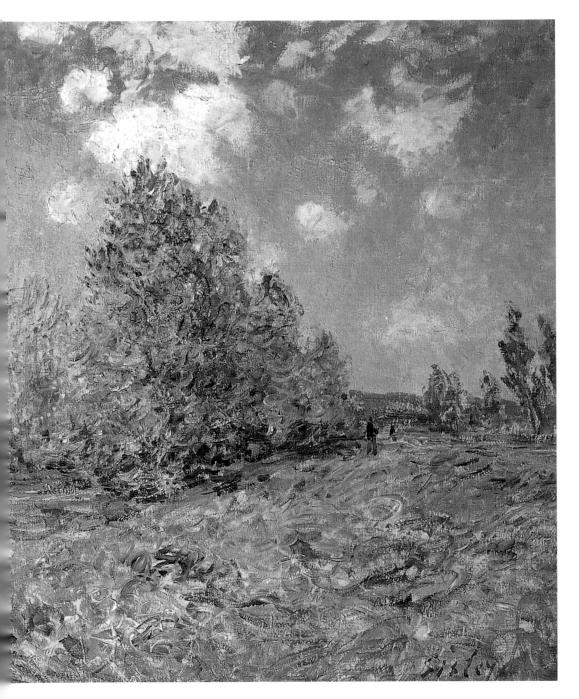

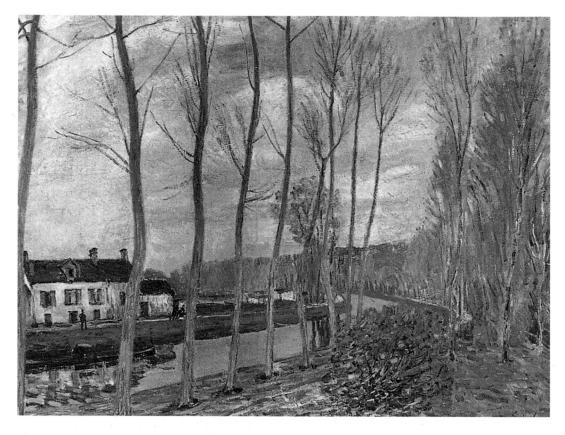

SISLEY

The Loing Canal Oil on canvas 1892. 73 x 93cm Sisley painted at least ten views of the canal, which was not far from his home at Moret. prices, Pissarro in fact complained to his son Lucien: "Doesn't Monet sell at a high price, and Renoir and Degas too? But Sisley and I are still bringing up the rear of the Impressionists."

In 1897, despite severe rheumatism brought on by long hours painting snowscapes *en plein-air*, Sisley set out on a tour of southern England and Wales, producing several landscapes; but on his return to Moret another, fatal illness began to take hold of him. He was dying of throat cancer. On 31st

December 1898 he wrote to his doctor: "I have given up, my dear Friend, I have lost all my energy; I can barely get into my armchair so they can make the bed." A brief remission followed in the new year. However, a week before his death Sisley summoned Claude Monet to entrust his affairs to him. The artist whom Pissarro had called "a great and beautiful painter" died on 29th January 1899 and was buried in the cemetery at Moret-sur-Loing; the ceremony was attended by a few friends including Monet and Renoir.

INDEX

Barbizon School 25-9 Batignolles Group 73-6 Baudclaire, Charles 9 Painter of Modern Life. The 51 Bazille, Frédéric 11, 12, 43, 48. 86. Pink Dress, The 59 Portrait by Renoir 222 Boudin, Eugène 19, 47 Beach Scene, Trouville 98 Low Tide near Honfleur 47 Cabanel, Alexander 40 Caillebotte, Gustave 108 Cassatt, Mary 114 Mother and Child 117 Cézanne, Paul 10, 11, 49, 50 Dr Gachet's House at Auvers 136 Colours 30, 31 Constable, John 15 Cottage among Trees with a Sand Bank 21 Hav Wain, The 20, 22 Corot, Camille 15, 37 Dardagny, Morning 127 death of 100 Forest of Fontainebleau, The 36 Landscape at Mornex, Savov 19 Courbet, Gustave 13, 15, 19, 33, 43, 50 Burial at Ornans, The 34 Entrance to the Straits of Gibraltar 24 Spanish Woman, A 33 Couture, Thomas 37 Romans of the Decadence

38, 41 Daubigny, François 25, 37 Spring 26 Degas, Edgar 10, 12, 14, 15, 42, 50, 95 Absinthe Drinker, The 183 Ballerina and Lady with a Fan 191 Bellelli family, The 44 Brothel Inmates 185 Cotton Market, The 91 Dancers at the Barre 172 Dancing Lesson, The 181 Edmond Duranty 184 Juckeys 193 life and works 174-95

Millinery Shop, The 188 Miss La La at the Cirque Fernando 187 New Orleans, in 90, 91 On the Cliff-top 177 Orchestra of the Paris Opera 81 Races in the Country 178 Rucing at Longchamb 54 Self-portrait 15, 173 Star, The 111 Three Russian Dancers 195 Woman Drving Her Foot Women on the Terrace of a Café in the Evening 113 Young Spartans 54, 175 Delacroix, Eugène 13, 15, 37, 58

Fantin-Latour, Henri 42 Manet. Portrait of 11,149 Tannhäuser on the Venusberg 66

Dutch landscape painting 28

Divisionism 121, 144

Géricault, Théodore 20 Nude Warrior with a Spear 45 Gleyre, Charles 11, 41, 43-9 Gova: Third of May, The 77 Guillaumin, Armand 10, 49, Aquaduct at Arcueil 99

Impressionists beginning of the end 113 - 21exhibitions 95, 96, 104, 107, 109, 115, 117 influences on 19 last exhibition 118, 121 modern life, 50,57 name, gaining 9 nursery of 42-50 origins of 20 Ingres, Jean-Auguste-Dominique

Japanese art 79, 80 Jongkind, Johan 19 Sainte Catherine's Market

at Honfleur, 8

Princess of Broglie, The 43

Odalisque 174

Manet, Edouard 12, 14-16, 37, 42, 73-76 Absinthe Drinker, The 151 Artist's Garden, The 168 At the Café-concert 169 Balconv. The 82 Banks of the Seine at Argenteuil 97 Bar at the Folies-Bergère 171 Reer Waitress The 167 Christ Macked by the Soldiers 68, 71 Copy, Delacroix's Dante 40 Couple Boating 163 Execution of the Emperor Maximilian, 77, 154 Folkestone Boat, Boulogne 160 Gypsy Woman Smoking a Cigarette 53 Italian Woman, An 30 life and times 149-171 Lola de Valence 57 Luncheon on the Grass 11. 16, 19, 41, 61-3 Madame Manet and Her Son Léon 161 Madame Manet at the Piano 159 Masked Ball at the Opera 101 Music in the Tuileries Gardens 13, 52 Nana 165 Old Musician, The 153 Olympia 68-70, 71, 157 Parents of the Artist 150 Portrait by Fantin-Latour 11, 149 River at Argenteuil 164 Spanish Singer, The 50, 51 Study for Bar at the Folies-Bergère 170 Study for the Beer Waitress

Bringing Home the Newborn Calf 32 Gleaners, The 33 Havstacks in Autumn 96 Potato Harvest 28 Monet, Claude 10, 11, 15, 20, 43 46, 49

Walk, The 148

Millet, François 37

Artist's Garden at Argenteuil, 17

Bathers at La Grenouillère 207 Beach at Honfleur 205 Reach at Sainte-Adresse 79 Beach at Trouville 87 Roulevard des Capucines 11, 14, 16, 103 Bridge at Arcontouil 209 Cliff Walk, Pourville 212 Cliffs at Varengeville 119 Gare St Lagare 210 Pont de l'Europe 109 Giverny in Winter 120 Grain Stacks, Sunset 213 Hôtel des Roches Noires. Trouville 86 Impression, Sunrise 11, 104, 210 Japanese Bridge at Giverny 217 life and works 197-219 Louvre, painting from 79 Luncheon on the Grass 72, 203 Nymphéas 219 Poplars 216 Portrait by Renoir 12, 197 Red Road, The 31 Rouen Cathedral series 214, 215 Route de Chailly. Fontainebleau 201 Sea at Fécamp, The 94 Spring Flowers 64 St Luzare Railway Station, Pont de l'Europe 109 Still Life with Bottles 200 Sunset at Lanacourt 2.11 Train in the Snow 208 View of the Rouelles 199 Walk in the Country 196 Morisot, Berthe 10, 12, 82-3

Napoleon III 12, 13, 60, 61, 65, 80 Neo-Impressionism 121

Chasing Butterflies 102

Paints 30, 31 tubes, in 29, 30 Photography 101-103 Pissarro, Camille 11, 12, 15, 16, 20, 37, 50, 82 Boulevard Montmartre by Night 147 Boulevard Montmartre, 145 Clearing in the Woods 56

Pissarro, Camille continued Côte des Boeufs at the Hermitage, Pontoise 139 Côte du Chou, Pontoise 105 Diligence at Louveciennes 133 Dulwich College 135 Haymakers, Evening 143 Kitchen Garden, The 115 Landscape at Eragny 144 life and works 125-47 Railway Bridge at Pontoise 75 Red Roofs 138 Seamstress, The 141 Self-portrait 10, 125, 137 Springtime in Louveciennes 131 Sunset at Eragny 124 Upper Norwood, Crystal

Palace 89

Renoir, Pierre-Auguste 10, 11, 15, 20, 29, 43, 48 Apple Seller, The 237 Artist's House at Essoyes Ball at the Moulin de la Galette 229 Bather (Eurydice) 241 Bathers, The 243 Bazille at Work 222 Dance in the Country 234 Girls at the Piano 239 Greenhouse, The 106 La Grenouillère 84 La Loge 225 life and works 221-43 Lise 223 Landscape at Guernsey 235

Woman Reading 129

Luncheon of the Boating Party 233 Madame Charpentier and Her Children 231 Monet, Portrait of 12, 197 Path in the Grass, The 227 Rose Field 80 Seated Bather 220 Self-portrait 13, 221, 242 Sisley, portrait of 245 Terrace, The 118 Trees in the Forest of Fontainebleau 49 Umbrellas, The 232 White Hat, The 31

Salon des Refusés 13, 58-65, 91, 92 Salon exhibitions 9, 11

Study for La Grande Jatte Sisley, Alfred 10-12, 15, 16, 20, 43, 48, 113 Bridge at Argenteuil 247 Flood at Port Marly 251 Landscape with a River 252 life and works 245-55 Loing Canal, The 254 Portrait by Renoir 245 Road at Louveciennes. Winter 248 Road from Mantes to Choisv-le-Roi 244 Road to Versailles 250 Seine at Bougival 93

Seurat, Georges

Zola, Emile 9, 49, 61, 64, 82

ACKNOWLEDGEMENTS

Baltimore Walters Art Gallery, p.28; Baltimore Walters Art Gallery, p.169/Bridgeman Art Library; Boston Museum of Fine Arts, p.178/Bridgeman Art Library; Boston Museum of Fine Arts, p.154/Visual Arts Library/Bridgeman Art Library; Cambridge, Mass., Fogg Art Museum, p.161; Cardiff National Museum and Gallery of Wales, p.164/Visual Arts Library/Bridgeman Art Library; Chicago Art Institute, p.11,14,17,32,41,54,68,79,99,212,213; Chicago Art Institute, p.118,188-9/Bridgeman Art Library; Cincinnati Art Museum, p.24/Visual Arts Library/Bridgeman Art Library; Cleveland Museum of Art, p.64/Lauros-Giraudon/Bridgeman Art Library; Cleveland Museum of Art, p.16,237/Visual Arts Library/Bridgeman Art Library; Copenhagen Ny Carlsberg Glyptotek, p.151; Essen Folkwang Museum, p.223/Bridgeman Art Library; Glasgow Burrell Collection, p.184/Bridgeman Art Library; Hamburg Kunsthalle, p.165/Bridgeman Art Library; Kansas City Nelson-Atkins Museum of Art, p.103/Bridgeman Art Library; London Christie's Images, p.47,49,56,106-7,129,134-5,148,170,252/Bridgeman Art Library; London Courtauld Gallery, p.171, 225/Bridgeman Art Library; London National Gallery, p.22-3,87,130, 138,146-7,167,187,207,232/Bridgeman Art Library; London National Gallery, p.98,127/Visual Arts Library/Bridgeman Art Library; London Noortman Ltd, p.8,199/Bridgeman Art Library; London Tate Gallery, p.186; London Victoria & Albert Museum, p.21/Visual Arts Library/Bridgeman Art Library; Los Angeles County Museum of Art, p.204/Visual Arts Library/Bridgeman Art Library; Madrid Prado, p.77/Index/Bridgeman Art Library; Moscow Pushkin Museum, p.72-3/Bridgeman Art Library; New York Metropolitan Museum of Art, p.162,230/Bridgeman Art Library; New York Metropolitan Museum of Art, p.43,50,96/Visual Arts Library/Bridgeman Art Library; New York Museum of Modern Art, p.121; Omaha Joslyn Museum, p.142/Visual Arts Library/Bridgeman Art Library; Paris Galerie Daniel Malingue, p.240/Bridgeman Art Library; Paris Louvre, p.26-7,34-5/Bridgeman Art Library; Paris Musée Marmottan, p.104,109,208/Peter Willi/Bridgeman Art Library; Paris Musée d'Orsay, p.12,86,197,210/Bulloz/Bridgeman Art Library; Musée d'Orsay, p.38-9,102,138,144,190, 208,222,226,228, 247/Giraudon/Bridgeman Art Library; Musée d'Orsay, p. 82,117,150/Lauros-Giraudon/Bridgeman Art Library; Musée d'Orsay, p.10,15,42,125,137,158-9,166,173,203/Peter Willi/Bridgeman Art Library; Musée d'Orsay, p.44,57,62-3,111,112-13,181,254/Bridgeman Art Library; Musée d'Orsay, p.114-15, 183,234/Roger Viollet/Bridgeman Art Library; Musée d'Orsay, p.71,59,250/Visual Arts Library/Bridgeman Art Library; Musée d'Orsay, p.81,133,136,239,242/Bridgeman Art Library; Musée Picasso p.241/Giraudon/Bridgeman Art Library; Pau Musée des Beaux-Arts, p.91/Bridgeman Art Library; Philadelphia Museum of Art, p.33,160,191/Visual Arts Library/Bridgeman Art Library; Princetown University Art Museum, p.53/Bridgeman Art Library; Private Collections, p.119,177; Private Collections p.18,104,141,176,168/Christie's Images/Bridgeman Art Library; Private Collections p.30,31,75,76,80,85,88-9,93,94, 120,125,185,192-3,196,216,219,220,244,248/Bridgeman Art Library; Private Collections, p.200,201,217/Visual Arts Library/Bridgeman Art Library; Rouen Musée des Beaux-Arts, p.251/Lauros-Giraudon/Bridgeman Art Library; St Petersburg Hermitage, p.145/Bridgeman Art Library; Stockholm National Museum, p.84/Bridgeman Art Library; Tournai Musée des Beaux-Arts, p.97/Bridgeman Art Library; Washington National Gallery of Art, p.101,153; Washington DC National Gallery of Art, p.110/Bridgeman Art Library; Washington DC National Gallery of Art, p.45/Visual Arts Library/Bridgeman Art Library; Washington DC Phillips Collection, p.223/Bridgeman Art Library; Washington DC Phillips Collection, p.174/Visual Arts Library/Bridgeman Art Library; Williamstown Clark Institute, p.13/Visual Arts Library/Bridgeman Art Library. Every Effort has been made to credit the copyright owners of the pictures used.